ALL THE TIME IN THE WORLD

Encyclopedia of the Exquisite:
An Anecdotal History of Elegant Delights

ALL THE TIME
IN THE WORLD

A BOOK OF Hours

JESSICA KERWIN JENKINS

NAN A. TALESE ✳ DOUBLEDAY

NEW YORK LONDON TORONTO

SYDNEY AUCKLAND

Grateful acknowledgment is made to the following for permission to reprint
previously published material:

Four lines from "Howl" from *Collected Poems 1947–1980* by Allen Ginsberg.
Copyright © 1955 by Allen Ginsberg. Reprinted by permission of
HarperCollins Publishers.

Six lines of song from *A History of Food* by Maguelonne Toussaint-Samat.
Reprinted by permission of John Wiley and Sons.

Illustrations by Minka Sicklinger
Book design by Pei Loi Koay
Jacket design by Emily Mahon
Frontispiece illustration courtesy of the Smithsonian
Institution Libraries, Washington, D.C.

LIBRARY OF CONGRESS CATALOGING-IN-PUBLICATION DATA
Jenkins, Jessica Kerwin
All the time in the world : a book of hours / Jessica Kerwin Jenkins. —
First edition.
pages cm
Includes bibliographical references.
1. Manners and customs—Miscellanea. I. Title.
GT90.J46 2013
390—dc23 2013000795

ISBN 978-0-385-53541-0

MANUFACTURED IN THE UNITED STATES OF AMERICA

10 9 8 7 6 5 4 3 2 1

First Edition

For Nico, who makes every second count

The honey of heaven may or may not come,
But that of earth both comes and goes at once.

—WALLACE STEVENS

ALL THE TIME IN THE WORLD

introduction

WHEN I WAS JUST STARTING OUT IN NEW YORK, working in a dull, gray office building, whenever the morning felt particularly bleak or tantalizingly sunny, I'd intentionally overshoot the front door, strolling eastward on Thirty-fourth Street, as if I were going somewhere else entirely. I'm embarrassed to remember how exhilarating it felt, and how thrilling it was to imagine one of my coworkers spotting me making my escape. I'd see a fantastic day spreading out before me, the matinees, the cafés, an afternoon wandering through Central Park. Then, at the corner of Fifth Avenue, I'd pause, like a trapeze artist at the end of her tether. And I'd turn on my heel and go back to work.

I should have gone to the Cloisters instead. Up above 190th Street at the Cloisters Museum, I'd have found a small leather-bound book, like a diary, made for a medieval queen of France.

A classic book of hours, *The Hours of Jeanne d'Evreux* is composed of short texts that guided the queen through her day—from morning prayers through vespers and the verses for compline, said just before bed—and through her year. The full effect is enchanting. In contrast to the book's pious theme, delicate images of monkeys, rabbits, dogs, and dancing revelers crowd the margins, little animations scholars call *drôleries*. Knights joust on one page; on another courtiers play "frog in the middle," something like blindman's buff meets tag. Holidays are noted in a striking red, some of the first "red-letter days."

My book is an homage to the books of hours treasured by women (and some men) of the Middle Ages and the Renaissance. These antiquated volumes were status symbols, fashion accessories, and talismans, often embellished with gold latches and gilt-edged pages, and done with illustrations in lapis or saffron. They opened a door to devotion, but also one to distraction.

Lately, my husband has been obsessed with GTD—Getting Things Done—a culty businessman's motto that glorifies the traditional to-do list. "GTD!" he crows, having Super Glued the broken handle of the teapot back together. Meanwhile, our individual Google calendars sync with our laptops, which, in turn, download data to devices that bleep in the middle of the night whenever it's time to pay a bill. In response to these twittering interruptions, a phrase I've been muttering lately is, "WWBD?" That is, What Would Baudelaire Do?

In the same way that my first book, *Encyclopedia of the Exquisite,* took inspiration from the earliest encyclopedias while offering an antidote to Wikipedia, *All the Time in the World* celebrates the traditional book of hours with the hope of countering the hyper-scheduled cult of Getting Things Done. Wistful poets, frilly ladies, passionate dandies, voluntary tramps, rainbow hunters, bold artists, and iconoclasts with a passion for good living lead the way as the pages move through the hours of the day offering a string of historical anecdotes to demonstrate the unusual, fantastic, and beautiful ways people have spent time across centuries and continents. It's an agenda turned upside down in favor of the impractical and the ephemeral: drinking hot cocoa, taking a nap, waltzing until dawn.

I hope that in some subtle way this book, like the giddy characters flitting through the margins of a medieval book of hours, provokes a happily warped awareness of how we pass the time, while suggesting some bold and wonderful ways to spend whatever we've got left.

In the early dawn, a riverboat calliope's thin song wafted down the banks of the Mississippi River where five sleepy-eyed boys stood barefoot on the cold sand, peering into the distance. It was 1869 and the circus was coming to McGregor, Iowa. When the twinkling ship reached the dock, a muscle-bound, cursing crew clambered off and, wagon by wagon, unloaded the entire show, including an elephant whose weight bowed the gangplank. Meanwhile, the boys, sons of a German farmer called Ruengeling, stood mesmerized. "What would you say if we had a show like that?" the eldest, seventeen-year-old Albert, asked his brothers.

Later that summer, the boys charged neighborhood kids ten straight pins' admission to their backyard circus. Eventually they added a billy goat, then a horse, and upped their fee. By 1884 they'd changed their name to Ringling, and soon enough, after hooking up with Barnum & Bailey, their circus was known as "The Greatest Show on Earth."

At the turn of the century, nearly a hundred small circuses crisscrossed the United States, traveling the rivers, roads, and rails, as enthusiasts gathered in the predawn hours to greet them at every stop. "When the circus came to town we managed to shake out of sleep at four o'clock in the morning," poet Carl Sandburg (1878–1967) remembered of his boyhood in Galesburg, Illinois.

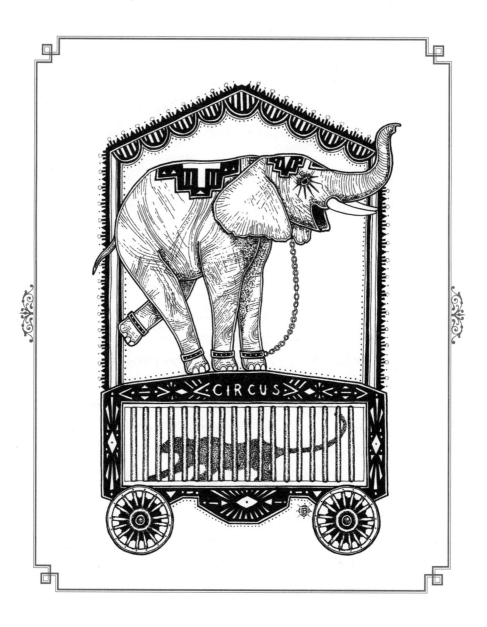

As soon as his feet hit the floor, he'd grab a slice of bread and butter and sprint off to the yards.

Farm families traveled from miles around on Circus Day. School was canceled. Shops closed. Attendants could sell eight thousand tickets in forty minutes for a big-top show that promised clowns by the dozen, lion tamers, and high-wire acrobats, who, in those days, were perfecting the midair triple somersault. For country folk, the circus provided "our brief season of imaginative life," the novelist Hamlin Garland (1860–1940) wrote. "In one day—in a part of one day—we gained a thousand new conceptions of the world and of human nature." In with the circus came the latest songs and jokes. It gave everyone something to talk about. "Next day as we resumed work in the field," Garland wrote, "the memory of its splendours went with us like a golden cloud."

Just like that, the cloud drifted on. Roaming the deep countryside, circus wagoners lost their way "with perverse frequency," one performer remembered. "You have slept four hours out of sixteen and are crawling along in the face of a drenching, blinding rainstorm—soaked, hungry and dazed." Yet, traveling by wagon, one also felt the "wild, free, clean abandon of the life," clown Jules Turnour (d. 1931) wrote. Turnover rates were high among circus workers, but there were always romantic souls desperate to run away from home and replace those who had returned.

To join the circus was to enter a different world. Circus people had their own slang: an elephant was a "punk," acrobats were

"kinkers," a joking clown was "cracking a wheeze." The cry "Hey, Rube!" was their call to arms, raised when an outsider violated circus code, and bringing anyone nearby to jump into the fray.

Sometimes they stayed in town for one night only. While the audience watched the show unaware, a circus train crew disassembled the tented city, packing up the menagerie, sideshow tents, and candy shops, then pressed on to the next destination, with the last cars pulling out after midnight. During the 1890s, the Barnum & Bailey Circus rolled along with a thousand employees, 407 horses, 12 elephants, 2 mules, and 4 camels, all in 102 wagons. The crew could transform an empty lot into a tented city in two hours flat, while in the just-constructed kitchen the cooks prepared two thousand cups of coffee, several thousand eggs, and five hundred pounds of meat. At 6:00 a.m., they rang the bell for breakfast.

6:05 AM ✳ LOVERS PART

"I never saw a lover rejoicing because he liked the dawn," sang the thirteenth-century Provençal troubadour Cadenet. For centuries the aching, reluctant farewells of lovers parting at sunrise generated poetic fodder in the form of the aubade, or dawn song, as when the ancient Roman poet Ovid (43 BCE–17 CE)

scolded Aurora, goddess of the rising sun, for tearing him from his lover's bed:

How often have I longed that night should not give place to thee, that the stars should not be moved to fly before thy face! How often have I longed that either the wind should break thine axle, or thy steed be tripped by dense cloud, and fall!

But, alas, his love-struck pleas would go unheeded. As he reported, "the day did not arise any later than usual."

Poets writing in Provençal, Kurdish, Chinese, Japanese, and Quechua all bemoaned the sad state of affairs, taking up the theme and describing the sorrow of a lover cooing his goodbyes from under a window or the pillow talk between two lovers just waking and forced to part. A medieval maiden might try to persuade her knight to stay, despite the danger of discovery. One poet wrote, in Hindi, "There is a wager between Dawn and my heart, which will first break." The more intense the lovers' joy, the more terrible their separation. They did what they could to stop time, but in the end it always turned out the same.

The thirteenth-century German poet Wolfram von Eschenbach regarded their eternal predicament with a sensualist's eye:

Their bright skin, that smooth skin,
came closer as the day appeared.

Weeping eyes—a sweet woman's kiss!
So were they all entwined,
mouth, breast, arms, and shining legs.

6:10 AM ✳ THE KABUKI DRUMS BOOM

To make the early-morning curtain, seventeenth- and eighteenth-century kabuki aficionados, on foot and riding in palanquins, made their way through the dark. In the streets of Osaka, Kyoto, and old Tokyo, ticket barkers shouted, whistled, or impersonated the theater's stars, giving a preview of what might be seen inside. Thundering drums announced the start of the show as teahouse attendants who worked in establishments attached to the theaters helped distinguished guests change into slippers, and then guided them toward an early preshow breakfast. Eating was as important as watching the show.

Inside the theater, runners delivered snacks to the box seats one after the next. First came tea and sweets, then appetizers and saki, then lunch, and then, in the afternoon, an assortment of sushi. Near dark, when the show was over, fancier guests retired to the teahouse for a banquet, hoping to meet the stars of the day.

But kabuki wasn't only for the rich. The theaters were crammed with all sorts—ladies, samurai, and geisha in the plush box seats,

but also shopkeepers and monks, who sat on tatami mats on the floor. "The people came in pushing and jostling, and eight persons sat knee over knee on a mat," an observer wrote in 1703. "It is very pleasant to see them pressed together like human sushi."

The plays centered on local scandal—vendettas, murders, swindles, and love affairs. The theme of lovers' suicide was banned, so as not to encourage the lovelorn. But displays of enthusiasm were encouraged. At crucial moments during a performance, a player would pause to strike a stylized pose, prompting the wild crowd to shout his name, or, if the performance lived up to the standard of his theatrical lineage, the name of his revered father. Fan club members devoted to a star performer arrived at the theater all dressed alike and clapped in rhythm during the show, leaving behind bales of rice and barrels of saki as gifts.

The first kabuki dance was performed by a Shinto priestess named Okuni on a dry riverbed in Kyoto in 1596. She later gave a repeat performance at the imperial palace. Following in her footsteps, women, mostly prostitutes, formed kabuki troupes, performing bawdy skits and slinky dances and inflaming the passions of young samurai, which raised a public alarm. "Recently there has been a tendency for even high-ranking people to use the argot of actors and prostitutes," pronounced an adviser to a seventeenth-century shogun. "Such a tendency will result in the collapse of the social order." The regent dictated harsh regulations

designed to loosen kabuki's hold, including a decree that theaters could be only partially roofed—over the stage and box seats—thereby limiting theater owners to operating on mild, sunny days. (This also meant that the show's opening drums served as a local weather report.) Theaters were restricted to the red-light districts outside city walls, as were the performers themselves, who could not legally venture beyond the kabuki zone's borders. Women were banned from the stage altogether in 1629, and when the long-haired boys who replaced them proved too attractive, the boys were forced to shave their heads so that they could no longer wear elaborate ladylike hairdos. To fake long, lustrous locks, the boys tied kerchiefs around their heads and used purple silk patches. "The appearance of their faces was smooth and like cats with their ears cut off, and they were a sorry sight," wrote a theatergoer.

And yet the devoted audience wouldn't abandon kabuki. In the eighteenth century, samurais entered the theater incognito, wearing baskets over their heads. Ladies-in-waiting, who, for propriety's sake, shouldn't have been at the theater at all, faked visits to their parents so they could flock to the latest shows. Even the most distinguished matrons, those who wouldn't dare go inside, stopped their palanquins in front of the theaters and had the curtain pulled back so they could take a peek. (The government soon passed a law against *that*.)

The only thing that could stop kabuki cold was closing the

theaters altogether, and this finally happened in 1713, after a lady-in-waiting to the emperor's mother fell in love with a leading man. The lovers were banished to separate islands and all the theaters in Tokyo were closed. It was temporary, of course. Once the theaters reopened, things carried on as before, with the playwrights taking inspiration from the illicit love story for years to come.

The true kabuki fan's dawn-to-dusk life consisted of "living only for the moment," author Asai Ryoi (1612–1691) wrote of the era's decadents, "savoring the moon, the snow, the cherry blossoms, and the maple leaves, singing songs, drinking saki, and diverting oneself just in floating, unconcerned by the prospect of imminent poverty, buoyant and carefree, like a gourd carried along with the river current."

January ✳ SKATERS GLIDE ON ICE

A PACK OF CHILDREN SKITTERED ACROSS the iced-over Moorfields on the outskirts of London in 1180, back when venturing onto the frozen water was something strange and noteworthy. Some, wearing sharpened bones strapped to their shoes like rudimentary ice skates, pushed themselves along with sticks "as swiftly as a bird flyeth in the air or an arrow out of a cross-bow," an awed observer noted. And occasionally they moved "swiftly on so slippery a plain, they all fall down headlong."

The scene was more dignified in 1662, when King Charles II (1630–1685), gracefully glided onto the frozen Thames—a habit he'd picked up while exiled in Holland. Somewhat nervously, diarist Samuel Pepys (1633–1703) tagged along to St. James Park to watch. The ice "was broken and dangerous, yet he would go slide upon his skates, which I do not like," Pepys wrote, admitting that

the king "slides very well." Some twenty years later, Pepys would make his own icy debut during a winter fair, dancing across the frozen river with the king's mistress, Nell Gwyn.

The Thames didn't freeze often, but when it did, it was an occasion. In 1813, hundreds assembled on London Bridge to see the first daredevils walk across the frozen river. Eager fairgoers soon followed, lured onto the ice by bookstalls, drinking tents, and a wheel of fortune, installed during a frost fair that lasted for months. Dancers whirled across the ice as a fiddler played a reel, and, from time to time, ice islets broke away from the mass, carrying unfortunate riders downriver. "As they passed under Westminster Bridge they cried out most piteously for help," a fairgoer reported, after watching two men drift away, never to be seen again. And yet, as risky as clambering out onto the ice was, when the thaw came, thousands of disappointed Londoners thronged the banks, "and many a 'prentice boy and servant maid sighed unutterable things at the sudden and unlooked-for destruction of the Frost Fair," a reporter noted.

But the English monarchy was never as clever with ice as Russia's imperial leaders. During St. Petersburg's bone-numbingly cold winter of 1740, Empress Anna of Russia (1693–1740), known for her cruel and grandiose sense of humor, ordered giant slabs of ice pulled from the Neva River to construct a palace. The royal architect directed workers in transforming the slabs, which were "carved into ornamental architectural shapes, measured with

compass and rule, and one slab placed upon another by means of levers," a visitor recorded, "water being poured over each and, freezing immediately, serving as strong cement." Once complete, the palace facade glowed blue like some strange precious stone and was decorated with carved columns and statues and an ice balustrade. Periodically, an ice cannon shot off iron cannonballs. Nearby, an enormous ice elephant spouted water from its trunk and "uttered a sound just like a real elephant, made on a trumpet by a man hidden inside it." The interior of a walk-in ice pyramid was lit up by a magic lantern, which projected flickering images across the slick walls.

Even more wonderful were the palace's interiors. The drawing room shimmered with an ice sofa and chairs, and an ice table, as well as an ice clock, its ice wheels visibly turning inside its frozen case. In the bedroom, visitors marveled at an ice bed, with its ice canopy, ice sheets, ice pillows, and ice blanket, and an ice dressing table stocked with an ice mirror, ice jars, and ice candlesticks. There was a carved ice fireplace filled with logs of ice. Even the palace's windowpanes were ice-glass, lit from within at night to give off a pearlescent glow.

Two people who came to know the place a little too well were the empress's poor jester, Prince Mikhail Golitsyn, and a young servant whom he was forced to marry, in order to amuse the court. After a grand mock wedding feast and a ball, the doomed couple were brought to the ice palace and ordered to stay the night

dressed only in their nightclothes, or, in some versions of the story, nothing at all. To keep warm, they ran through the palace slapping each other. In any case, they survived.

In March, when the south wall of the ice palace gave way, the largest remaining blocks were carted off to the real imperial palace to restock the ice cellar.

6:45 AM ✳ MATISSE BOWS TO CÉZANNE

It was a morning ritual. As the first rays of sun rose behind Notre-Dame de Paris and shone through his window during the winter of 1899, Henri Matisse (1869–1954) slipped out of bed to stand before *Three Bathers* by Paul Cézanne (1839–1906). The painting, done in a lush Impressionistic style, depicted three sturdy nude women splashing near a riverbank. Matisse was thirty years old. He had just moved to Paris and was flat broke. In grubby corduroys, he worked as a day laborer for one franc an hour, while his wife, Amélie, a dressmaker, supported the two of them. Matisse's painting career had been on the rise. The French government had even bought some of his canvases. But that was before he had laid eyes on audacious new works by Van Gogh, Gauguin, and Cézanne and had decided to join the avant-garde. Matisse's painting teacher refused to comment on his distorted new vision,

except to say, "Under the circumstances I really don't see how any remarks that I might have to make could be of any particular service to you." But seeing Cézanne's bathers gave Matisse resolve. He offered a gallery owner his own paintings in exchange for the work, and Amélie pawned her prized emerald ring to cover the balance. She didn't understand the painting, but she knew her husband needed it. "If I am wrong, then Cézanne is wrong," Matisse would tell himself. "And I know Cézanne is not wrong."

Others weren't so sure. Ultrarealism ruled the day, and Cézanne's hazy vision was utterly unorthodox. It took thirty years for the intrepid painter to land his first show. Even then, when the gallerist displayed a Cézanne bathing scene in his front window, his friends rushed in and convinced him to take it down. Inside the gallery he hung Cézanne's nudes facing the walls.

Throughout his career Cézanne repeatedly painted groups of bathers, always with slight variations. The writer Émile Zola (1840–1902), a childhood friend, described how as young men living in Paris the two spent their Sundays out in the countryside lounging near a watery spot, their "green pond," where the trees came together "as in a chapel." From that vantage point, Cézanne took "haphazard glances" at people scantily clad and bathing near the shore. His eye was like a camera. It had to be, because find-ing a group of artist's models audacious enough to pose together naked out in the woods was out of the question.

Cézanne's bathers directly influenced a whole generation

of painters, including Matisse, Pablo Picasso, André Derain, Georges Braque, and, later, Jasper Johns. Pierre-Auguste Renoir once persuaded an adventurous collector to buy one of the radical paintings. Then, in order to get the man's wife used to it, Renoir dropped by with it, as if it were his own, and pretended to leave it behind accidentally. "At the Salon d'Automne of 1905 people laughed themselves into hysterics before his pictures," wrote Leo Stein (1872–1947), Gertrude Stein's brother, and a passionate collector of Cézanne's work. "In 1906 they were respectful, and in 1907 they were reverent."

Few who appreciated Cézanne, however, were as reverent as Matisse, who called him "the father of us all." The Matisse family closely guarded *Three Bathers* for more than thirty years, refusing to sell it even when money was tight during World War I. They sold a Gauguin instead. And then they pulled the children out of school to save on tuition fees. "In the thirty-seven years I have owned this painting, I have come to know it fairly well, though I hope not entirely," Matisse wrote when he finally presented *Three Bathers* to the city of Paris in 1937. "It has supported me morally at critical moments in my venture as an artist. I have drawn from it my faith and my perseverance."

The Swedish naturalist Carl Linnaeus (1707–1778) was fascinated by what he called "the sleep of plants," periods when various species closed their blooms, folded their leaves, and seemed to be at rest. At home in his gardens at Uppsala, Sweden, he kept meticulous records of the times flowers opened and shut. Around 1751, he began dreaming of a flower clock, which, unlike a sundial, "could tell the time, even in cloudy weather, as accurately as by a watch." Planted in a round garden patch in twelve wedged sections, like the face of a clock, the marigolds would open at seven in the morning, the red pimpernels at eight, and on through the hours, with night-blooming flowers, such as the evening primrose, opening around six. "But pray consider what will become of the clockmakers if you can find out vegetable dials," a friend teased. Further exercising his fascination with the rhythms of nature, Linnaeus carefully reconceived the yearly calendar. There was the month of Reviving Winter, encompassing December 22 through March 19, followed by the month of Thawing, through mid-April, the month of Budding, through the beginning of May, and on.

Independent of Linnaeus's plant watching, in the summer of 1877 English scientist Charles Darwin (1809–1882) observed time's passage with the help of sleeping seedlings. "I am all on

fire at the work," he wrote to a friend. Studying tiny red cabbage cotyledons, he gummed a single brush bristle dipped in ink to a tiny leaf, and as the plant moved throughout the day, the hair traced its path across a white card. (The delicate results were actually quite pretty.) Darwin's conclusion: Light affected his cabbage plants "almost in the same manner as it does on the nervous system of an animal." Nearly every living thing ticks in time with an internal biological clock responding to light.

Like flowers, humans have their own rhythms, a "human clock" set in motion by the tasks of the day, and German Romantic writer Jean Paul Friedrich Richter (1763–1825) liked to imagine synchronicity between the two. "At three o'clock the yellow meadow goat's-beard opens, and brides awake, and the stable-boy begins to rattle and feed the horses beneath the lodger," he mused. "At five, kitchen-maids, dairy-maids, and buttercups awake; at six, the sow-thistle and cooks."

Each lived and worked in harmony with a unique internal clock—as did Darwin himself, of course. Once, a friend asked Darwin's gardener about the great scientist's health. "I often wish he had something to do," the man replied. "He moons about in the garden and I have seen him stand doing nothing before a flower for ten minutes at a time."

7:30 AM ✳ FINDING ONESELF

The coquette's "first care after getting out of bed is to consult her mirror," one eighteenth-century Parisian noted. In lands far and wide, people have greeted the morning with a peek at their reflected selves since at least the fifth century BCE, when Greeks primped before small disks of polished metal. In ancient China, mirrors were mystical love tokens, engraved across the back with bits of poetry, like one that read "Looking at the light of the sun, let us forever not forget one another." Couples in those days broke a small mirror in half so that when they were apart each could carry a piece, and, when the time came, each would be buried with his or her mirror shard.

In medieval Europe, mirrors were treasured objects, magical and rare, worn as jewelry or brought to holy shrines, where their shining surfaces could capture a saintly aura. Then, suddenly, in

the mid-seventeenth century, the magic disappeared. Mirrors were everywhere. "This precious miracle is found today as often in the hands of the great as in those of the small," a French writer noted. Mirrors were made of tin, polished jet, rock crystal, or silvered glass—anything that could reflect a face. Peddlers walked the streets singing, "Little mirrors shiny and snug / Ready to reflect your ugly mug!" Ladies carried pocket mirrors ever at the ready, enclosed in a small ivory or ebony box, or worn attached to their belts. As glass became cheaper and easier to manufacture during the 1800s, mirrors grew ever larger. There were mirrors hung in parks, for instance on all the walls of a grotto housing a waterfall, in order to amplify the views. The most stylish people hung them in every room, delivering a "disastrous blow" to the art market, as mirrors replaced canvases.

One of the most emphatically creative artists to use mirrors in her work, however, was American dancer Loie Fuller (1862–1928), known for her new-tech vision and curvy physique. She intrigued audiences with her reflected image during a "Danse du Miroir" in fin-de-siècle Paris, performing her choreography on a tiny octagonal stage. The stage was open at the front, with mirrors forming its walls, hanging above, and laid below on its floor—requiring, surely, a delicate step—and all illuminated by tiny electric lights at the interstices. Wearing hundreds of yards of billowing, flyaway silk, she was a butterfly, a cloud, a flame, inspiring Art Nouveau—era artists from Henri de Toulouse-

Lautrec to René Lalique to Auguste Rodin. Inside her mirrored prism, Fuller became a small troupe of synchronized dancers, all fluttering in voluminous robes. "By some mysterious arrangement, eight Loie Fullers appear to be dancing at the same time," a spectator wrote, "and the whole stage is bathed in a flood of glorious tints, in which may be seen arial forms, in cloudlike vestures. . . ." Then Fuller added the coup de grâce: a sheet of transparent glass, stationed between her and her audience, that served as a one-way mirror when the auditorium went dark. The crowd watched Fuller watching herself from every angle and echoed a thousand times, her undulating dress floating in a spectral haze.

During Fuller's performances, "one feels subtly transported into the strangest regions of the dream," wrote a French critic, finding "in these astonishing apparitions, something satanic and demonic, but of a gentle Satanism, of a poetic and suggestive demonality, which sets one on the starry and luminous path of hashishian dreams." Once she danced with photographs of snowstorms and moonscapes projected onto her silks, and once she wore robes treated with phosphorescent salts so that they glowed blue and gave off light enough to read by.

Her artfully enhanced image didn't always mirror the offstage reality, however. "No, no," complained a child visiting Fuller's dressing room after one show. "This one here is a fat lady and it was a fairy I saw dancing." Fuller tried to be "equal to the situation," she recalled in her memoirs. "Yes, my dear, you are right," she told the young fan. "I am not Loie Fuller."

In centuries past, two quintessentially American breakfast foods, pancakes and doughnuts, were rich treats that Europeans indulged in before embarking on the lean forty days of Lent. On Shrove Tuesday, or "Pancake Day"—the last day before that yearly deprivation—fifteenth-century London mayor Simon Eyre ordered a pancake feast made for all the city's apprentices. Every parish rang a bell—the pancake bell—so the boys could leave work early, a tradition that continued into the 1800s with a rollicking pancake toss held at schools. If a boy was lucky, he caught a hot pancake winged right out of the frying pan, as described in several lines penned in 1614:

> *And every man and maide doe take their turne,*
> *And toss their pancakes up for feare they burne.*
> *And all the kitchen doth with laughter sound,*
> *To see the pancakes fall upon the ground.*

The French made beignets, and the Dutch made their fried-dough cousins the *oliekoeken,* or oil cakes, which migrated to America in 1796 when a Dutch housewife opened New York City's first proto-doughnut shop. But for more than a century, most Americans associated doughnuts and pancakes with hearty New England fare. Lumberjacks working the Maine wilds ate five

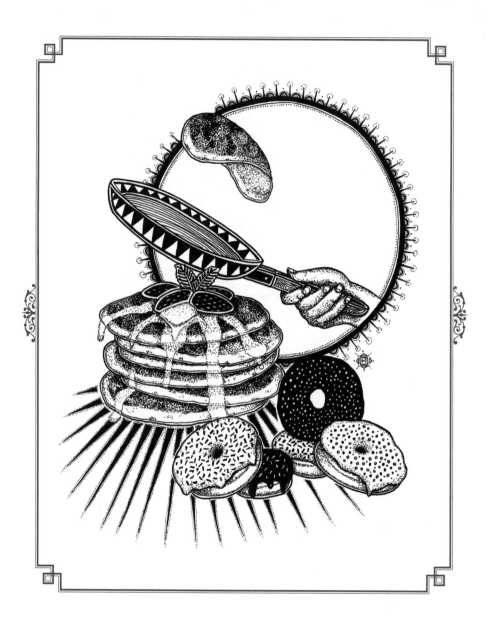

meals a day, including doughnuts furnished "ad libitum," according to *The New York Times* in 1878, as well as stacks of flapjacks, and tea "strong enough to float an ax." New Yorkers thought that all the sweet fare made for an odd breakfast. "Pie and doughnuts go hand in hand all over New England," the paper reported several years later. "What New York man or woman can think of pie as a breakfast dish without a shudder? The New Englander doesn't shudder. He likes it at any time."

Naturally, it fell to a New Englander, Maine's Captain Hanson Gregory (1832–1921), to invent the doughnut hole. When eating a fried cake and steering his ship through a swell in 1847, he impaled his cake on his ship's wheel in order to save it for later, or so the story goes. (Another version claims he cut out the undercooked, over-greased center of his mother's doughnuts with a round lid after a bout of indigestion.)

Yet doughnuts were slow to spread countrywide until Red Cross workers served them to soldiers during World War I. After that they quickly became comfort food, "the epitome of domestic bliss and family welfare," according to *House Beautiful*. In the 1930s, when every cigar shop and corner drugstore installed a soda counter, young men in smart white caps served breakfast doughnuts and pancakes every morning in an exuberant flurry.

Like doughnuts, pancakes were still popular at sea. A reporter asked Captain Bob Bartlett about eating flapjacks out on the open ocean in 1935. "Did we have pancakes in the Arctic? Sure we did,"

he answered. "There we'd be, all hands around the fire, and the fellow making the pancakes would put it right in the plate of a man."

Jenkins-Style Maine Pancakes

> *2 cups sifted flour (or gluten-free substitute)*
> *½ teaspoon salt*
> *Tiny pinch of cinnamon*
> *2 teaspoons baking powder*
> *½ teaspoon baking soda*
> *2 tablespoons sugar (or none, if you prefer)*

Whisk together the dry ingredients. Then beat together and add to the dry mix:

> *1 egg*
> *1½ cups buttermilk (or sour milk that's just gone off)*

When the batter is uniformly mixed, gently stir in:

> *3 tablespoons melted butter*
> *1 cup Maine blueberries (frozen okay, or high-bush blueberries, if necessary)*

Fry up the pancakes, slowly but surely, in a cast-iron pan greased with a little butter. Serve with dark, rich B-grade maple syrup.

Gluten-free tip: At home we use Bob's Red Mill gluten-free all-purpose baking flour plus ½ teaspoon Bob's Red Mill xanthan gum.

8:00 AM ✳ KING LOUIS XIV RISES

As the queen of France Catherine de' Medici (1519–1589) wrote, when all the princes, lords, and aristocrats came to the bedroom of François I to watch him put on his clothes, they were "greatly contented" by the sight. France's kings offered such contentment for centuries, as they were dressed each morning by the highest court officials at ceremonies extolling the royal waking—the *lever*—and undressed at night for the royal bedtime, the *coucher*. Not surprisingly, the extravagant Louis XIV (1638–1715) took the ritual to the brink, turning the moment when he changed out of his pajamas into a daily pageant.

Each morning, eagerly waiting courtiers, having conducted their own *lever* ceremonies at home, filled the king's antechamber at Versailles. As the palace clock sounded eight, the king's valet, Bontemps, approached his bed and said, "Sire, the clock has struck." Over the course of the next hour and a half, as Louis rose, shaved, and dressed, more than a hundred people filed into the royal bedroom, beginning with those holding the highest credentials and continuing by degrees.

First in were the male family members, permitted early entry while he was still in bed. The valet presented the king with wine for washing his hands over a silver basin. Sieur Quentin, the barber, showed him a selection of wigs. Louis's valet brought the royal slippers, and one of the courtiers, usually the Duke de Beauvillers, was granted the right to hand over his dressing gown. After the king knelt beside his bed for a few short prayers, he sat in his armchair so that the next round of nobles and officials could be let in.

Friends took precedence, as well as those with status—cardinals, dukes, presidents of parliament, governors of the provinces. Before each entered, a page murmured the name of the proposed caller to the Duke de Beauvillers, who quietly repeated it to the king. If the king had no objection, the caller was ushered in. Meanwhile, another page handed the king's stockings to an official, who passed them to the king, who put them on. Another official offered the shoes. Someone held the king's mirror for him while he shaved. And they weren't done yet. After the king paused for a quick breakfast, the dressing continued, with yet more people arriving to watch.

There were breeches to hand off, and handkerchiefs, but the most complex maneuver involved discreetly removing the king's dressing gown and nightshirt while he slipped into his shirt. It went like this: The Marquis de la Salle took the nightshirt by the right sleeve, while Bontemps took the left. Another courtier

brought a fresh shirt, which had been warmed, passing it off to a duke, or, if the dauphin was there, then to the dauphin, who would give it to the king. Meanwhile, two specially appointed members of the entourage used the king's dressing gown as a curtain to keep him from flashing the crowd. The Duke de la Rochefoucald, who twice fought over the right to present particular garments to the king, held the privilege of handling his underwaistcoat and buckling on his sword.

Every aspect of Louis XIV's life was choreographed—his meals, his evenings, his playing cards, his hunting trips. When Louis XV (1710–1774) took the throne, he too endured the ceremonies of his rank, but he also constructed a private bedroom near the official state bedroom. In the evenings, he went through motions of the *coucher,* then got dressed again and set out for a late night in Paris. In the mornings, he'd get up early in his private apartment and set his own fire, and would have been up for hours before slipping into the state bedroom and pretending to wake for the gathering crowds.

There was only one ceremony Louis XV liked: presenting his dogs with their daily royal biscuits.

February ✳ KEATS LOVES AND LOSES

"STILL, STILL TO HEAR HER TENDER-TAKEN BREATH /
And so live ever—or else swoon to death." So ends English poet
John Keats's extraordinary "Bright Star," which some believe
was written for his love Fanny Brawne (1800–1865) in February
1819, shortly after their engagement. But February would soon
prove an unlucky month for Keats (1795–1821). The next year, on
February 3, he caught a chill and suffered a lung hemorrhage, the
result of carelessness and the tuberculosis that would eventually
kill him. He was prone to illness, which made his recklessness
that much more dangerous. The doctor had ordered him to wear
a heavy coat, as he explained that week to his sister, Fanny Keats,
but he went without it anyway. "You must be careful always to wear
warm clothing not only in frost but in a Thaw," he cautioned her.
Too late.

Keats's most impassioned letters after that fateful date were written to his fiancée. Though the sentimentality of his late letters embarrasses modern academics, the letters paint a sad and vivid picture of his voracious love and his weighty melancholy. Fanny and her family lived next door at the time, making his rooms a "pleasant prison." "I wish I had even a little hope," he told her. "I cannot say forget me, but I would mention that there are impossibilities in the world."

After becoming ill, he offered to break off their engagement on the day before Valentine's Day, but in the end he realized he was "not strong enough to be weaned." Instead, he lay in bed and bristled with jealousy, thinking about her living her life and moving through the world. "I wish you to see how unhappy I am for love of you, and endeavour as much as I can to entice you to give up your whole heart to me whose whole existence hangs upon you. You could not step or move an eyelid but it would shoot to my heart. I am greedy of you. Do not think of anything but me. Do not live as if I was not existing," he wrote. "Do not forget me." His illness lingered through the spring and summer, when his doctor ordered him to travel to Italy, with the hope that escaping the damp English countryside could save him still. The trip seemed impossible. His heart would break. In mid-September, he left for Rome, never to see Fanny or to write to her again.

He died in Rome on February 23, 1821, at the age of twenty-five. One of his great contributions to literary thought was the concept

of negative capability—"that is when man is capable of being in uncertainties, Mysteries, doubts, without any irritable reaching after fact & reason," he explained. Fanny demonstrated her own faculty for negative capability by loving poor Keats through all the uncertainties. As she wrote to his sister after his death, "it is better for me that I do not forget him."

8:05 AM ✳ THE PRE-RAPHAELITES GET TO WORK

There were no late sleepers on the "Jovial Campaign" of 1857. Just after 8:00 a.m., the English Pre-Raphaelite painter and poet Dante Gabriel Rossetti (1828–1882) yanked the bedclothes off his team of young recruits so they could resume their work of painting frescoes on the walls of Oxford University's new debating hall. Instead of collecting pay that summer, the men were given room and board—which they took as a series of feasts—and were allowed a free hand with the murals. Rossetti chose the legends of King Arthur as their romantic theme, setting himself the task of painting the panel of Sir Lancelot dreaming of Guinevere. But aside from Rossetti, only one other member of the group, which included the then twenty-three-year-old William Morris (1834–1896) and the artist Edward Burne-Jones (1833–1898), had ever tried his hand at painting.

Rossetti's only requirement was a love of beauty and a shared sense of fun. Inexperienced undergraduates who joined in were given paints and brushes and sent up ladders. As the crew worked, they discovered that the hall's whited-out windows made a perfect surface for Burne-Jones's cartoon drawings of wombats, and on the walls high up near the roof beams, they drew caricatures of Morris, who was soon to become a design legend, but had never even met a painter before in his life. "By God," one cartoon was captioned, "I'm getting a belly!" As they worked, they pelted one another with soda water corks and the sound of their laughter carried, so that students studying in the library next door could hardly concentrate. An annoyed scholar complained, "One can't get them to be quiet at it—or resist a fancy if it strikes them over so little a stroke on the bells of their soul—away they go jingle-jangle without ever caring what o'clock it is." Morris became so enraptured by the group's medieval fantasy that he wore a made-to-order chain mail suit to dinner. The group ran up an enormous tab, consuming roast beef, plum puddings, and a good deal of ale.

Rossetti was the magnetic epicenter of the artistic fray, "the planet around which we revolved," one of the young collaborators remembered. "We copied his very way of speaking . . . we sank our own individuality in the strong personality of our beloved Gabriel." Rossetti lent the neophytes confidence, but he wasn't a great role model. The jovial artists shocked Oxford's dons with their raucous behavior that summer. "We became so fierce that

two respectable members of the University—entering to see the pictures—stood mute and looked at us," one of them remembered, "and after listening five minutes to our language, they literally fled from the room! Conceive our mutual ecstasy of delight." During another official visit, Rossetti accidentally dumped an entire bowl of precious lapis lazuli pigment from the top of his ladder. "Oh, that's nothing," he told the visitors. "We do that all the time."

It didn't matter that the young painters got out of bed so early. They failed to complete the murals. Rossetti left Oxford that fall with his panel unfinished, and as none of the artists had under- stood the techniques of fresco painting, all of their paintings faded and flaked off of the plaster walls almost immediately. Two years later they had deteriorated further and all but disappeared.

Still, while the Jovial Campaign was in full swing there was "no work like it for delightfulness in the doing," Rossetti wrote to a friend, "& none I believe in which one might hope to delight oth- ers more according to his powers."

 8:59 AM ✳ THE 20TH CENTURY LIMITED ARRIVES AT GRAND CENTRAL

At 8:59 the stationmaster at New York's Grand Central Terminal announced the track number on which the 20th Century Limited

would arrive from Chicago at 9:00 a.m., though regulars could guess it would be track 26 as usual. The 20th Century traveled between New York and Chicago in less than twenty hours, with much fanfare, ferrying glittering passengers such as Theodore Roosevelt, Lillian Russell, Mae West, Diamond Jim Brady, J. P. Morgan, Enrico Caruso, Gloria Swanson, Joan Crawford, Marlene Dietrich, Ginger Rogers, and Cary Grant. (Wall Street was assigned to one section of the train and Hollywood to another.) All that star power lured the celebrity hounds, corralled behind ropes, "like duck hunters waiting in their blinds," according to one witness. Some high school girls went every morning. Greta Garbo dodged the crowd by riding an elevator down to the baggage room, then slipping out a back door. Film star Clara Bow (1905–1965) worked the opposite tactic. In 1930, dressed in a fur and a modish hat, she was met trackside by her fiancé, and the two posed for cameramen as the flashbulbs "boomed and spurted a cloud into the rafters," *The New*

York Times reported. Her fiancé had hung out with the photographers all morning, but he now feigned surprise at their presence. "What's all this?" he asked. "Indeed what is this about?" The two posed a little longer anyway, and Bow kissed her beau for posterity. "She kissed him, somewhat abashed," the *Times* noted, "but without blushing." She was America's favorite It girl, and she didn't blush easily.

With a dramatic flourish, porters in both cities unrolled a special crimson carpet on the platform before the 20th Century's arrival and departure—the first "red carpet," besides the one the Vanderbilts' butler unfurled in front of the family's Fifth Avenue mansion. The train's every swank detail promoted a sense of luxe living. It was "not like an ordinary, human kind of train at all," one writer proclaimed in 1906, four years after the maiden run. It boasted electric lights before most American homes did. Its restaurant compared with the best in each city. There were onboard tailors, valets, ladies' maids, stenographers, manicurists, and a barber. Baths could be taken in either fresh or salt water. The first telephones, used trackside, were installed in the 1920s, and throughout the trip passengers were kept apprised of the latest news from the stock market. At the end of each run, the guests' drawing rooms and sleeping compartments were rearranged so that their windows faced the Hudson River both coming and going. (The route from New York climbed north along the Hudson, then to Buffalo, and along the shores of Lake

Erie before arriving in Chicago.) "No effort nor expense has been spared to provide the traveling public with all the comforts and conveniences that are afforded by the highest grade hotels," a reporter raved, "the furnishings and fittings being complete in every detail."

Beyond its cushy amenities, however, the 20th Century was known for its speed. During one stretch in 1905, the engine did 90 mph, sending one rail worker to "the verge of a nervous collapse," the *Times* reported. The 20th Century ran on a split-second timetable, and handlers were devoted to keeping to it, going so far as to run a snowplow train in front of the engine during heavy weather. Locomotives stood by in case of engine failure. Over the course of its reign, which ended in 1967, the 20th Century's traveling time was cut from twenty hours to sixteen and a half.

All along the route, people out in the countryside made a hobby of watching the 20th Century go by, leaving a whiff of glamour in its wake. In the meantime, gilded passengers like Bow spent their hours on board simply making themselves comfortable. What did Bow do during her cross-country trip? reporters at Grand Central wanted to know. "Oh, nothing much," her secretary said, "except play pinochle all day long."

The earth was created "on October 23, 4004 BC at nine o'clock in the morning," the English scholar Sir John Lightfoot (1602–1675) announced in 1644, having calculated the precise moment by adding together every time span mentioned in the Bible. Lightfoot's endeavors were symptomatic of the seventeenth century's mounting obsession with accuracy, dividing time into smaller and smaller increments. Still, for millennia, people had lived without clocks, and many of them liked it that way. As an ancient Roman poet wrote,

> *The gods confound the man who first found out*
> *How to distinguish hours! Confound him, too,*
> *Who in this place set up a sundial,*
> *To cut and hack my days so wretchedly. . . .*

An Egyptian specimen from around 1500 BCE is the earliest sundial on record. Similar devices were used alongside the sand- or water-filled hourglass until the fourteenth century, when creative metallurgy and clever springs powered the first mechanical clocks. Yet, throughout history, different societies cut and hacked time in different ways. Europe's medieval monks lived in concert with bells that reminded them to pray, eat, and sleep. Seventeenth-century Parisian tanners worked from sunrise to

sunset in the summertime, and in wintertime they worked until it was so dark they could no longer tell two similar coins apart. Similarly, a Parisian regulation stated that the workday should start as soon as it was light enough to easily recognize someone in the street.

Clocks fulfilled a yearning for something definite, and though expensive and easy to break, they were also impressive. A big clock mounted high on a tower lent a city a certain swagger. Such clocks did more than tell the time. In the mid-fifteenth century, a trumpeting angel, a fleet of saints, and a procession of magi paraded out of Bologna's city clock. In Soleure, Switzerland, a warrior beat his chest every quarter hour, and a skeleton turned to stare at the man on the first stroke of every hour. In Ghent, Adam tolled the hours and Eve the half hours as a snake slithered between them. At noon in Strasbourg, while the bells of the carillon played, a wheel turned, bringing three mechanical magi circling around the enormous clock to bow before a statue of the Virgin. Then, with a final flourish, a giant mechanical bird perched on top of the apparatus opened its beak, extended its tongue, crowed, and flapped its wings.

For the town fathers of Lyons in 1481, telling time was not the only argument in favor of installing a grandiose clock. A petition justifying such an extravagance argued that not only would the sight bring more merchants to the city's fair, but "the citizens would be very consoled, cheerful and happy and would live a more orderly life."

In mid-eighteenth-century Spain, aristocratic ladies were worshipped like living goddesses, each served by her own *cortejo,* a well-bred male friend. He was an unmarried gentleman, not a servant, though he worked pretty hard, dedicating his days to making her happy. A decent *cortejo* kept his lady apprised of all the latest fashions from Madrid, and he would bring her beautiful flowers and pretty fans, escort her to church, and to the theater. He would dance with her at parties. She could take his hand when climbing down from her carriage. And, while the sixteenth-century Aztec ruler Montezuma might have drunk hot chocolate from a golden goblet served by naked virgins, the Spanish lady was awakened at 9:00 a.m. on the dot by her smiling *cortejo* bringing her hot chocolate in bed. (These women were passionate about cocoa spiced with cinnamon, and they sipped it even while in church.)

As a rule, ladies didn't like their *cortejos* to speak with other women. "Even the slightest conversation with another woman is sometimes visited with her severe displeasure," a visitor to Spain reported. Another noted how miserable the women were when their *cortejos* were out of sight. "He must be present every moment in the day, whether in private or public, in health or sickness, and must be every where invited to attend them." Generally speaking,

the relationship was assumed to be platonic, though French and English visitors found it peculiar that a woman's *cortejo* was a man who was not her husband. When Queen Maria Luisa de Parma (1751–1819) went so far as to install her twenty-four-year-old *cortejo* in the post of prime minister, it caused a scandal even in Spain. But for the Spanish, any husband who was jealous of his wife's *cortejo* was considered uncivilized.

Needless to say, signing on as a *cortejo* wasn't for everyone. "The sublime touch of the *cortejo*," one Spaniard explained, "consists in carrying out amiable and frivolous tasks with a dignified and effortless air that shows a spirit exercised in these delicate maneuvers."

Hot Chocolate Deluxe

This recipe makes a really rich European-style hot chocolate.

> *4 cups organic whole milk*
> *½ cup water*
> *½ cup sugar*
> *Smallest pinch of cinnamon (optional)*
> *Tiny pinch of sea salt*
> *8 ounces nice bittersweet chocolate, or a mix of bittersweet and*
> * semisweet, or whatever you like*

In a saucepan, heat over a low heat the milk, water, sugar, cinnamon, and salt (if you're using it), stirring, until the mixture just reaches a boil. Off the heat, whisk in chocolate, broken into chunks, or use a hand-held immersion blender, if you have one. Either way, aerate for about a minute. Serve while still hot and frothy. If your tastes run toward the decadent, try a Parisian variation, doubling the chocolate and replacing 1 cup of the milk with heavy cream.

9:20 AM ✳ MODELS DISROBE

"We rose before it was light, and dressed ourselves with freezing fingers," a nineteenth-century Englishwoman recalled of her Parisian art student days. "We were out at 'first breakfast' in a humble *crémerie,* drinking our hot chocolate, in thick white bowls like mortars, crunching our crisp rolls with the worthy working folk of Paris in their blue blouses at the marble tables; then trudging bravely, for an hour, through the snowy streets of leafless Elysian Fields and boulevards . . . long before the majority of the Paris students had left their warm nests of homes." The passionate women who studied at the city's Académie Julian were serious about art.

Rodolphe Julian, a former wrestler (1839–1907), opened the coed school in Saint-Germain-des-Prés in Paris in 1868, and

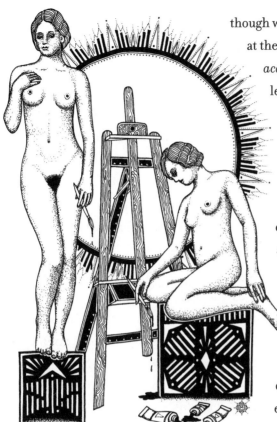

though women weren't allowed at all at the École des Beaux-Arts, at his *académie* female students could learn all the classical techniques, including drawing and painting from the nude. The very idea caused an uproar. As an American guidebook for art students explained, it was "an impossibility that women should paint from the living nude models of both sexes, side by side with Frenchmen." Open-minded artists felt otherwise. "Some of our countrymen find an impropriety in our working in a mixed atelier, and perhaps there is, according to society's code, but if a woman wants to be a painter, she must get over her squeamishness," an American woman wrote. "If she wants to paint strong and well like a man, she must go through the same training." Monsieur Julian's democratic solution: separate studios for male and for female students, and no male visitors in the ladies' atelier.

The women joined a long tradition of artists studying the nude, a practice that had become increasingly important for artists during the sixteenth and seventeenth centuries. By the eighteenth century, des Beaux-Arts employed a handful of male models, most wearing beards, ever ready to pose as biblical characters. The senior-most among them wore royal livery and, like other members of the academy, lived in the Louvre. Female nude models, on the other hand, worked only in private ateliers until the mid-nineteenth century, when they began to pose at the École des Beaux-Arts, and as images of female nudes came to dominate the art scene.

To be sure, the female model's position was precarious. "In effect, for us the sight of a nude young woman on the model table, in full daylight, is so far removed from any sensuality," the manager at Jean-Auguste-Dominique Ingres's studio noted carefully, "that the model understands immediately that she is dealing only with a painter, not with a man." Interlopers were not welcome. One afternoon, as Ingres worked with his students, the model leapt down and "threw herself beneath the model stand, taking all her clothes and hiding herself as best she could," the manager remembered. A worker making repairs outside was caught with his nose pressed against the window.

Some female models became artists themselves. The curvaceous Victorine Meurent (1844–1927), who posed nude for Édouard Manet's most provocative works—wearing a ribbon

necklace in his *Olympia* and even less in *Le déjèuner sur l'herbe*—
was later recognized as a fine painter in her own right. Painter
Gwen John (1876–1939) moved from England to Paris in 1904 and
modeled to support her artistic career. She found that working
for other female artists was easier than working for men, except
for one client who left her mid-pose while she retired to another
room for a quick romp with her boyfriend. John eventually took
up with Rodin, becoming his lover and his model. Occasionally
she posed for herself, sketching nude self-portraits in her rooms
on the rue du Cherche-Midi.

The queen of bohemia in fin-de-siècle Paris, however, was
the artist's model supreme, Sarah Brown (1869–?), a favorite at
the École des Beaux-Arts and at Académie Julian. "She has the
virginal features of the Middle Ages," an admirer wrote, "hair the
colour of fire, and she is built like a statue." The former circus
rider also knew how to stir things up. When a student flirted with
her while she posed at the Académie, she hurled paint at him and
sparked a full-studio brawl. "She would desert an artist in the
middle of his masterpiece and come down to the studio to pose
for the students at thirty francs a week," one writer sighed. "Gor-
geously dressed, she would glide into a studio, overturn all the
easels that she could reach, and then shriek with laughter over
the havoc and consternation that she had created."

She topped that by appearing as Cleopatra in a tableau vivant
styled as "The Last Days of Babylon," arranged on a parade float

during the Bal des Quat'z-Arts in 1893. Her costume consisted of a few strands of pearls, several gold bracelets, some well-placed baubles, and black net stockings. She was arrested for public nudity and the uproar over her trial erupted into a full-scale riot, with enraged students laying siege to the police headquarters and rampaging through the Latin Quarter for a week. She would have had a better legal argument if she'd posed in the thick flesh-colored tights of the sort an acrobat might wear. "She only saw the artistic side of things," a journalist reporting on the proceedings explained, "and she adds that everybody thought she had tights on."

10:00 AM ✳ THE ROYAL TABLECLOTH IS LAID

When laying the royal table during the Elizabethan era, those entrusted with the task left nothing to chance. Preparing the banquet hall, a pair of servants—one carrying a rod, the other the tablecloth—entered the room as if the queen herself were present. After kneeling three times with "the utmost veneration," they spread the cloth with the rod, and then proceeded to kneel again. Sometimes, before the cloth was laid, the chief table setter kissed his hand and placed it on the center of the table, showing his sidekick where to put the damask. By William and

Mary's reign, table-setting maneuvers might begin at ten o'clock in the morning and go on until dinnertime. The setters were like priests preparing the altar. It was a solemn business freighted with symbolism. To "share the cloth" with a nobleman meant to be treated as his equal, while one might say of an unworthy man, "He and I are not of the same cloth." It was meant literally. If an aristocrat ate at a table with his servants, for example, everyone's plate sat on the bare tabletop except for that of the great man himself.

During the seventeenth century, the French made an art of cleverly creasing their tablecloths, pressing a latticework pattern of folds that looked like waves into the fabric. An accidental wrinkle was called a "coffin," and the superstitious believed that if seen on the table it predicted death for one of the guests. Napkins held a similar fascination. Wealthy hosts hired professional napkin folders for big events, as on one afternoon in 1668 when English diarist Samuel Pepys came home to find his napkins sculpted into "figures of all sorts, which is mighty pretty." He was so "mightily pleased with the fellow that came to lay the cloth and fold the napkins" that he considered hiring him to teach Mrs. Pepys the trick. Napkins were coaxed into the shapes of frogs, fish, boats, chickens, peacocks, and swans. And they were supposed to be kept very clean, a difficult task as forks came into vogue very slowly, "to the saving of napkins," the playwright Ben Jonson (1572–1637) had noted. (The British navy forbade forks at

the dinner table as late as 1897, as they were considered pretentious.)

Such was the case not only in Western Europe but in Constantinople, as English writer Lady Mary Wortley Montagu (1689–1762) discovered when visiting the Sultana Hafiten in the early eighteenth century. "The magnificence of her table answered very well to that of her dress," Lady Mary wrote home to a friend—a lofty comparison, considering that the sultana's tunic was decorated with diamond fringe and pearls as large as peas. But while the sultana's knives were gold, studded with diamonds, "the piece of luxury that gripped my eyes was the tablecloth and napkins," Lady Mary noted. They were of the lightest silk and each was finely embroidered with silk-and-gold flowers. "It was with the utmost regret that I made use of these costly napkins," she added. "You may be sure that they were entirely spoiled before dinner was over."

March * PILGRIMS EMBARK

THE URGE TO TRAVEL STRIKES AT THE END OF MARCH, when early pilgrims and modern American teenagers alike have flocked to far-flung destinations. Beginning as early as 326 CE, Christian women like Emperor Constantine's mother, Helena, set out as pilgrims, traveling from Rome to Jerusalem. For centuries afterward aristocrats and saints followed in a steady stream, guidebooks in hand. It was a long haul. Walking across Europe, the average traveler covered twelve miles a day, or, riding a mule, covered twenty. Once the intrepid souls arrived in Venice, they bargained their way onto ships, and were packed belowdecks in cramped quarters that were "enclosed and exceedingly hot, and full of various foul vapors," a fifteenth-century woman remembered. The journey across the sea took a month, and it took most European visitors more than a year to make the trip to the Holy Land.

Besides the physical challenges, pilgrims faced a whole host of temptations en route. As the fourth-century mystic Gregory of Nyssa pointed out, the voyage to Palestine encouraged "moral mischief." "Change of place does not effect any drawing nearer to God," he argued, suggesting everyone simply stay home. "What advantage, moreover, is reaped by him who reaches those celebrated spots themselves?" he demanded. Yet the urge to visit new lands and holy sites persisted. According to Cyril, Bishop of Jerusalem, firsthand experience was invaluable. Writing at the end of the fourth century, he explained that seeing is believing. "Others merely hear, but we see and touch."

Across Christendom in the Middle Ages, prospective pilgrims needed permission from their bishops before setting out, in order to prove that they hadn't merely succumbed to wanderlust, and curiosity about anything beyond holy relics and religious sites was suspect. Curiosity itself, in fact, was a problem with historical precedent. The ancient Greeks condemned inquisitiveness, as it led to gossip. Christian thinkers argued that too much interest in this world was a distraction from reaching the next. Saint Augustine (354–430) made a similar complaint, claiming that curiosity was "desire—cloaked under the name of knowledge and science— not for fleshly enjoyment, but for gaining personal experience through the flesh." He cast a wide net, condemning someone, for instance, who spent too long watching lizards or wondering at a spiderweb, or anyone who listened to silly stories, watched

sports, played games, or went to the theater. Santo Brasca, a fifteenth-century Italian pilgrim to Jerusalem, warned would-be pilgrims that "a man should undertake this voyage solely with the intention of visiting, contemplating and adoring the most Holy Mysteries . . . and not with the intention of seeing the world, or from ambition, or to be able to say 'I have been there' or 'I have seen that.' " Eve was curious, after all, and we all know how that turned out.

For an ethically sensitive traveler like the great Italian scholar and poet Petrarch (Francesco Petrarca, 1304–1374), Augustine's edict posed a sticky problem. Petrarch was naturally curious. In the spring of 1336, he famously climbed to the top of Mont Ventoux in Provence, compelled by "nothing but the desire to see its conspicuous height." One of the manuscripts in his possession during that romp was Saint Augustine's *Confessions*. While making the hike, Petrarch happened to open to a page where Saint Augustine railed against men who "go out to admire the mountains' peaks, giant waves in the sea, the broad courses of rivers, the vast sweep of the ocean, and the circuits of the stars—and they leave themselves behind!" Caught in the act, Petrarch trekked back down the mountain in silence, chastened.

Only in the seventeenth century was the quality of curiosity finally redeemed, celebrated as the "singular passion" that separates humans from animals, as English philosopher Thomas Hobbes (1588–1679) argued. For Hobbes and his Enlightenment

friends, curiosity offered deep gratification. It was "a Lust of the mind, that by a perseverance of delight in the continual and indefatigable generation of Knowledge," Hobbes wrote, "exceedeth the short vehemence of any carnal Pleasure."

10:30 AM ✳ BECKETT AND JOYCE STROLL ALONG THE SEINE

In 1928, the young Samuel Beckett (1906–1989) left Ireland for Paris, where he landed work as an English tutor at the École Normale and, through friends, was invited to dine with the famed avant-garde Irish writer James Joyce (1882–1941). That night, Beckett wore a tight suit and came home so late he had to climb over the École fence to get to his rooms. It was the beginning of an unusual, and important, friendship. Joyce, Beckett's senior by twenty-four years, was a formidable figure, dressed in his fin-de-siècle smoking jackets and eccentric cravats, sometimes sporting an eye patch, and often lounging with a cigarette dangling loosely and dangerously from his fingertips. Beckett imitated the master, sitting just like Joyce, with one leg crossed and wound around the other, posing with his cigarette just so, and even sporting the same sort of pointy-toed patent leather shoes that Joyce wore, though they pinched his feet.

As one of Joyce's friends and followers, Beckett ran errands for Joyce, whose eyesight was failing. (Joyce's wife, Nora, called it doing "little jobs for Jimmy.") The apprenticeship was, in some ways, a means of paying it forward. As a young man, Joyce had met the great Irish poet William Butler Yeats (1865–1939), who lent a hand with his literary start. Joyce, in turn, helped Beckett, introducing him to powerful people on the Paris literary scene and recommending him for magazine assignments. They shared a slightly morbid, oddball sense of humor. Beckett remembered a joke that Joyce used to tell about a man eating a bowl of soup in a hotel dining room: "Looks like rain, sir," the waiter says, peering out of the window. The man replies, "Tastes like it too."

Evenings chez Joyce could get rowdy. Joyce sat at the piano and sang Irish ballads while both writers put back the drinks. Yet, often enough, the two were quiet in each other's company, comfortably sharing long stretches of silence. "Beckett was addicted to silences, and so was Joyce," a friend said. "They engaged in conversations which consisted often of silences directed towards each other, both suffused with sadness, Beckett mostly for the world, Joyce mostly for himself." Silence seemed to deepen their friendship. While Joyce remained on formal terms with most in his circle, invariably using "Miss" or "Mister" in addressing them, Beckett was an exception. "I was very flattered when Joyce dropped the 'Mister,'" Beckett remembered. "The nearest you

would get to a friendly name was to drop the 'Mister.' I was never 'Sam.' I was always 'Beckett' at the best."

It's easy to imagine the two writers strolling along Paris's Quai de Branly overlooking the Seine, as they often did on Sunday mornings. When they reached the Île des Cynges, a sliver of a tree-lined island, they continued along without speaking. Anytime Joyce called to invite Beckett for a walk, Beckett hustled over, "honored by the demand, which it was a privilege to fulfill." With his eyesight fading, Joyce didn't like to go out walking alone. Beckett gingerly took him by the elbow whenever they crossed the street. "There wasn't a lot of conversation between us," Beckett said. "I was a young man, very devoted to him, and he liked me. And he used to call on me if he needed something. For instance, someone to walk with him."

10:50 AM ✳ SOCIETY VISITS THE POOR

Fashionable women during the mid-nineteenth century ventured into the slums of London or Paris once a week, usually between nine and noon, to visit the poor. In the days before social welfare, private philanthropy kept the urban poor afloat, and an overwhelming number of ladies' societies formed to address the issue, their membership determined to make improvements. London's

parishes were divided into districts, with visitors assigned to each, usually with one lady responsible for visiting twenty to forty families, delivering blankets, food, coal tickets, and religious tracts door-to-door.

The tradition was long-lived in Europe. "Often, when they had no more agreeable occupation at hand, the Misses Murray would amuse themselves with visiting the poor cottagers on their father's estate," Emily Brontë wrote in *Wuthering Heights* (1847), "to receive their flattering homage, or to hear the old stories or gossiping news of the garrulous old women; or, perhaps, to enjoy the purer pleasure of making the poor people happy with their cheering presence and their occasional gifts, so easily bestowed, so thankfully received." Boredom drove them to kindness. For a lady of standing, the only other irreproachable undertaking outside the home was teaching Sunday school. Visiting had advantages over simply writing a check.

It broke "the langour and monotony of life; opening those fountains of benevolent sensibility, which unbroken prosperity is so liable to dry up," read one etiquette guide. Consequently, visiting the poor became a "fashion and a rage," according to English writer Lucy Aikin (1781–1864). "A positive demand for misery was created by the incessant eagerness to relieve it." It could be an awkward exchange. In their exuberance, or ignorance, ladies often barged into tenement houses with only the slightest perfunctory knock, imagining their hosts to be so bowled over

with gratitude as to not mind the intrusion. "In order to acquaint ourselves with the circumstances of these persons, no formal introduction will commonly be found necessary," another etiquette writer suggested. Some guides reminded visitors to dress with utmost simplicity, with "the absence of anything that might remind those you go visit of the advantages denied them," as one cautioned. On the other hand, Jane Ellice Hopkins (1836–1904), a volunteer who once interceded between a drunken man and his wife by banging spoons on a tea tray, recommended dressing in silk, as one would in one's own drawing room, to demonstrate respect for one's hosts.

No matter what their motivations, however, wealthy visitors developed sympathy for circumstances they might not otherwise have understood. And many learned to become not only benefactors to those they met visiting, but also friends, dissolving some of the social distance between them, but also countering the growing geographical divide. "It is our withdrawal from the less pleasant neighbourhood to build for ourselves substantial villas with pleasant gardens, which has left these tracts what they are," wrote social reformer Octavia Hill (1838–1912). By their mere presence, she argued, visiting ladies could change the status quo. "See then that you do not put your lives so far from those great companies of the poor which stretch for acres in the south and east of London," she wrote, "that you fail to hear each other speak."

Standing on a New York pier, having just arrived from England in
1882, and wearing a fur-trimmed coat and patent-leather shoes,
Oscar Wilde (1854–1900) couldn't be missed. His cravat was sky
blue. His hair hung in dark waves to his shoulders. And "his shirt
might be termed ultra-Byronic," a reporter noted, "or perhaps–
décolleté." Wilde, then twenty-eight, a poet and a self-described
aesthete, was on a mission to promote the Aesthetic Movement
then popular in England. Though he'd planned to stay in America
only for several weeks, his cross-continental tour stretched on for
more than a year, during which the press followed his every move,
noting his likes, dislikes, impressions, and opinions, his "irregu-
lar and protruding teeth," his velvet knee breeches, and his every
accessory, including the occasional heliotrope boutonniere.

On the pier that morning, he detailed his creed for the "crowd
of admirers who surrounded him." "Aestheticism is an attempt
to color the commonplace," Wilde proclaimed, "to make beauty
stand out wherever it is." A reporter asked him to describe, for
instance, the beauty of a grain elevator over on the other side of
the river, but Wilde said he was too nearsighted to see it and that
he'd have to have a look some other time. Wilde and the tenacious
reporters in his wake developed a love/hate relationship over the
coming months. The celebrity interview was a recent American

invention and didn't yet exist in England, but Wilde was quick to learn the ropes. "Interviewers are a product of American civilization, whose acquaintance I am making with tolerable speed," he told *The Boston Globe* several weeks later. "You gentlemen have fairly monopolized me ever since I saw Sandy Hook. In New York there were about a hundred a day. . . . But then," he added, "I am always glad to see you." He liked to give interviewers a real show, flinging himself across the sofa and playing the languid poet, providing reams of material. "I love flowers, sir, as every human being should love them," he told one newspaperman. "I enjoy their perfume and admire their beauty." He didn't always appreciate the resulting articles, however, and claimed that only the English newspapers still held "an old-fashioned regard for truth." Yet, with so much on his agenda, who could fret over bad press? "Our duty is to admire and worship the beautiful and the good,"

Wilde said. "Everything else, including the annoyances, is mere failures, simply shadows."

As he crossed the country by rail, curiosity seekers flocked to each station, craning to get a look at this flowery character through the train windows. A popular tune of the day went:

Oscar dear, Oscar dear,
How utterly flutterly utter you are.
Oscar dear, Oscar dear,
I think you are awfully wild, ta-ta.

During his yearlong tour, Wilde gave dozens of lectures—on "The Decorative Arts" or "The English Renaissance"—in New York and Boston but also in smaller locales, such as Atchison, Kansas. In a rough Rocky Mountain mining town he lectured on "The Ethics of Art," reading passages from the autobiography of the Renaissance artist Benvenuto Cellini. He told a reporter: "I would dignify labor by stripping it of its degradation, and that by developing all that is beautiful in the laborer's surroundings and opening his eyes to it. Ah! I would speak to the hard-working people, whom I wish I could reach through the prejudice that shuts them and me away from each other." In order to reach those people, he descended a mineshaft in a rickety bucket "in which it was impossible to be graceful," and deep underground drank whiskey with the men.

Another lecture, on "The House Beautiful," offered instruction on aestheticizing the American home. No plain marble tables. No stuffed birds. "Have nothing in your houses that is not useful or beautiful," Wilde demanded. There was far too much glaring white and dreary gray used in American interiors, he moaned. Pianos were melancholy. The revolving stool "should be sent to the museum of horrors." He was no fan of hat racks, brightly painted ceilings, or bad art. "Poor pictures are worse than none." On the subject of fine china he was adamant. "There is nothing so absurd as having good china stuck up in a cabinet merely for show while the family drink from delft," he raved. "If you can't use good old china without breaking it, then you don't deserve to have it."

Often during his trip, reporters claimed to have seen Wilde carrying around a sunflower, or a lily, or even gazing into a box of violets in order to compose himself. Flowers were his refuge, and he reserved his worst condemnation for their silk or paper imitators. "Of all ugly things," he told his American admirers, "nothing can exceed in ugliness artificial flowers."

11:10 AM ✳ THE MARQUISE DE POMPADOUR PAINTS HER FACE

In her apartment at Versailles, King Louis XV's pretty, pale mistress Madame de Pompadour (1721–1764) woke and drifted

toward her vanity table, artfully stage-set with porcelain paste pots and pomade and creams, lacquered powder boxes and swans-down powder puffs, ribbons, pompons, and lace. She did a preliminary round of primping, applying a foundation base of lead white to her skin, as was the fashion, and a dab of rouge, while her maid half-styled her hair. Then, at eleven o'clock, after an impressive number of noblemen, artists, and writers, including Diderot and Voltaire, had clustered around, she applied her makeup again, as if for the first time, demonstrating how she put together her look. Voltaire (1694–1778) composed these lines in honor of their mornings together:

Pompadour your divine pencil
should draw your face.
Never would a more beautiful hand
make a more beautiful work of art.

Others appreciated her artifice less.

"The second toilette is nothing but a game invented by coquetry," grumbled a critic. But it wasn't merely Pompadour's charm or beauty that lured a flattering crowd. Just like the king at his *lever,* she went through her morning routine for the audience, sitting in her frothy negligee while a maid powdered her hair. She applied a streak of eyeliner and dusted her cheeks with several thick layers of rouge. Even her most important guests stood, and she rose only to greet princes of royal blood and cardinals. As the king's official mistress, she held enormous sway. "The ministers tell her ahead of time whatever they have to say to the King," noted the Austrian ambassador. "He himself wants it that way." She brokered deals, and the men asked her opinion about everything. She was, as one of the aristocrats put it, the "oracle of the Court." "She decides, she arbitrates, she looks upon the ministers as hers."

Of course, the king's ministers weren't hers at all, though attendance at her morning toilette outshone that at the queen's. She was born Jeanne-Antoinette Poisson, a bright and rosy bourgeois beauty with an eye for architecture and an easy way with the artists and thinkers who were around her. After their affair began in 1745, the king elevated Pompadour to marquise and installed her at Versailles as his official mistress. She was the ultimate arriviste, as her makeup made abundantly clear. Ordinary eighteenth-century Parisiennes dabbed rouge on their cheeks,

simulating a healthy blush. That was not the Versailles way. The courtiers' intense, garish makeup was wholly artificial, and heavy rouge was reserved for the elite. On arriving at Versailles, the Austrian Marie-Antoinette (1735–1793) adopted the flaming-red-cheeked custom. Louis XV even decreed that his daughters should wear rouge, when they were old enough. "It is well known that rouge is nothing more than the mark of rank or wealth, because it cannot be supposed that anyone has thought to become more beautiful with this terrible crimson patch," a detractor sniped in 1750.

When the king was no longer interested in Pompadour as a lover, he realized that he'd come to rely on her political craftiness in ways that could not be undone. In the late 1750s, when Pompadour suffered fevers, migraines, palpitations, and even seizures, she commissioned several portraits by painter François Boucher (1703–1770) to remind the world of her former glory. In 1758, Boucher painted her posed in full regalia, pink roses blooming on her green gown and on her cheeks. The next year, he painted her again, this time as the quintessential mistress, glowing and pink-cheeked, her dainty brush loaded with rouge as she sat at her vanity table.

By then she'd given up performing her toilette for visitors, and instead greeted them while seated at her loom.

With their toes in the sand, ancient Romans thought they'd reached Olympus. Then, as now, lazing in the sun at the shore was one of life's chief pleasures. The Roman elite maintained dozens of villas along the coast, including those at splashy Antium (modern Anzio), a spot favored by the good-time emperors Caligula and Nero. But when the empire collapsed, lounging at the beach went with it. Over the next millennium, modesty ruled across Europe's beaches. Visitors to the English seaside in the eighteenth and nineteenth centuries were subjected to bathing machines, booths wheeled into the water by attendants so that the boxed-in bather could remain primly hidden inside. Even into the late nineteenth century, the idea that French men and women might dip themselves along the same stretch of sand shocked the English.

Over the years, solar enthusiasts, Scandinavians, and the medically adventurous crowed about the health benefits of sunlight, but the beach never regained its former glamour until the early 1920s, when a small coterie of chic American ex-pats made Saint-Tropez what it is today. First came songwriter Cole Porter (1891–1964), who rented a chateau in Antibes in the summer of 1921, when the summer was still considered off-season. Two years later, a couple of Porter's guests, the Murphys—the hand-

some heiress Sara Murphy (1883–1975) and her socialite/painter husband, Gerald (1888–1964)—struck out on their own and turned summer along the Côte d'Azure into a way of life. At Villa America the Murphys created a series of sumptuous and sunny tableaux vivants for their guests, as if summering were an artistic calling. They believed that "only the invented part of life was satisfying," Gerald explained, "only the unrealistic part."

"When we went to visit Cole, it was a hot, hot summer, but the air was dry, and it was cool in the evening, and the water was that wonderful jade-and-amethyst color," he remembered. "Right out on the end of the Cap there was a tiny beach—the Garoupe—only about forty yards long and covered with a bed of seaweed that must have been four feet thick. We dug out a corner of the beach and bathed there and sat in the sun, and we decided this is where we wanted to be." Most days, at eleven o'clock the Murphys hosted guests such as Pablo Picasso (with whom Sara may have had an affair) and his first wife, Olga, along with F. Scott Fitzgerald and Zelda, or Ernest Hemingway and his first wife, Hadley, for an excursion down to the beach. While the children did exercises with Gerald and romped in the surf, the Murphys paddled around in a canoe, served sherry, sunbathed, and swam. When everyone was worn out, they all went back to Villa America for a lunch of omelets, a salad from the garden, and local wine, served on the terrace under the linden tree. Afterward, there was a costume party or a treasure hunt for the kids. The Murphys took their leisure seriously.

"I could stand it for about four days," American novelist John Dos Passos (1896–1970) said of his time as a guest there. "It was like trying to live in heaven. I had to get back down to earth." Others were smitten. Gertrude Stein and Alice B. Toklas came to stay. The Stravinskys took a house in nearby Nice. Cocteau and the opium-loving crowd found their way to Villefranche. Diaghilev and the Ballets Russes settled in at Monte Carlo. The rest of the society types whom the Murphys hoped to avoid followed, slicking their newly bared skin with the first suntan oil, Jean Patou's Huile de Chaldée, and soaking in the rays. "It was delicious," remembered Prince Jean-Louis de Faucigny-Lucinge (1904–1992), who boldly took his new bride to the Riviera for their summer honeymoon. "We immediately started sunbathing, exaggerated sunbathing. It was a study, it took time, hours and hours of sunbathing."

11:55 AM ✳ SHADE IN THE GARDEN GROTTO

When the sun is high, a shady garden grotto offers quiet respite and a poetical spot in which to ponder life's mysteries. The earliest garden grottoes were ancient Greek and Roman holy shrines thought to be mystical passageways to the underworld or the stony homes of nymphs and muses. During the Renaissance, fanciful gardeners revived the style. The Italian poet Petrarch called the

rocky garden grotto at his retreat near Avignon one of the essentials of a life of leisure. "Hither I retreat during the noon-tide hours," he wrote to a friend. "I am confident it much resembles the place where Cicero sometimes went to declaim. It invites to study."

One of the most influential grottoes was the one Sir Francis Bacon's secretary Thomas Bushell (1593–1674) built around a craggy twelve-foot rock full of nooks and dripping water at Enstone in Oxfordshire, England—the grotto soon to be known as the Enstone Marvels. Reports of the mighty rock and its wonders made their way to King Charles I and Queen Henrietta, who paid a visit one afternoon in 1636. They were impressed with the spring-fed waterworks, the Neptune fountain, and by Bushell's apartment above the grotto—a little hermitage all draped in black, "representing a melancholly retyr'd life like a Hermits," said Bushell. The queen gave him an Egyptian mummy to decorate his tiny retreat. Unfortunately, it moldered in the damp.

In the next century, the grotto was a customary extravagance in every fine English garden. Poet Alexander Pope (1688–1744), who set the fashion in landscaping, claimed one of the best, its walls covered with seashells in the ancient Roman style. His friend William Warburton (1698–1779) compared the shadowy hideaway to Pope's best work, noting "the beauty of his poetic genius in the disposition and ornaments of this romantic recess." Mirror shards and exotic gifts from friends studded the walls. The Dowager Duchess of Cleveland sent masses of amethyst. Another friend

sent glimmering ores. A third gave pieces of lava from Mount Vesuvius and a fragment of marble from an ancient Roman grotto thought to have been home to the nymph Egeria. Friends sent fossils, crystals, petrified moss from the West Indies, gold from Peru, silver from Mexico, and Brazilian pebbles. Classical busts and urns were on display, as was a hummingbird's nest. From a star-shaped mirror on the ceiling "a thousand pointed rays glitter and are reflected all over the place," Pope wrote to a friend. Most spectacular of all, however, was that the dark grotto became a camera obscura when its doors were closed, with images of the Thames and the surrounding countryside projected onto the walls through a small aperture. It all created an "undistinguishable Mixture of Realities and Imagery," according to a visitor.

Pope's nineteenth-century biographers supposed that he'd overdecorated with friendly gifts he simply couldn't refuse. But Pope loved the eclectic mix, putting off the day when the grotto would be finished, and continuing to embellish it until just before his death. "I am one of that sort who at his heart loves bawbles better (than riches)," he wrote to the Duchess of Marlborough, "and throws away his gold and silver for shells and glittering stones."

For her part, another of the era's great grandes dames, Frances, Countess of Hertford, judged her own grotto "much prettier than Mr. Pope's," as England's passion for unusual seashells raged. Rare shells were sold at auction during the 1760s, and those who

kept shell-decorated grottoes and elaborate shell temples spent small fortunes on the prettiest specimens, especially those from the West Indies. Margaret Bentinck, Second Duchess of Portland (1715–1785), constructed a cave studded with a thousand snail shells, and so obsessed over her collection that after her death everything she owned went toward covering her debts. Over a seven-year span, Sarah Lennox, Duchess of Richmond (1705–1751), with her daughters, created an artificial cave, designing intricate symmetries across its walls in a mosaic of shells and bits of mirror glass. Captain Charles Knowles carted an entire shipload of shells to complete the décor, while the floor was set with polished horses' teeth.

The poets praised such efforts and applauded the ladies who spent their days plastering shells to the walls. "The beauties of this grott divine," an admirer wrote in 1746 of Lady Fane's grotto in Berkshire. "What miracles are wrought by shells, / Where nicest taste and fancy join."

NOON ✳ LUNCH ON HIGH

A breathtaking new skyline rose over Manhattan during the first half of the twentieth century. "It is demonstrable that small rooms breed small thoughts," an American writer explained, describing

in 1905 the view from atop the colossal twenty-two-story Flat-iron Building. "It will be demonstrable that as buildings ascend so do ideas. It is mental progress that skyscrapers engender." In Europe, it would have been unthinkable to overshadow hallowed cathedrals and monuments, even in the name of mental progress. But in the United States, audacious sky-scraping constructions seized the popular imagination, as did the men who built them. As pioneering beam walkers ventured into midair, the physical danger made the men seem superhuman. The London *Daily Herald* called New York's steelworkers "classical heroes in the flesh."

In 1925, construction crews raced to complete 350 new buildings across the city, a "chase up into the sky," as *The New York Times* called it. Five years later, the city's best workers, known as "sky boys," were erecting the Empire State Building—sixty thousand tons of structural steel—at the rate of four and a half stories a week. Many were Caughnawaga Mohawks, recently arrived from a reservation near Montreal. Others were sailors with experience rigging tall ships. (The word "skyscraper" referred to a ship's sails until the late nineteenth century.) Journalists and photographers ascended the buildings to find the skyboys more than a thousand feet in the air, strolling the latticed beams without hard hats, safety gear, or a care in the world. Riveters used their torches to light cigarettes. Crowds gaped from the windows all around them. It was the "best open-air show in town," a reporter noted.

Of course, the men weren't there to put on a show or to enjoy

the altitude. "Yeah, it's a nice view, but we ain't got much time for that," one of the steel-men told the *Times*. Still, at noon when the whistle blew and they sat down to "gulp down two sandwiches, coffee or milk, and pie," they couldn't help but enjoy the panoramic sprawl. Mobile cafeterias shuttled up and down the skeletal structure, and only a handful of men left the site for their lunch break. As one veteran steelworker quietly confessed, "hopping around above the steeples with nothing but a six-inch steel beam between you and an introduction to the angels" was a "joy-ride." After all, if the skyboys didn't love it up there, "instead of being steel-workers they'd be selling fish, or something," he said. "It's a romp."

APrIL ✳ CHERRY BLOSSOMS FALL

FOR CENTURIES JAPAN'S EMPERORS HOSTED lavish celebrations in April to savor the ephemeral blossoming of the cherry trees.

The ritual began during the Heian era (794–1185), when an acute aesthetic sensitivity defined courtly life and slowly spread from the palace's highest echelons to the commoners, and from the cities to the provinces. Elegance mattered, as did a heartfelt empathy for natural fragility, an ideal best represented by the cherry blossoms, which fell after some three days of flowering, a dicey period during which even a brief storm could wipe them out entirely, making their beauty all the more precious.

Like the great emperors, sensitive scholars, monks, and witty wanderers of the thirteenth century gathered under Japan's cherry branches to compose poetry, each contributing a line or two to

the creation of a communal poem. Feasting ensued, as it will, and social standing mattered less than a shared sense of poignancy.

In 1598, Emperor Hideyoshi (1536–1598), the swaggering Cecil B. DeMille of cherry blossom parties, threw a famous bash, his last hurrah, inviting several hundred courtiers to Daigo-ji temple, in Kyoto. Hideyoshi, who loved a theatrical touch, oversaw every aspect of the massive preparations. He ordered the restoration of a tenth-century pagoda at the site. Nearby, gardeners installed an immense, handsome boulder hauled in from one of the imperial palaces. Another pavilion, hitched to the shore by quaint bridges, was constructed in the middle of the great pond. The workers fabricated waterfalls, built teahouses and a stage. Most impressively, Hideyoshi had more than seven hundred cherry trees transplanted from across Japan.

When the great day finally arrived, the courtiers all gathered, the ladies wearing daringly draped robes and boyishly cut hairdos. Hideyoshi dressed magnificently, wearing false whiskers and false eyebrows, and with his teeth blackened,

as was the fashion. And then came the main event, as he led his guests through an impossibly lush tunnel of full-blooming cherry trees, their fallen blossoms carpeting the pathway with delicate petals. "The entire temple was filled with great pleasure," a spectator reported. "Everyone was satisfied."

Yet the fourteenth-century monk Yoshida Kenko (born ca.1283) had noted that blossom viewing need not be thought of as a once-a-year party, but could be instead a year-round state of mind. "Are we to look at cherry blossoms only in full bloom, the moon only when it is cloudless?" he wondered. "People commonly regret that the cherry blossoms scatter or that the moon sinks in the sky, and this is natural; but only an exceptionally insensitive man would say, 'This branch and that branch have lost their blossoms. There is nothing worth seeing now.'"

12:20 PM ✳ THOREAU BREAKS FOR LUNCH

When *Walden* was published in 1854, critics puzzled over Henry David Thoreau's account of his experimental years living in the Massachusetts woods, where he called a self-built shack home. Most agreed that Thoreau (1817–1862) had a witty, pretty way of describing nature, and many could see the value in his seeking a less complicated life. But the fact that he emerged from his self-

imposed seclusion every day or two—strolling the mile or so into Concord for a bit of fun or going to his mother's house for lunch—seemed like cheating. As his mother divulged, "Henry was by no means so utterly indifferent to the good things of life as he liked to believe himself." One of his critics put it less kindly: "He played savage on the borders of civilization."

And yet, though some might have thought he exaggerated his independence, it's true that out in the woods Thoreau lived quite simply. "It appeared more beautiful to live low," he wrote. He proudly went without underwear, gloves, or an overcoat. Once, when camping in the mountains without a blanket, he covered up at night with a wooden board held by the weight of a big rock. With his expenses kept in check by his keen thrift, Thoreau was freer than most. At Walden Pond he might spend the afternoon reading while lolling in the shade next to a brook. "What he did there," a critic wrote, "besides writing the book before us, cultivating beans, sounding Walden Pond, reading Homer, baking johnny-cakes, studying Brahminical theology, listening to chipping-squirrels, receiving visits, and having high imaginations, we do not know." For Thoreau it was enough.

In the woods he found the solitude he dearly craved. "You think I am impoverishing myself by withdrawing from men," he wrote to a friend, "but in my solitude I have woven for myself a silken web or chrysalis, and nymph-like, shall ere long burst forth a more perfect creature, fitted to a higher society." He said he'd

rather sit "on a pumpkin" alone than suffer sitting with others "crowded on a velvet cushion."

Yet, when Joseph Hosmer, son of a farmer friend, turned up one Sunday in 1845, Thoreau graciously played the host, serving a bang-up meal that demonstrated his self-reliance. "His hospitality and manner of entertainment were unique, and peculiar to the time and place," Hosmer later recalled. In a stone-lined fire pit, Thoreau made flatbread with lake water, baking the loaves on a stone. Then he roasted some horned pout *en papillote*. His beans, which he raised by the acre, were his pride and joy. "What shall I learn of beans or beans of me?" he wrote. "I cherish them, I hoe them, early and late I have an eye to them; and this is my day's work. It is a fine broad leaf to look on. My auxiliaries are the dews and rains which water this dry soil, and what fertility is in the soil itself, which for the most part is lean and effete. My enemies are worms, cool days, and most of all woodchucks. The last have nibbled for me a quarter of an acre clean." During the season, he began hoeing at around five in the morning, and quit at noon to pursue "other affairs."

When he died, Thoreau had published only two books, and *Walden* had attained only moderate success. His American peers viewed his work with critical distance. John Greenleaf Whittier (1807–1892) called *Walden* "capital reading, but very wicked and heathenish." "The practical moral of it," he wrote, "seems to be that if a man is willing to sink himself into a woodchuck he can

live as cheaply as that quadruped, but after all, for me, I prefer walking on two legs." Oliver Wendell Holmes (1809–1894) sniffed that Thoreau's Walden experiment "carried out a schoolboy whim to its full proportions."

But Thoreau's ideas about independence, liberty, and living the good life survived to influence later thinkers, including Mahatma Gandhi and Martin Luther King Jr. He refused to be satisfied by the status quo, preferring—most of the time—to "live on the stretch." As Thoreau explained, "I wanted to live deep and suck out all the marrow of life."

12:50 PM ✳ FEASTING ON FRESH CRAB

Late in China's Ming era (1368–1644), a time of extreme extravagance, the Yangtze region of Jiangnan, around the city of Shouzu, was the nexus of the pleasure-seeking set, where the locals were "habituated to excess and splendour, and to a delight in the rare and strange," one denizen reported. They paraded by in the richest clothes, and dined like kings.

For many, the height of sensual fulfillment lay in eating fresh river crabs on an autumn afternoon. Zhang Dai (1597–ca.1684), a writer and bon vivant from the region, spent his later days destitute and lonely, remembering the good times, when he "painstak-

ingly researched the daily pleasures of the mouth and stomach." The most pleasant of those pleasurable days were autumn afternoons when Zhang and his friends convened their Crab-Eating Club down on the riverbanks. The freshwater crabs were plump—"as big as a serving dish," he recalled—and their claws were perfectly purple. Each club member was allotted six crabs, cooked riverside and eaten one at a time, so the delicate dish wouldn't lose its flavor. The friends dug into bamboo shoots and newly harvested rice, chasing it all down with wine and snow orchid tea. "When I think of it today," Zhang wrote, "it is really as though we had tasted the offerings of the immortals come from the celestial kitchens, reaching the point of total satiation and intoxication."

Playwright Li Yu (1610–1680), another local artist with an oversize appetite, lived his days in an aesthetic haze, going so far as to sleep with a vase of flowers tucked inside his bed curtain. "Once, just as I was about to waken from a sweet dream, I smelled the scent of the winter-sweet and my throat and mouth were filled with a clear, delicate fragrance that seemed to emanate from somewhere inside of me," he recalled. "My body felt light and as if about to ascend, and I concluded I was no longer part of this mortal world."

Li Yu rhapsodized about flowers and Suzhou strawberries, and once penned a poem titled "Eating Fresh Lichees in Fujian." But, as everyone around him knew, nothing transported him to that otherworldly realm like a lunch of fresh crab. "My family tease

me for considering crabs as important as life itself," he wrote. His tastes, like Zhang Dai's, often exceeded his budget, though he saved each year in anticipation of crab season. "From the day the crabs appear until the end of the season, I never let an evening or, indeed, a couple of hours go by without indulging in them." Fresh, plump crab, "smooth white like jade" and "rich yellow like gold," should be eaten simply steamed in the shell and served on a bed of ice, he declared. "It has already attained a perfection of color, fragrance, and flavor that nothing else can surpass," Li wrote. "Blending it with other flavors is as hopeless an enterprise as lighting a torch to increase the sun's heat or scooping water to increase the river's depth."

1:00 PM ✳ NAPTIME

The afternoon nap is a pleasure known from Papua New Guinea to Patagonia. The Bible mentions Ishbosheth, who fell into bed at noon. Ancient Romans rested during the *hora sexta,* the sixth hour after dawn. Centuries later, Benedictine monks followed suit, settling down in summertime for a midday snooze. After a full meal, as nineteenth-century health experts argued, the period of repose aids digestion. "Muscular exertion draws the blood to the muscles, and brain work draws it to the head; and in consequence

of this the stomach loses the supply which is necessary to it when performing its office," a popular American magazine noted. "The heaviness which is felt after a full meal is a sure indication of the need of quiet."

Some of history's big achievers advocated for the midday nap. Thomas Edison (1847–1931), who often worked through the night, could drop off almost anywhere, napping in the park under a tree or right on top of his workbench. Winston Churchill (1874–1965) was a true believer, insisting, "You must sleep sometime between lunch and dinner, and no half-way measures. Take off your clothes and get into bed."

Yet, slowly, as business leaders in industrialized countries focused evermore on productivity, the nap went into demise. Once, people had been paid by the job, working and napping at their own pace. But when workers began to earn their pay by the hour, there could be no napping on company time—that is, except in Latin American holdout countries, and in warm-weathered, big-hearted Mediterranean countries like Spain, the stalwart napping zones.

Similarly, China traditionally held a strict reverence for the nap, or *xiu xi*. Ancient Taoists were staunch nap takers—a trend that caught on among the literati during the Song era (960–1279). Throughout Mao's rule, the *xiu xi* was upheld by Article 49 of the People's Republic's 1950 constitution, which proclaimed: "The working people have the right to rest." Rest was necessary in

order to maintain top production speeds, Chinese experts argued. Meanwhile, American critics rolled their eyes, with a *New York Times* reporter in 1973 calling the Chinese *xiu xi* a "habit that is as unshakable as in Spain and at least as costly in terms of man-hours lost to the economy. . . . A bed is preferred, but any flat surface will do."

Finally, during the 1980s, Chinese officials fell prey to international anti-napping sentiments, convinced that indulging in *xiu xi* put them at a disadvantage. The government made an official change to the national work schedule, cutting the workers' three-hour lunch break to a mere one hour. That left Spain the single industrialized country that officially condoned the nap. That is, until 2006, when government workers' official lunchtime siesta was reduced from three hours to a fleeting sixty minutes.

1:30 PM ✳ PAGES TURN, PLOTS THICKEN

As a girl, Frances Burney d'Arblay (1752–1840), aka Fanny Burney, later one of the premier British novelists of her age, was suspicious of her own love of reading. "I make a kind of rule never to indulge myself in my two most favourite pursuits, reading & writing, in the morning," she confided to her diary at age fourteen. "No, like a very good Girl I give that up wholly." She focused on

her needlework instead, "which means," she wrote, "my Reading & writing in the afternoon is a pleasure I am not blamed for & does me no harm, as it does not take up the Time I ought to spend otherwise." Reading was a reward for good deeds done. But even so, reading alone made her a little nervous. "Anything highly beautiful I have almost an aversion to reading alone," d'Arblay insisted.

Reading silently—without speaking the words aloud—was a new skill. Monks and aristocrats had learned to read to themselves by the fifteenth century, but for everyone else, the undertaking was still decadent and strange. And if the novel offered an especially guilty pleasure in the eighteenth century, it was because more than any other kind of literature it fanned the seductive powers of the imagination. "It is to be feared, the moral view is rarely regarded by youthful and inexperienced readers, who naturally pay the chief attention to the lively descriptions of love, and its effects; and who, while they read, eagerly wish to be actors in the scenes which they admire," cautioned the English Reverend Vicesimus Knox (1752–1821) in 1787. Unlike biographies, or tame books of letters, novels of the sort one read alone inflamed ardor, an effect that the pious insisted few readers could resist.

Young women were especially at risk, due to the assumed depths of their empathy. They read "to the neglect of industry, health, proper exercise, and to the ruin both of body and of soul," snapped the author of *The Evils of Adultery and Prostitution* (1792).

"The increase of novels will help to account for the increase of prostitution and for the numerous adulteries and elopements that we hear of in the different parts of the kingdom." Medical writers chimed in too, advising young women to avoid fiction entirely, as it could affect the nervous system, leading them to the verge of hysteria, or worse. "A novel read in secret is a dangerous thing," one etiquette writer warned.

Still pondering the topic a century later, in 1896 the British advice writer Lady Laura Ridding wondered, "What Should Women Read?"—in her article of the same title. Whatever it was, it shouldn't be "morbid, pessimistic, coarse, flippant, irreverent . . . bigoted controversial books." Instead, proper reading should educate. And yet, "the strawberry ices of literature glow on every railway bookstall in the shape of the lighter magazines, the society and comic papers, fashion journals, sensational stories," Ridding sighed. There was simply no denying the deliciousness of an afternoon spent on the sofa, as another writer put it, with "a shilling shocker and a shilling's worth of sweeties."

On the whole, however, Victorian England didn't pay much attention to that sort of prim critique. Perhaps everyone was too busy reading novels to care. "We have become a novel-reading people," wrote Anthony Trollope (1815–1882) in 1870, having supplied readers with some of the era's best-loved books. "Novels are in the hands of us all, from the Prime Minister down to the last-appointed scullery-maid."

Arriving at New York's JFK airport in the spring of 1974, German artist Joseph Beuys (1921–1986) was quickly wrapped in felt, strapped onto a gurney, and loaded into an ambulance. The staged abduction was the beginning of his provocative performance piece *Coyote,* or *I Like America and America Likes Me.* Handlers shuttled the artist down to SoHo and into a stark art gallery, where he spent the next three days locked inside with a wild coyote. Theirs was a strange dance of "long, calm, concentrated, almost silent days of dialogue between representatives of two species," wrote an observer, following the action from behind an installed length of chain-link fence.

During a seventy-five-minute sequence repeated over those three days, Beuys, dressed like an eccentric shepherd, watched the animal's every move, responding with choreographed movements of his own. He liked to think of the piece as a concert. "When I first came in," an art critic wrote, "I saw the coyote and two piles of felt. One of them turned out to be Beuys, wrapped, and with a wooden cane sticking out of the top." Sometimes Beuys got up, threw off his cape, and struck three notes on a triangle hanging by a string from his waistband. (The sound cued a gallery attendant in the next room to play a recording of a roaring turbine.) Beuys threw his pair of work gloves to the coyote to play with. He sat on the coyote's pile of straw, which had traveled with

the animal from upstate New York, and smoked a cigarette. And on it went, as Beuys's performance was set in motion by the coyote a dozen times during the days they were together. "When he came near to my figuration, I bowed in devotion," said Beuys. "When he lay down, I knelt. And when he fell asleep, I fell over. Then when he sprang up again, I threw off the felt and jumped up too. That was how the cycle went."

Sometimes the coyote snapped at Beuys's crook-handled staff, or shredded pieces of his felt, and sometimes the animal made a nest in it, curling up for a nap. Felt was a potent symbol for the artist, who, as a bomber pilot in 1940, had been shot down in the Crimean mountains, then saved by Tatars who wrapped him in layers of fat and felt to keep him from freezing to death. For Beuys, the *Coyote* performance offered another kind of healing. It was a ritual meant to mend the centuries-old rift between America and the Native Americans, who revered the coyote as an archetypal trickster. "You could say that a reckoning has to be made with the coyote," Beuys explained, "and only then can this trauma be lifted."

At the end of their time together, Beuys tenderly hugged the coyote goodbye. Then he rewrapped himself in his felt, climbed back onto the gurney, and rode in the ambulance to the airport to fly home. He was pleased with the outcome of his performance and also with his new coyote friend. "I really made good contact with him," he said. At the time of Beuys's death some twelve years later, when his enigmatic, ritualistic approach to performance art

was still confounding art world pundits, *The New York Times* would wonder whether Beuys was "shaman or charlatan, sage or pest, saint or silly."

Maybe Beuys was a trickster, but the unforgettable images of his iconoclastic *Coyote* solidified his reputation as a powerful force on the international performance art scene. "The spirit of the coyote is so mighty that the human being cannot understand what it is," he said, "or what it can do for human kind in the future."

1:55 PM ✳ PROUST STEADIES HIMSELF FOR A DUEL

In the 1890s, Marcel Proust (1871–1922) was a dandyish young society reporter observing and absorbing the glittering Paris scene that swirled around Count Robert de Montesquiou (1855–1921), one of the century's most dedicated aesthetes. For fun, de Montesquiou and his frivolous friends, including Sarah Bernhardt, liked to dress up, lacing themselves into eighteenth-century costumes styled after those of Marie Antoinette and her crew. At his parties, the beau monde walked over flower petals. Rare blooms and birds filled his Japanese-inspired hothouse. His pet turtle's shell was encrusted with jewels. Not too surprisingly, Proust, the bright young man-about-town, became his protégé.

Spending time at de Montesquiou's side, Proust steeped himself in tales of bygone intrigues, minutely studying the aristocratic characters who surrounded him. (De Montesquiou himself later served as a model for Proust's fictional Baron de Charlus.) The young writer also developed expensive tastes that meant he had not "a penny left for flowers," as he told a friend. At the time of his literary debut in 1897, however, Proust's connection to the great social lion would put him at a more serious disadvantage. Criticism of his melancholic first book, *Les Plaisirs et les jours,* a small collection of tales and poems, was, for the most part, unenthusiastic. But the review by writer Jean Lorrain was merciless.

Lorrain (1855–1906), de Montesquiou's arch-nemesis, was another perfumed and decadent type, with his jewels, his hennaed mustache, and his addiction to both ether and rough sailor boys. That didn't stop him from calling Proust's writing "precious and pretentious," or from claiming that the book was full of "inane flirtations." And then he went a step too far, insinuating that Proust was having a homosexual love affair, which was illegal at the time. Instead of suing Lorrain for libel, Proust challenged him to a duel.

Dueling, a genteel way for courtiers to settle their differences since the Renaissance, was dangerous until the second half of the nineteenth century, when strict protocols kept the body count low. The new codes frowned on the most deadly forms of the duel and encouraged the aggrieved to rely on level-headed advocates,

"seconds," who could negotiate a low-risk contest and a bloodless resolution. Seconds, for example, could improve the odds by regulating the number of shots fired or substantially increasing the distance from which the parties would shoot. They also tended to work together to smooth things out so that the shooters were less intent in their aim. "Honor is no less sacred than governmental laws," wrote Comte de Chatauvillard in 1836, and yet, the fencing expert continued, "honor might require us to risk our lives, but not to play with them." Proust chose his seconds wisely: Impressionist painter Jean Béraud and socialite swordsman Gustave de Borda, known as an unequaled duelist. Lorrain took a painter and a novelist as his team.

While most dueling was done in the early dawn, the city's haute-bohemians lived by a different clock. In a forest outside Paris, Proust, Lorrain, and their seconds met on a rainy afternoon in February 1897. Proust, ever the gentleman, nearly shook hands with the enemy before his seconds stopped him. At twenty-five paces, the two men faced off with pistols and exchanged fire. Proust almost hit Lorrain's foot. But he didn't. And that was that.

Proust's friends took pride in his ability to rise above his habitual nervousness during the proceedings. "He showed a *sang-froid* and a firmness that appear incompatible with his nerves," one noted. Later in life, Proust's agitated condition and ill health would keep him in bed for long stretches at a time, but in facing his enemy, the idea that he might have to wake up early was more

frightening than death by gunshot. "My sole concern was that the duel would take place before noon," he remembered, writing to de Montesquiou years later. "When I was told that it would be during the afternoon, it was all the same to me."

2:00 PM ✳ THE BATHS BUILD STEAM

The ancient Roman workday ended around noon, the same hour that the public baths opened. A savvy habitué, the poet Martial (ca.40 CE–ca.102 CE), noted that the city's spas were at their hottest during the first two hours, as attendants stoked the fires, and that the social scene was roiling by late afternoon. From the sound of it, he'd visited every spa in town. He liked the Thermae of Titus, and took his dinner guests to the Balneae of Stephanus. He went to the Thermae of Agrippa when he needed to see his patrons, and though he appreciated the luxury of the Thermae of Nero, for him the place was just too hot.

Everyone—freeman, woman, or slave—was welcome at Rome's low-cost public baths. Paid for by the city's elite and splendidly decorated with statues and mosaics, the baths were built for the pursuit of pleasure, though men and women bathed separately—most of the time. There were promenades, gymnasiums, hot rooms and cold plunge pools, masseuses who gave rubdowns, and snack vendors who served eggs, lettuce, and sausages. For

Cicero (106–43 BCE), the bell that announced the opening of the baths each afternoon was a sweeter sound than the voices of all the philosophers of Athens. Even those who bathed at home dropped by the public baths to meet friends in the late afternoon, when social climbers and hungry poets prowled the steamy realms, hoping to land a dinner invitation.

Over many centuries, the public bath came into and went out of fashion, spreading across Europe, first with the Romans, then with the returning Crusaders, who probably introduced the bagnio, or hammam, to twelfth-century London. By the late Middle Ages, fears that the baths spread disease and fueled prostitution forced many to close their doors. Another sea change occurred in the early seventeenth century, when medical writers championed the hot bath, though the Puritans could hardly agree. By the late seventeenth century, public bathhouses had cropped up across London once more, this time reimagined in a fantasy-Oriental style and dubbed "Turkish baths," with a nod to Istanbul's Roman thermal spas, many of which were still in operation.

The Duke's Bagnio was the first. Then came the rest—the China Hummum, the Turk's Head, Pero's Bagnio, and the Hummums of Brownlow Street, where, one ad promised, "persons may sweat to what degree they please." A hint of hedonism kept bathers happy. As in the ancient world, they were tempted by snacks and drinks—especially exotic coffee. And as in ancient Rome, the sight of so much skin, and the occasional brow-raising mix of male and female bathers, lent London's bagnios a wicked reputation. In

truth, some baths doubled as brothels, while others were above-board.

At the turn of the seventeenth century, the English writer Ned Ward (1667–1731), who wrote articles as the "London Spy," visited a hammam in Covent Garden for an "hour's baking." Swaddled with a cloth "no bigger than a fig-leaf," and wearing wooden-soled shoes to protect his feet from the scorching floors, he started in the steam bath. "I began immediately to melt, like a piece of Butter in a Basting Ladle, and was afraid I should have run all to Oil by the time I had been six minutes," he reported. As he sat and sweated, "warm as a cricket at an oven's mouth," a man rubbed him down with a rough glove before sending him on to the sauna, where he could "boil out those gross humours that could not be emitted by a more gentle perspiration."

A much more decorous English writer, James Boswell (1740–1795), dared only dip his feet into a hot bath while visiting Holland in 1763. The experience left him tantalized and slightly scandalized. "But if I receive so much delight from washing my feet, how great must have been the luxury of the Romans, who solaced thus their entire bodies," he mused. "Truly, without exaggeration, one cannot imagine anything more consoling than after a day of annoyance and fatigue to undress and stretch one's self out at full length in fluid warmth, to have one's nerves gently relaxed, to enjoy indolent ease and forget all one's cares. . . . A warm bath is, I confess, a most agreeable kind of luxury, but luxury is very dangerous."

May * DESERT ROSES BLOOM

CLASSICAL PERSIAN POETS WROTE THOUSANDS of tender verses in praise of the rose, which bloomed briefly during the abrupt Middle Eastern spring only to wilt and crisp in the summer heat. Still, that fleeting span was heaven on earth. As the medieval Persian poet Hafiz (ca.1325–1389) wrote, "Earth rivals the Immortal Garden during the rose and lily's reign."

Roses of every variety became the focal point of the ancient Persian garden, secreted away behind high walls and inspired by the Koran's descriptions of the otherworldly afterlife. They were arranged around flowing fountains, surrounded by fruit trees and planted in lavish banks. (The Persian word *pairidaēza*, meaning "walled in," became "paradise" in English.) "In no other country of the world does the rose grow in such perfection as in Persia," wrote a nineteenth-century springtime visitor, "in no country is

it so cultivated, and prized by the natives. Their gardens and courts are crowded with its plants, their rooms ornamental with vases, filled with its gathered bunches and every bath strewed with full-blown flowers, plucked from their ever-replenished stems."

As with the ancient Persians, the ancient Romans fell for the rose and loved it with abandon. Emperor Nero (37–68 CE) was said to have thrown a banquet during which several dinner guests suffocated under a heavy rain of rose petals released from the ceiling. It's no wonder early Christians like Saint Clement of Alexandria (ca.150–ca.215) frowned upon the rose and its decadent associations, denouncing the flower and its perfume too. Women who scented themselves with rose, Saint Clement claimed, were "directed to the gratification of insatiable desire." Admiration for the flower itself was acceptable, "if a concession must be made," he granted, "but let them not crown themselves with them." The rose slowly regained popularity without his support, and, ironically, would eventually become a symbol for the Virgin Mary.

The Persians' *Rosa centrifolia* certainly smelled divine, and various foods and drinks made use of it. The damask rose, thought to have sprung up from a droplet of Muhammad's sweat, became the prime source for the kingdom's rose water. Heady Middle Eastern recipes of the medieval era called for rose water and rose petals. The celebrated Persian doctor Avicenna (980–1037) prescribed rose water cordials as a cure for ailments of the heart, and therefore the spirit, mixing in pomegranates, saffron, egg yolks, and, sometimes, ground gems or pearls. After Avicenna, rose became a key ingredient in ancient love potions—a concept that, once again, traveled to Europe. Later, Portuguese traders would quench their thirst with a Persian drink made of five ingredients—grape juice, rose water, sugar, cinnamon, and lemon juice, over ice—called *panj*, the Persian word for "five," which became "punch" in the West. Meanwhile, the Persian word for rose water, *gulāb*, became the name of another sweet drink, known in English as the "julep."

Yet, in ancient Persia, the rose was never just a rose, but a solemn representation of both the beauty of the beloved and the transcendent yearning for the divine. "I am so drowned in my love for the rose," wrote the twelfth-century poet Attar, "that my own existence has become effaced."

Rose Julep

Emily Butters and Forrest Butler of Royal Rose syrups created this fresh, rosy take on the mint julep, to be sipped and savored come springtime.

2–3 mint sprigs, torn, plus one for garnish

1 ounce Royal Rose rose syrup

1 ounce fresh ruby grapefruit juice

½ ounce fresh lime juice

Splash of soda or seltzer water

Shake the first four ingredients with ice and strain into a rocks glass filled with ice. Top with soda water. Garnish with a sprig of mint.

2:20 PM ✳ THE GLASS HARMONICA ENCHANTS

Women of polite eighteenth-century society made music at home with ladies' instruments—the guitar and the glass harmonium. "There is hardly a private family in a civilized nation without its flute, its fiddle, its harpsichord, or guitar," the English music historian Charles Burney (1726–1814) noted. The guitar, introduced in Britain in the 1750s, was easy to learn, but it was also known for showcasing its players' best attributes. "The Attitude this Instrument almost naturally throws the Performer in, is very graceful, and forms a Line of Beauty," explained an early English player, Ann Ford (1737–1824), "not to mention the Advantage which the Hands and Arms are seen in, &c. &c. &c." Women in Ford's circle often kept a guitar close at hand when posing for artists like Thomas Gainsborough and Joshua Reynolds.

For all the guitar's sophisticated allure, however, Ford's own father had her arrested—twice—while she was en route to perform. He couldn't bear the indignity of her musical talent going on public display. On her third attempt, he hired a pack of thugs to block ticket holders from entering the concert hall. Not surprisingly, his efforts turned her into a sensation. Eventually Ford married, moved out, and arranged a series of small afternoon concerts in which, between one o'clock and three, she'd sing Italian arias and play the viola da gamba and the guitar. She was "partly admired & partly laugh'd at" around London, according to Gainsborough, though others said that she played so sweetly it moved her audience to tears.

During her stage career, Ford also pioneered the use of another novel instrument, the glass harmonica, once performing an entire concert by tracing the rims of a set of tuned wineglasses with a damp fingertip, which she kept moist by dabbing it on the pulp of an unripe grape. The "armonica," as it was known, was a quintessentially feminine instrument. American inventor Benjamin Franklin (1706–1790) created the device, lining up a graded series of stemless lead crystal glasses along an iron spindle attached to a foot pedal. When a player pumped the pedal, the glasses spun, ready to give off their slightly macabre, saccharine sounds. "The advantages of this instrument are, that its tones are incomparably sweet beyond those of any other," Franklin crowed. The armonica's glassy music—which sounds something like an enchanted calliope—was credited with reconciling fighting

friends, but also with making women faint. "No instrument that I know has so celestial a tone," wrote English poet Thomas Gray (1716–1771). "I thought it was a cherubim in a box." (Composers from Beethoven to Björk have tried it since, and several craftsmen worldwide still fabricate the instrument.)

The eerie, ethereal tones charmed some, but the sound was a little too airy for those of a superstitious bent. "Like every pleasure of a refined nature that leads the mind to contemplation, if too much enjoyed, it abstracts us from the ordinary enjoyments of social life, and thus may become an evil," German musicologist Friedrich Rochlitz (1769–1842) warned. "Also, we should not indulge in its soft and pleasing tones too much at night." The glass harmonica was consequently banned in some German towns. It was also often blamed for the physical ailments of professional players. It was said that "permanent nerve damage" induced by the instrument forced the musician Marianne Davies (ca. 1743–1818) into an early retirement. When one of the best-known players, Marianne Kirchgessner (1769–1808), died suddenly of a fever, rumors circulated that the cause of death was "nervous excitement" aggravated by the armonica's penetrating sound.

On the other hand, the famous German hypnotist Dr. Franz Mesmer (1734–1815) praised the power of the armonica's angelic tones, which charged the atmosphere, he explained, channeling the "magnetic fluid," or "ether," from another plane, and thereby

easing his patients into a trance. Mesmer played the instrument himself, spinning the glasses after dinner in the twilight, improvising warbling, mournful melodies. His deathbed wish was to hear the glass harmonica one last time.

Ultimately, however, the instrument was remembered as a means for a woman to show off her delicate feminine nature, as with the guitar. "When it was claimed that the armonica exerted a magical influence on the nerves," one writer remembered, "the instrument could not fail to captivate every sensitive soul. For any young lady of breeding it would have been most ill-advised, as soon as the glasses were even touched, not to fall into a tolerably convincing swoon."

2:35 PM ✳ NEEDLES TAKE TO CLOTH

Aristocratic ladies whiled away the hours for centuries by embroidering, spinning, weaving, and making lace. As the Venetian noblewoman Christine de Pisan (1364–ca.1430) wrote, a proper princess would go to mass in the morning, distribute cash among the poor, and then, after a meal with her ladies-in-waiting, spend the afternoon doing needlework with them. The only other option seems to have been doing nothing at all. "Rather than be idle, she will take up some handiwork, such as sewing fine cloth. Then

they may all indulge in some amusements," wrote Christine. The recent introduction of strong, thin needles made such delicate amusements possible. Past instruments weren't as user friendly. Bronze needles were too coarse. Bone needles broke. Silver needles were fine, but expensive. Steel needle manufacturing developed in the mid-sixteenth century, but even two hundred years later needles were prized, kept close in tiny decorated cases.

Some women stitched little gifts for their lovers—slippers or suspenders—weaving in locks of their own hair, or they crafted elaborately worked curtains for four-poster beds. Edith, wife of Edward the Confessor, embroidered robes for him in eleventh-century England. In France, Catherine de' Medici, famously handy with a needle, kept the ladies of her court busy fabricating hundreds of lacy squares to decorate her boudoir. Queen Jeanne of Navarre (1528–1572) was so bored by the long hours she spent in church that she petitioned the synod to allow her to work on her tapestry while listening to sermons. England's Queen Elizabeth I (1533–1603) gave up the needle when she took the throne, but Mary, Queen of Scots (1542–1587), could not keep her hands still and received her ministers and ambassadors while at her embroidery.

Other women sang as they stitched. According to Homer, who is thought to have written in the eighth century BCE, Circe sang at her loom. In medieval France, women trilled sad tales of love, *chansons de toile,* or "weaving songs." One *chanson,* for exam-

ple, described a heartbroken belle who, "with a silk cloth on her knees," worked as "warm tears rolled down her face." How similar it is to a weaving song from ancient Egypt:

Singers are at the looms in the weaving rooms.
What they sing to the goddess are dirges.

Like the noblewomen hidden away behind castle walls, nuns in European convents spent most of their time embroidering and lace making when they weren't at prayer. It's said that Saint Etheldreda, in seventh-century England, entered a convent just so that she could embroider without interruption. But in the next century, the English church tried to discourage too many hours spent at needlework, cautioning nuns that it was better to sing and read religious texts instead. Nuns in the thirteenth century were warned away from attempting the fanciest frills when a guide urged opting for the "plainer kinds" of patterns. "Do not make purses in order to win friends," the book advised, and "do not make silk caps or bandages or lace without permission."

Over the ages, however, spinning, lace making, and embroidery had become so intertwined with the deepest assumptions about femininity that well into the nineteenth century it was impossible to disentangle the two. "Skill with the fingers, this domestic work, is what truly constitutes a woman," the renowned French author Madame de Genlis (1746–1830) noted. Another

French writer on manners, the Baronne Staffe, put it more bluntly. "The woman who does not enjoy needlework," she wrote in 1900, "is not a woman."

3:05 PM ✳ A WHOLE LOT OF NOTHING

In 1968, the mysterious artist Ray Johnson (1927–1995) convened six meetings of the New York Correspondence School, its members all artists and hipsters who participated at Johnson's behest by mailing art to one another. One afternoon, they gathered in Central Park and strutted about on stilts, but more often at NYCS events they "sat around wondering when the meeting would start," a journalist wrote. "It never did—and that was the point." Nothing happened.

Johnson was a "nothingness" connoisseur who performed his well-attended Nothings as an antidote to the art world's Happenings. "His most eventful Nothing, a half minute affair, came about when he dumped two boxes of wooden dowels down a stairwell, just out of earshot of an invited audience," *The New York Times* reported. "It sounded to me like a waterfall or coal going down a chute," Johnson told the paper. What else Happened? "Nothing."

At NYCS's height, Johnson spent some eight to ten hours a day in his spartan Lower East Side apartment managing its cross-

country postal network made up of several hundred of his friends. He would start a cartoonish drawing, or a Pop-inflected collage, and send it off to another member, directing that person to add to the piece and mail it on to a third person—Chuck Close, say, or Dennis Hopper or Ultra Violet. Photocopied ads were layered over strange bits of ephemera and doodles in a way that mirrored Johnson's aesthetic. His look, Johnson said, was "sandpapered painted cardboard chunks casting shadows with hand-lettered poems, ink drawings of combs, condoms, massage balls and snakes, lists of famous people and Movie Stars and dollar bills painted on white backgrounds." He described the NYSC as a "fantastic, gigantic Calder mobile . . . constantly in motion."

Someone new to the list might receive an envelope posted from Cherry Hill, New Jersey, and containing a stick of Wrigley's gum, or a set of hospital forms to be filled out, or an advertisement for a smoking product made from lettuce leaves, and then an envelope from MoMA containing nothing at all. "I was no longer sure what was or wasn't a communication from the NYCS," said one correspondent. When a young woman received a packet of indecent material labeled with Johnson's return address, the NYPD called him in for questioning.

Sometimes larger objects entered the mailed melee, as when Johnson received elephant dung from the Sacramento Zoo. "It was beautiful, almost a religious object," he said. "I put it on a Victorian table and made drawings of it."

"My fondest memories," another correspondent recalled, "are of a series of chairs, smaller chairs mailed whole, larger chairs mailed disassembled to fit within postal size limits. The challenge was to mail them unwrapped and visible, persuading postal clerks to accept the items as falling within regulations." It made for some exciting trips to the mailbox.

During the NYCS's heyday, Andy Warhol (1928–1987) tried to buy up all the Johnson mail art he could, but, overall, Johnson's wasn't a commercial endeavor. Apart from a handful of gallery shows, he shunned the moneyed side of the art world, preferring to display his artworks on the sidewalk or in Grand Central Terminal. He once showed his latest pieces to a collector at a rest stop just off the Long Island Expressway. He didn't sell much and he liked it that way, remaining in "voluntary poverty" in an apartment that contained a bed, a table, a chair, a typewriter, and a coffee pot. "Living this way, I can do what I want," he told an interviewer, "which is, to write letters." Like Warhol, he was captivated by pop culture, and, in the spirit of his Nothings, held fan club meetings for Marcel Duchamp, Anna May Wong, and Edie Beale, while images of Greta Garbo, Marilyn Monroe, and Marianne Moore peppered his artwork. One well-loved collage is an image of James Dean wearing Mouseketeer ears made from a pack of Lucky Strikes. For the most part, however, mailed artwork couldn't be bought or sold, only received. After many years of discussing the possibility of a show with one gallerist, he told

her he'd come up with the perfect solution. "We'll have," he said, pausing, "Nothing in the show."

Johnson's art was in the creative act itself, something he tried to explain during a lecture. The talk "consisted of my trying to move a piano across a stage," Johnson remembered. "People kept coming up to ask if they could help, and I said, 'Certainly not! I mean the point is that I can't move this piano, and I'm struggling to move it and it's obviously not going to get moved across the stage, and I'm putting out a great exertion of energy, and I'm on a public platform and you are all viewing me, which is the whole point of this thing.' I said, 'You figure it out.'"

Some did, some didn't. Sometimes even Johnson's NYCS members didn't understand what was going on. "I didn't go to many Correspondence School meetings," one artist remembered. "A lot of them were very boring. They were like cocktail parties without drinks."

3:20 PM ✳ WALKING FOR SPORT AND PLEASURE

A vogue for walking tours swept England in the 1780s. "Shall we suppose it a greater pleasure to the sportsman to pursue a trivial animal, than it is to the man of taste to pursue the beauties of nature? To follow her through all her recesses?" asked the great

English walker William Gilpin (1724–1804). Guidebooks like those by Gilpin led ambitious and rustically romantic pedestrians to England's relentlessly idyllic Lake District, where poets such as Thomas Gray, William Wordsworth and his sister Dorothy, Thomas De Quincey, and Samuel Taylor Coleridge liked to roam. For their ilk, walking was akin to religion, and by De Quincey's estimate, William Wordsworth (1770–1850) walked some "175 to 180,000 English miles" during his lifetime.

When the Wordsworth siblings and Coleridge (1772–1834) teamed up to trek together in 1798, they raised the five pounds they needed to cover their expenses by writing a poem together for a literary magazine, a collaboration that later became "The Rime of the Ancient Mariner." Their friendship wasn't always so breezy, however. After they'd spent some days walking together across Scotland a few years later, tensions drove the party apart and Coleridge struck out alone, walking 263 miles during an eight-day stretch. He knew how to keep himself amused. Instead of following a path down a mountain—too boring—he took the "first possible" way down, no matter where it led, relying "upon fortune for how far down this possibility will continue." He nearly killed himself that way once, descending Scafell Pike.

Coleridge wasn't the only one who liked to walk alone. For writer William Hazlitt (1778–1830), never known for his sociability, it was the only way to go. "I cannot see the wit of walking and talking at the same time," he declared in 1822. Without company,

he was unencumbered, free from distraction. "I want to see my vague notions float like the down of the thistle and not to have them entangled in the briars and thorns of controversy," he continued. "Give me the clear blue sky over my head and the green turf beneath my feet, a winding road before me, and three hours' march to dinner—and then to thinking! It is hard if I cannot start some game on these lone heaths. I laugh, I run, I leap, I sing for joy."

Scottish writer Robert Louis Stevenson (1850–1894), who crisscrossed 120 miles of French countryside while walking alongside a donkey, echoed the notion. "If you go in a company, or even in pairs, it is no longer a walking tour in anything but name; it is something else and more in the nature of a picnic," he argued in 1876. "A walking tour should be gone on alone, because freedom is of the essence; because you should be able to stop and go on, and follow this way or that, as the freak takes you; and because you must have your own pace, and neither trot alongside a champion walker, nor mince in time with a girl."

Stevenson, no mincer, wasn't searching out the picturesque, after all, but "certain jolly humors," gently fatigued muscles, and a big appetite. Setting the right pace, with the right intention in mind, was imperative. The blissful walker wasn't an "overwalker," who "stupefies himself at 5 miles an hour," Stevenson noted, but one who might still linger a bit by the side of the road, if he felt like it. "It is almost as if the millennium were arrived, when

we shall throw our clocks and watches over the housetop, and remember time and seasons no more," he wrote. "You have no idea, unless you have tried it, how endlessly long is a summer's day, that you measure out only by hunger, and bring to an end only when you are drowsy."

3:30 PM ✳ CASANOVA UPS THE ANTE

When the Chinese emperor Mu-tsung played a card game with his wives on New Year's Eve in 969 CE, he probably had no notion that the amusing invention would travel the Silk Road through India and Persia before reaching the West, forever changing the nature of entertainment. But when the first playing cards arrived in Italy and Spain around 1370, they ignited a veritable card craze. In a swift fifty years, the irresistible plaything spread from the Mediterranean to Russia's Ural Mountains. Everyone was consumed.

Almost as quickly as they caught on in Europe, however, cards were banned. By 1394, the City of Paris had enacted laws forbidding the lower classes from playing cards on weekdays, to keep them safe from the novel vice. On the steps of St. Peter's in Rome, Saint Bernard of Siena preached against playing cards in 1432, demanding that the pious come forward into the square, heads hung low, to burn their decks. In England, the outspoken

preacher John Northbrooke cursed "carding" in 1577, claiming it led to "idleness, loitering, blasphemy, misery, infamie, shame, penury, and confusion."

Meanwhile, the European gentry took up a series of games that promised the thrill of dice and the strategic intrigue of chess. They obsessed over two-player piquet in the sixteenth century, and sat at triangular tables to play ombre in the next. Faro and whist came into style in the eighteenth century, as did brelan—a precursor to poker—which, because of its high stakes, was favored by Parisian libertines, according to Denis Diderot (1713–1784). "It is most enjoyable, that is, most ruinous, when there are three or five players," he wrote. "One cannot play it without becoming obsessed by it, and once taken with it one loses all taste for other games." Brelan relied on bluffing, which appealed to the sly nature of the city's aristocrats, though the Marquis de Mirabeau (1715–1789) fretted over its influence on the citi-

zenry at large. "In Brelan everything is a function of shrewdness," he declared, "and it is important to stop citizens from growing accustomed, even in their games, to using sharpness to set traps for one another."

One of that era's greatest gamblers knew a thing or two about using his wits to meet his ends—Giovanni Giacomo Casanova (1725–1798), the Venetian adventurer who loved cards almost as much as he loved women. Casanova described his very gentle-manly passion for gaming while traveling in Sulzbach, where a brusque young Frenchman named d'Entragues challenged him to a game of piquet. "I am not interested," he told d'Entragues, recalling the occasion in his memoirs, "for you and I do not play in the same way. I play for my pleasure, because play amuses me, whereas you play to win." D'Entragues took his comment as an insult, and Casanova decided to play him after all, betting the hot-headed young man that whoever left the gaming table first would forfeit fifty louis d'or.

They sat down at three in the afternoon and got right to it. The game went on for hours. Friends watched for a while, then left for dinner, drifting back again afterward to find the two still hunched over their cards at midnight, playing in silence. Casanova took only a cup of hot chocolate and a little broth for strength and held his ground through the night. At six the next morning, the friends returned to cheer on the dogged players. Casanova was down one hundred louis—"yet the game was going my way," he

wrote. The two men pressed on through the day and into the next night, never interrupting their play. By then, Casanova noted, his opponent was flagging, mixing up his cards and losing track of the score. He looked, Casanova said, "like a dug-up corpse." Casanova wasn't faring so well himself. But neither would quit. "I felt my strength failing," Casanova remembered, "and I hoped every minute to see him drop dead, for fear that I should be beaten despite my strong constitution."

At daybreak of the second morning, Casanova finally took the lead and the realization of certain defeat proved too much for his poor opponent. After a sip of broth, d'Entragues "became so ill that he reeled in his chair, broke into a sweat, and fainted," Casanova wrote. After forty-two hours of gaming, he was carried off to bed and Casanova pocketed the winnings. The two men agreed never to play cards together again.

 3:51 PM ✳ **NELLIE BLY ARRIVES IN JERSEY CITY**

American reporter Nellie Bly (1867–1922) reached Jersey City at 3:51:45 one January afternoon in 1890, just seventy-two days, six hours, eleven minutes, and a quarter second after she'd left to travel around the world—and eight days faster than Jules Verne's fictional Phileas Fogg, the protagonist of *Around the World in Eighty*

Days. That she was only twenty-two years old, a woman, and that she had traveled alone made Bly a phenomenon.

The young reporter had set sail in November 1889 wearing a blue plaid traveling coat and taking with her £200 in gold and English banknotes. In a small bag she carried some underclothes and a giant jar of cold cream. As the ship got under way, she immediately became seasick. "And she's going 'round the world!" a fellow passenger scoffed. After arriving in London and crossing the Channel, she traveled on from Calais to Brindisi by train, noting that she "might have seen more while traveling through France if the car windows had been clean." On the boat from Brindisi to Port Said, a rumor circulated that she was "an eccentric American heiress, traveling about with a hairbrush and a bank book." At Ismalia she watched a juggler do a magic trick. At Aden she marveled at the locals' beautiful teeth. In Ceylon she bought some baubles and a monkey she named McGinty. At a Japanese teahouse, she and her fellow travelers refused to take off their shoes, though they "effected a compromise" with the management by pulling cloth slippers over their shoes before entering. Bored and ship-bound once again, she thrilled to the sight of a monsoon out at sea. It was "the most beautiful thing I ever saw," she wrote. "I would sit breathless on the deck watching the bow of the ship standing upright on a wave, then dash headlong down as if intending to carry us to the bottom."

The World, Bly's paper, trumpeted her progress on its front

page. When she couldn't file her stories at a distance, her editors in New York improvised, writing about the sights she would probably see wherever she was. Circulation numbers went through the roof. Bly had become known to readers two years earlier with "Ten Days in a Madhouse," an exposé for which she'd had herself committed to a "human rat-trap," the notorious asylum on Blackwells Island. Her stunt inspired throngs of female reporters to pose as factory workers, beggars, chorus girls, and opium den habitués (presaging Gloria Steinem's stint as a Playboy Bunny). Bly arrived in Hong Kong to learn that her latest imitator, Elizabeth Bisland (1861–1929), an editor for *Cosmopolitan,* had set out from New York on the same day as she had, racing in the opposite direction, west to east. Bly affected nonchalance. "I am not racing with anyone," she told her informer. "If someone else wants to do the trip in less time, that is their concern."

It seems Bly had a much better time than her competitor, despite her seasickness. While Bisland bristled at celebrity, calling those who came out to get a peek at her "martyrs to curiosity," Bly reveled in the limelight. In the final stretch of her trip, as she crossed America by train, thick crowds pressed in at each station while Bly shook so many hands that "my arms ached for almost a month afterwards," she reported. It was a "maze of happy greetings, happy wishes, congratulating telegrams, fruit, flowers, loud cheers, wild hurrahs, rapid hand-shaking and a beautiful car filled with fragrant flowers attached to a swift engine." Bisland

had been ahead of Bly in Hong Kong, but she'd missed her connection in Brindisi, and Bly beat her to New York by four days.

As Bly arrived at Pennsylvania Station, the police could hardly contain the crowd. Somebody snatched her gloves and handkerchief as souvenirs. People stood on overturned carriages in the street to see the woman who'd gone around the world. Bly was happy to be home. In some ways, she was extraordinary, but she was also the archetypal American tourist. "There is really not much for Americans to see in the foreign lands," Bly told an interviewer. "They are so very, very slow in Europe and to my mind are behind America in almost everything."

June * BLONDIN CROSSES NIAGARA FALLS

ANCIENT ROME SAW ITS SHARE of tightrope walkers, as did medieval Paris, where the most dashing daredevil descended from the top of Notre-Dame cathedral with a candle in each hand, according to some accounts, gingerly placing a golden crown on the head of Queen Isabella of Bavaria upon landing. In London, diarist Samuel Pepys saw a rope dancer, as they were called in the seventeenth century, "who danced blindfolded on the high rope, and with a boy of 12 years old tied to one of his feet about twenty feet beneath him, dangling as he danced, yet he moved as nimbly as if he had been a feather," he wrote. "Lastly he stood on his head on the top of a very high mast, danced on a rope that was very slack, and finally flew down the perpendicular on his breast, his head foremost, his legs and arms extended."

No one, however, could top the French tightrope walker

Charles Blondin (1824–1897), who announced that he would cross Niagara Falls in the summer of 1859. "Thoughtless people, meaning no special harm, may promise themselves a sort of excitement in looking at a fellow creature in deadly peril and in shuddering through the moments of the indecent exhibition," *The New York Times* chided. They certainly did. Some twenty-five thousand people turned out to see Blondin walk across the 1,100-foot span on a rope stretched 160 feet above the water. The riverbanks above the chasm were packed with picnickers. Brass bands played and banners flew.

The show began at 5:00 p.m., when Blondin appeared on the American side, blond, mustachioed, carrying his balancing pole and wearing tights covered in shining spangles. From far across the falls in Canada he appeared to be "a mere thread over an awful abyss," a reporter noted. "The slightest misstep, the merest dizzi-

ness, the least uncertainty, would cast him at once into the perdition beneath." But Blondin was never uncertain. While crossing, he waved to friends and to a steamboat below. He paused to lie down on the rope and balanced the pole across his chest. He tossed a line down to the boat, and then used it to pull up a bottle, from which he took a sip. And when he'd gone all the way to Canada and back again, the cheering crowd hoisted him onto their shoulders.

All summer long, Blondin crossed the gaping ravine—walking, say, with a sack over his head so he couldn't see, or blindfolded, or, once, in shackles. He turned somersaults on the rope, walked across backward, crossed at night and stood on his head as fireworks blazed all around him. He wasn't done yet. He pushed a wheelbarrow into what appeared to be midair, carting a chair out there and sitting on it midway. He carried a 136-pound man from one side to the other on his back. And once he hauled a cookstove out onto his tightrope, lit a fire, cracked some eggs, and made an omelet. Two ladies fainted when he pretended to slip during another performance. The next summer, he revamped the routine once more, capering on the rope for thousands of admirers, including the visiting Prince of Wales, and making the trip on stilts. "Thank God, it is all over!" the prince said afterward, presenting Blondin with a diamond-encrusted ring.

Blondin, who began walking the tightrope at four years old and traveled the world, continued to perform audacious feats in China, Japan, India, and across Europe until he was well into his

seventies. Whenever he carried people over the falls on his back, he told them to be still, not to choke him—and not to look down. He never admitted to any nervousness whatsoever and usually whistled or hummed as he went. "I have never felt fear," he told a reporter in 1894. "Not even when I first crossed Niagara. Puf. They laughed and said: 'There's a fool of a Frenchman going to commit suicide,' or 'I don't believe he'll ever try,' and so on, but I have crossed Niagara 300 times since then."

 4:20 PM ✳ BICYCLES OVERTAKE THE BOIS

Like Marcel Proust's fictional demimondaine Odette de Crécy, during the mid-nineteenth century, stylish Parisiennes took to the Bois de Boulogne every afternoon around four or five, circling the lake in magnificent carriages or languidly strolling down the Allée des Acacias. Ostensibly, they went to take the air, but, as Proust noted, the chance to see and be seen was the real draw. As if "paying scant attention to the passers-by," he wrote of Odette, who wore a small bunch of violets pinned to her bodice and a pheasant feather in her hat, she walked with her carriage trailing behind her, "as though the important thing for her, her one object in being there, was to take exercise, without thinking that she was seen, and that every head was turned towards her."

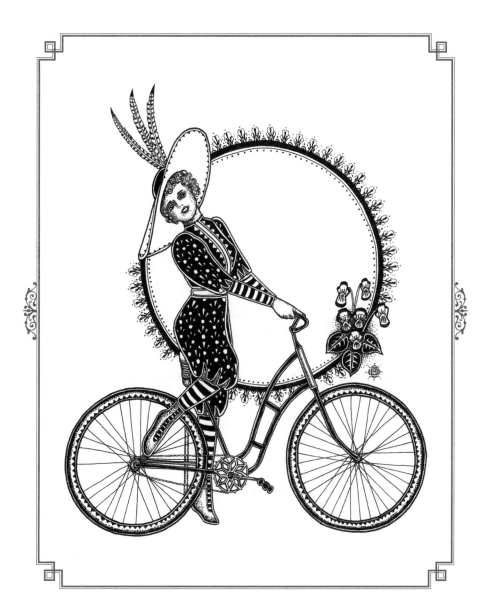

The Bois was the place to flaunt the most outrageous new fashions, as riding in a carriage one could wear an outfit deemed too racy for the street. "In a carriage," explained the Viscountess de Renneville, writing in the mid-1800s, "one can risk any fashionable extravagance and novelty; it is the pedestal of eccentricity: pelisses in muslin, white embroidered dresses, rich silk dresses in soft colors, taffetas with impossible checks, bareges with chantilly flounces, and pompadour or star-speckled tarlatans." Diamonds and emeralds were acceptable in a carriage in the Bois, but never in the morning, or on foot anywhere beyond the park's borders. The women arrived each afternoon via the Champs-Élysées, lined with benches and chairs three deep so the fashion fans could watch them pass.

Then, in the 1890s, the bicycle took off and utterly changed the city's elaborate notions of chic. Parisian socialites thrilled to the new toy, almost immediately abandoning their frothy carriage costumes for scandalously simple biking attire—bloomers and pantaloons. Couturier Charles Frederick Worth offered smart cycling suits, and the minister of the interior lifted a ban on women wearing pants in order to accommodate the fad. "Fashionable women first tried the bicycle in the country in the grounds of the château," a journalist of the era noted. "What could have been in Paris a sinful outrage to the prejudices of good society became possible behind one's own gates. One is not always upon dress parade in the country." Before long, however,

they were back on parade in the Bois, while, as ever, pretending to be there for their health. Madame did not like to be seen around town in her bicycling costume, a writer explained. "So she rides to the Bois in her coupé, and meets the groom who brings her bicycle. The man, if he can ride, follows at a respectful distance, and the return to town is made in the same discreet manner."

As often happened, however, on the other side of the Atlantic such radically fashionable notions did not go over well. "Some people have questioned whether cycling is healthful for women," an American journalist warned in 1892. "Some say that it is too much of an exertion, that it is liable to injure a woman internally, besides being unfeminine and immodest." Cycling had not yet been accepted as the "correct thing," the writer concluded. In Newport, Bar Harbor, and Southampton, society women who'd cycled the Bois in Paris pushed the new style, as locals balked. One early adopter in upstate New York, Huybertie Pruyn, was stopped on the street by several older women while wearing a bicycling suit she'd bought in France. Their advice: get rid of it. "It went down acceptably in Paris—nobody noticed it, but later in Albany it was a sensation," Pruyn recalled. A California dentist refused to pull the tooth of a woman who turned up wearing bloomers, and in Alabama a man attempted suicide because his wife was similarly dressed. "The woman who has the courage of her convictions can put on a pair of bloomers and mount her wheel secure in the conviction that every man she

passes will turn around and look at her," a New York journalist reported.

Harassed in Manhattan's parks, some bloomer-clad women asked their tailors to design bicycle costumes with pockets to hold pistols. Others rode with chaperones. But even in Paris, bloomers could still prove provocative. A young American writing for *The New York Times* in 1900 described her turn in the Bois and the many men who commented as she passed, including one who cycled up beside her, grinning and making certain propositions. She was shocked, having during all her years of cycling in New York endured only the occasional "comment of the butcher boy." She rolled on. In the end, no matter how much attention she attracted, or what the unsavory types had to say, she couldn't imagine life without the freedom of the ride. "I said to myself, in solemn conclave: 'Will you give up riding?'" she wrote. "'Never,' replied myself, 'not for all the contemptible cowards in France who call themselves men!'"

 4:25 PM ✳ RAINBOWS BRIGHTEN THE HORIZON

For thousands of years the mechanics of the rainbow remained a mystery, even to the exalted minds who studied the phenomenon. Aristotle (384–322 BCE), one of the first scholars to devote time

to sky watching, saw two lunar bows during his fifty years. Iraqi mathematician and physician Alhazen (965–1039 CE) continued the study, writing on rainbows, shadows, mirrors, and the Milky Way while under house arrest for failing to dam the Nile by order of the caliph. The thirteenth-century Franciscan scientist, and closet alchemist, Roger Bacon (ca.1220–1292) discovered while at Oxford that the rainbow appeared when there was a span of 42 degrees between the line of sight and the sun's rays. "Each of a hundred men," he explained, "would see a different rainbow, to the center of which his own shadow would point."

Philosopher René Descartes (1596–1650) diminished the rainbow's remaining secrets during the 1620s. Rainbow fountains, like those at the Villa d'Este near Rome, were then de rigueur in Europe's posh gardens. To visitors, such a fountain was "a very great wonder, and those who see it, would swear it were a natural rainbow indeed," one reported, marveling at the colors the fountain threw into the air. Descartes, however, strove to remove any doubts, exposing the fountain's scientific inner workings. He vowed to replace reverence for magical garden design with a respect for math, philosophy, and what he called the "science of miracles," recasting the biblically significant rainbow, and the trick rainbow, as the scientific rainbow, using a glass sphere and methodically laying out a mechanical theory of refraction. His reasoning was too complex for most people. Instead, it was Sir Isaac Newton (1642–1727), offering nonscientists a straightfor-

ward explanation of refraction—and the rainbow—with his *Opticks* in 1704, who would forever after be known as the rainbow killer.

English poets William Wordsworth (1770–1850) and John Keats (1795–1821) and essayist Charles Lamb (1775–1834) debated the issue at a raucous dinner party in London in 1817. Newton's work prized science over poetry, the poetry crowd bemoaned, and his theory promoted just the kind of factual information that disrupted the lyrical flow. Lamb attacked the old scientist, calling him a "fellow who believed nothing unless it was as clear as the three sides of a triangle." Then the trio drank to "Newton's health, and confusion to mathematics!" Keats pressed the subject further in his poem *Lamia,* published in 1820, writing:

> *Do not all charms fly*
> *At the mere touch of cold philosophy?*
> *There was an awful rainbow once in heaven:*
> *We know her woof, her texture; she is given*
> *In the dull catalogue of common things.*
> *Philosophy will clip an Angel's wings,*
> *Conquer all mysteries by rule and line,*
> *Empty the haunted air, and gnomed mine—*
> *Unweave a rainbow. . . .*

Wordsworth, on the other hand, disagreed with his literary peers, arguing that scientific knowledge only enhanced

the artistic imagination, when the two were properly woven together. He held that nothing could dim the rainbow's wondrous power, no matter what our understanding of the laws of light. "My heart leaps up when I behold / A rainbow in the sky," he wrote. "So was it when my life began; / So is it now I am a man. . . ."

4:30 PM ✳ POETS OF THE ORCHID PAVILION

In almost any age there is nothing poets like better than gathering outdoors to muse upon nature and the nature of life over a glass of wine. Their efforts give soul to the landscape and provide an inspiring lens through which to see the world.

These elements came together perfectly one hallowed April afternoon in China in 353 CE during a party hosted by the acclaimed calligrapher Wang Xizhi (ca.303–ca.361), who turned the gathering into a legend with his remembrance of it, a beloved example of ancient Chinese prose.

Wang Xizhi had invited forty-one friends to celebrate the Bathing Festival in his country garden in the mountains near what is now Shaoxing, Zhejiang. In the Orchid Pavilion, the group lounged beside a "swirling, splashing stream, wonderfully clear, which curved round it like a ribbon," and they played an old game,

challenging each other to create a perfect poem in the amount of time it took a floating wine cup to drift on the stream's gentle current from one player to the next. When the cup arrived, each player held forth with an attempt at spontaneous verse, then drank the contents. "I release my pent-up feelings / Among these hills and streams; / Serenely I abandon all restraints," one of the poets sang. And then he drank down his wine. Another chimed in: "All my hopes and longings / Have as their limit / These mountains and streams." And he snatched up a cup. Then came poet Yu Yue's elegant response, "My spirit glides / Between heaven and earth." It was a great day for feeling free.

Wang Xizhi collected all their poetic efforts—only twenty-six guests were up to the task—into a treasured volume of early Chinese poetry, creating a cult of the Orchid Pavilion in generations to come. The party was depicted in scrolls and paintings in China and in Japan. Garden designers created pavilions with special "wine-cup streams" built into their floors.

In those days, landscape painting, gardening, calligraphy, and poetry were so closely intertwined that to truly excel in any of the arts, an artist needed intimate knowledge of each. Literary scholars were asked to name the most striking aspects of an important garden. An especially nice spot, for example, might be dubbed the Place for Listening to the Sighing Pines, Lotus Cove, or the Place of Clear Meditation. "If we leave the chief sights and pavilions without a single name or couplet," a writer explained,

"the garden, however lovely with its flowers and willows, rocks and streams, cannot fully reveal its charm." Signs printed with poetry hung in the gardens. Polished rocks were inscribed with a few lines of verse.

Composing poetry and creating a garden represented the same urge to merge with the natural world. "This was a day when the sky was bright and the air was pure. A gentle breeze warmed us," Wang wrote of that hallowed afternoon by the Orchid Pavilion's stream. "Upwards we gazed to contemplate the immensity of the universe; downwards we peered to scrutinize the abundance of living things. In this way, we let our eyes roam and our emotions become aroused so that we enjoyed to the fullest these sights and sounds. This was happiness, indeed!"

 4:45 PM ✳ TRAMP POETS SEEK SHELTER

A certain type of American adventurer—the tramp poet—spent his afternoons searching for a snug, dry place to spend the night on the road. After drifting through art school, poet Vachel Lindsay (1879–1931) set out tramping in the summer of 1912. He meandered on foot for hundreds of miles, from his hometown of Springfield, Illinois, to Missouri, through Kansas, up and down Colorado, and into New Mexico, boyishly handsome in a yellow

corduroy suit, a fancy sombrero, and a flaming-red tie. All the way, he walked "meditating on the ways of Destiny" and preaching what he called the "Gospel of Beauty," as described in his one-page pamphlet "for making America lovelier," and in a small booklet called "Rhymes to Be Traded for Bread," which he offered to those he met.

Lindsay's was the "church of the open sky," he liked to say, and it was governed by a series of self-imposed rules, which were, basically, to have "nothing to do with cities, railroads, money, baggage or fellow tramps." "I always walked penniless. My baggage was practically nil," he wrote. He recommended that anyone out tramping should seek a big lunch at about ten forty-five in the morning, and start looking for dinner, lodging, and the next morning's breakfast by around a quarter to five. When hungry, he would try some five potential benefactors before finding one who happened to be "in the meal-giving mood." In a letter home to Springfield, he wrote, "if eating were as much in my letters as in my thoughts, this would be nothing but a series of menus!" Sometimes he cut weeds or hoed potatoes for his patrons in return. As for accommodations, competition among tramps on the trail made each night a scramble. Still, as Lindsay described it, life on the road was sweet: "Sleeping in a hay-loft is Romance itself. The alfalfa is soft and fragrant and clean, the wind blows through the big loft doors, the stars shine through the cotton-woods."

For the vagrant poet, encountering the world at large and escaping the suffocation of a monotonous, workaday world was life's aim. Harry Kemp (1883–1960), author of the best-seller *Tramping on Life* (1922), described the horrors of getting caught up in conventionality with this verse:

Now that white sheets have held me
For many a wakeful night,
Convention's bonds have spelled me,
And slain is my delight. . . .

Likewise, some years earlier, in 1884, the twenty-five-year-old writer Charles F. Lummiss (1859–1928) sought bliss in the wilds while trudging cross-country from Ohio to California, a trip of 143 days and 3,507 miles, and a journey "spiced with frequent danger." Alone on the open road, he set his own broken arm and got lost in a blizzard. It was all part of the rush. "I was after neither time nor money, but life—not life in the pathetic meaning of the poor health-seeker, for I was perfectly well and a trained athlete," he explained carefully, "but life in the truer, broader, sweeter sense, the exhilarant joy of living outside the sorry fences of society, living with a perfect body and a wakened mind, a life where brain and brawn, leg and lung all rejoice and grow alert together."

When the English naturalist Robert Hooke published *Micrographia* in 1665, his descriptions of the minuscule life forms he found under the microscope shook the world. Hooke's observations and drawings were not only minute, they were inspired. Under his lens, fleas seemed "adorn'd with a curiously polished suite of sable Armour, neatly jointed." Watching the action magnified, Hooke (1635–1703) let one of the armored creatures shimmy over to his finger to suck his blood. "I could plainly perceive a small current of blood, which came directly from its snout, and past into its belly," he wrote, observing that "there seem'd a contrivance, somewhat resembling a Pump, pair of Bellows, or Heart." He looked at a needle, a grain of sand, and flecks of charcoal, recording each with careful renderings. Nothing like it had ever been seen before. Diarist Samuel Pepys stayed up until two o'clock in the morning poring over *Micrographia,* later reporting to his friends that it was "the most ingenious book that I ever read in my life."

Naturally, curious readers sought entrée to this magical miniature world. In the eighteenth century, lecture demonstrations provided highbrow amusement across Europe, as did scientific toys like the microscope. At court, microscope gazing was all the rage. English poet Stephen Duck (1705–1756) penned a few lines on the subject, dedicated to Queen Caroline:

Dear Madam, did you never gaze,
Thro' Optic-glass, on rotten Cheese?
There, Madam, did you ne'er perceive
A crowd of dwarfish Creatures live?
The little Things, elate with Pride,
Strut to and fro, from Side to Side
In tiny Pomp, and pertly vain,
Lords of their pleasing Orb, they reign
And, fill'd with harden'd Curds and Cream
Think the whole Dairy made for them.

Over the next century, microscopes were built to suit a range of budgets. Some were done in gilt and mahogany. Some were made from cardboard and sold for a penny. Nineteenth-century enthusiasts came together in well-appointed drawing rooms to pass their evenings examining peculiar insects and interesting plants. Like the aquarium, the microscope offered a whole new perspective. It "opened up new regions for observation and has given an entirely new direction to our thoughts," wrote one Cambridge professor. "We are probing more into the very deepest recesses of nature, and enquiring into her closest secrets."

Popular books, such as *Evenings with the Microscope* and *Half-Hours with the Microscope,* guided initiates through a series of micro-revelations. "Like the work of some mighty genie of Oriental fable," wrote the author of the former, "the brazen tube is the

key that unlocks a world of wonder and beauty before invisible, which one who has once gazed upon it can never forget, and never cease to admire." Focusing the eyepiece and using a candle or oil lamp for illumination, microscopists could explore the intricacies of a bee's stinger, a drop of blood, the ravines and gullies of a strand of human hair, or the scales of a flounder, without ever leaving home.

The specimens that most amazed amateurs were the darting "animalcules" found in a droplet of water taken from a vase in which flowers had been left to molder. There was beauty hidden in the decay. "These little creatures prove quite fascinating; and hour after hour will be spent in watching their habits and movements, till the powers of the student are exhausted," chirped the author of *Drops of Water*. "It is a wonderful fact, that a drop of water, exhibiting to the eye only a few particles of vegetation and sand, may, by the aid of a glass, be found to contain a crowd of animated beings, all beautifully and curiously constructed, all enjoying life, and providing for their various wants—their beauty so great, that we can scarcely bear to lose sight of them by withdrawing the eye from the microscope."

Even for a serious scientist like Hooke, the device was no mere tool, but a portal to another plane. "I have often, with wonder and pleasure, in Spring and Summer-time, look'd close to, and diligently on, common Garden mould," he wrote, "and in a very small parcel of it, found such multitudes and diversities of little

reptiles, some in husks, others only creepers, many wing'd, and ready for the Air."

5:35 PM ✳ THE SHADOWS COME ALIVE

In striking contrast to the Western cult of bright lights and shining baubles, Japanese aesthetes have, over the centuries, honored the mystery, subtlety, and beauty of the shadows. In 1933, the novelist Junichiro Tanizaki (1886–1965) contemplated this contrast in his fantastically meandering essay "In Praise of Shadows," which ultimately defended Japan's old ways.

He began by pondering the architectural divide. Western-style glass windows were a world away from the traditional Japanese home, where "the light from the garden steals in but dimly through paper-paneled doors, and it is precisely this indirect light that makes for us the charm of a room." "We do our walls in neutral colors so that the sad, fragile, dying rays can sink into absolute repose," he wrote, whereas light-loving Westerners "paint their ceilings and walls in pale colors to drive out as many of the shadows as they can." And outdoors, "We fill our gardens with dense plantings," while "they spread out a flat expanse of grass." A champion of dim lighting, Tanizaki was once dismayed to find that an esteemed Kyoto restaurant had abandoned candle-

light dining in favor of electric lighting, and he requested a candle at his table instead.

Tanizaki wasn't always such a traditionalist. Though born and raised in Tokyo, as an aspiring writer he fell under the influence of Baudelaire and Poe, and his first stories flaunted a peculiar form of decadence—a predilection for beautiful but cruel women and a deeply rooted foot fetish. He was infatuated with the West in those days, happily anticipating a new wave of Western modernity that would rise in Tokyo after the big 1923 earthquake, one that would bring "orderly thoroughfares, shining, newly-paved streets, a flood of cars, blocks of flats rising floor on floor, level on level in geometrical beauty, and threading through the city elevated lines, subways, streetcars. Western clothes, Western lifestyles."

But when his vision became reality, instead of embracing aesthetic revolution, Tanizaki fled into the past. "Now that Tokyo has at last become Westernized, I have bit by bit come to dislike the West," he said in 1934. "Instead of pinning my hopes on the future, I think nostalgically of the Tokyo of my childhood." Delving into old Japan, he found an exoticism of the sort he used to seek elsewhere. He visited the ancient sights around Nara and Tokyo like a tourist. He moved to old-fashioned Osaka, and he dressed in a kimono. He scoured the antique shops for dusty artifacts. "As a general matter we find it hard to be really at home with things that shine and glitter," Tanizaki wrote. "On the contrary, we

begin to enjoy [a thing] only when the luster has worn off, when it has begun to take on a dark, smoky patina." Treasured objects in old Japan were those with a "sheen of antiquity" or a "glow of grime" that demonstrated longevity and the nostalgic touch of many hands.

He lived out his later years in the past and made his home in the shadows, cherishing the bygone manners, the half-light, and all that had been lost. "We delight in the mere sight of the delicate glow of fading rays clinging to the surface of a dusky wall," Tanizaki wrote, "there to live out what little life remains to them."

5:40 PM ✳ DIARISTS TAKE NOTE

Sixteenth-century amateur writers tried their hands at travel diaries and modest memoirs, but no one got too personal. That sort of soul-baring journaling wouldn't occur until two hundred years later, as the culture of religious reflection and self-scrutiny encouraged diarists to dig deeper. Over time, the diary became increasingly intimate: a place to reminisce, a record of precious memories and treasured secrets.

Yet well into the nineteenth century, keeping a diary remained a matter of taste and decorum, and experts consistently advised against getting too carried away. "One must not attempt too

much," an American journalist counseled budding diarists in 1883. "A country school-teacher, leading a humdrum life in a little village, does not need a diary large enough to set down the doings of court and king." Instead, one was meant to keep a modest record of payments made, visitors received, books read, letters written, and any change in health. It was all recorded for posterity. "Most people take an interest in the weather," the article went on, and so "it may be well therefore to note first the extreme of temperature." The best time to write in a bedside diary, experts agreed, was in the evening.

And yet, while a mountain of minutiae could be expected of most amateurs, on the contrary, keeping a diary helped novelist Virginia Woolf (1882–1941) cut loose. On the pages of her diary, she set off writing in a "rapid haphazard gallop . . . jerking almost intolerably over the cobbles." Her hand moved over the page faster than her mind could censor it, sweeping up "several stray matters which I should exclude if I hesitated," she wrote, "but which are the diamonds of the dustheap." Most days, after her real day's work, and while taking her tea, Woolf sat down with her diary, sometimes stalling for a few weeks between sessions, only to return again. Over the course of twenty-seven years, she eventually filled twenty-six volumes, with the last entry recorded only several days before her death.

"What sort of diary should I like mine to be?" she mused in 1919. "Something loose knit and yet not slovenly, so elastic that

it will embrace anything, solemn, slight or beautiful that comes into my mind. I should like it to resemble some deep old desk, or capacious hold-all, in which one flings a mass of odds and ends without looking them through. I should like to come back, after a year or two, and find that the collection had sorted itself and refined itself and coalesced, as such deposits so mysteriously do, into a mould, transparent enough to reflect the light of our life, and yet steady, tranquil compounds with the aloofness of a work of art."

SUNSET ✳ GONDOLAS DRIFT

The austere gondola, with its low-slung body and curving prow, has enthralled visitors to Venice since the days when George Gordon, Lord Byron (1788–1824), glided about on the city's canals. Though taking a gondola ride was already a touristy cliché by the 1890s, few could resist it. "There are, of course, many sights in Venice, but I am happy to say we attempted but very few of them, preferring rather to loll on the gondola cushions, and be rowed promiscuously about," an American traveler wrote, "landing where and when the whim took us, and defying the most urgent persuasions of the guide-book or our gondolier to see such and such a palace." As sightseers passed beneath the bridges and

under the balconies of Venice's glorious palazzi, the boat's gentle rhythm lulled them into a stupor. "Reclining luxuriously on the soft, dark-fringed cushions of the night-hued gondola, life and sight-seeing take an altogether different aspect from any other point of view elsewhere," another nineteenth-century visitor wrote. "The feeling that 'it is good to be here' steals over the senses as deliciously as by a magician's enchantment. Existence becomes a never-ceasing, varying dream of dissolving and reshaping views that come and go like beauteous phantoms in the borderland of the material and spiritual worlds."

Around the turn of the century, artists such as John Singer Sargent (1856–1925), who painted hundreds of watercolors reflecting the city's every nook, hired gondoliers to row them to spots where they could best capture the spectral light cast over its waters. One guidebook claimed that any diligent boatman would "wash brushes, clean palettes, and set up the easel in the floating studio which, but for the occasional oscillation, is the most charming form of out-of-door work. He will fetch and carry water for your bath, hunt up models, clean boots and run messages all day long."

It was too good to last. The city's canals thronged with an estimated ten thousand gondolas during the sixteenth century, but by the early 1900s the gondola's days were numbered. Speedy motorboats sputtered and sloshed along the Grand Canal, competing for fares, and by the 1960s the boatyards were building just

a dozen new gondolas each year, leaving only around five hundred on the water.

One of these was more famous than any other of its era—ex-pat American art collector Peggy Guggenheim's sleek black gondola, with seats flanked by a pair of carved golden lions, each holding a trident in its tail. Besides a jaw-dropping collection of Picassos, Mirós, Man Rays, and works by Max Ernst, one of her husbands, the gondola was Guggenheim's great love. "I adore floating to such an extent I can't think of anything as nice since I gave up sex, or rather, since it gave me up," she wrote in 1956 to her old friend Djuna Barnes.

Everyone in town knew Guggenheim (1898–1979), whom Venetians nicknamed "the last duchess." Most evenings at the "irresistible hour," as she called it, just as the sun went down, she would set out from her art-filled eighteenth-century palazzo on the Grand Canal to see the city at its best. "She knew every foot of every back canal," a friend remembered. "She would sit in her little chair with her Lhasa apsos lounging underneath and her gondolier standing behind her on the stern deck, rowing. She'd give him directions with hand signals, as if she were driving a car, without so much as saying a word or looking back at him." The boatman, Bruno, also happened to be the city's corpse collector, and as they rode he serenaded her with funereal dirges.

For Guggenheim, who moved to Venice in 1947, there was nothing like a cruise at sunset. "This is the moment to be on the

water. It is imperative. The canals lure you, call you, cry to you to come and embrace them on a gondola," she wrote. "More pity to those who cannot afford this poetic luxury. In this brief hour all of Venice's intoxicating charm is poured forth on its waters. It is an experience never to be forgotten."

Guggenheim died at age eighty-one and was buried in the garden of her palazzo, alongside her series of beloved small dogs. Hers was the city's last privately owned gondola.

JULY ✳ FRUIT MAKES JAM

SUMMER KICKS OFF THE JAM-MAKING SEASON, first with rhubarb and strawberry preserves, then cherry jam, elderberry conserves, and, finally, quince paste. Now it's the stuff found in any grocery store, but in centuries past, as honey slowly gave way to pricy, imported sugar, which in 1353 Paris could be sold only to aristocrats by law, preserves took on an haute tone. It was said that France's King François I (1494–1547) loved quince paste so much that it brought tears to his eyes. Once, he'd brought some to share with his mistress Madame d'Étampes, when he realized that she had another lover hidden under her bed. Instead of losing it, the king simply slid the sweet dish to his rival as he left, saying, "Here you are, Brissac, everyone has to live!" Clearly, his generosity knew no bounds.

The great Provençal apothecary and mystic Michel de Notredame, aka Nostradamus (1503–1566), loved preserves almost as much. He put out a small book of jam recipes—as well as his book of predictions—in 1555, offering his variations on Middle Eastern recipes that came via Italy and Moorish Spain to France. His own black cherry jelly was "as clear a vermillion as a fine ruby," he bragged, declaring his candied orange peel "excellently tasty." He also offered a Love Jam recipe, which he claimed was so potent that "if a man were to have a little of it in his mouth, and while having it in his mouth kissed a woman, or a woman him, and [he] expelled it with his saliva, putting some of it in the other's mouth, it would suddenly cause . . . a burning of her heart to perform the love-act." (For those inclined to try, the ingredients may prove a hurdle: mandrake apples picked at dawn, the blood of seven male sparrows, and octopus tentacles, combined with honey and various herbs and spices.)

Nostradamus wasn't the only one who believed in the aphrodisiac power of jam, however. One writer of the day referred to a beauty's "marmalade lips," while the term "marmalade-madams" took on a more salacious connotation. English cookbooks offered sensuous jam formulas—which, for the most part, sound more appetizing than the one Nostradamus crafted—including a love potion that called for sugar, quinces, and orange peel scented with musk, ambergris, and spices.

In England, aristocratic devotion to jams and jellies in the

seventeenth century brought noblewomen into the garden and kitchen. At a garden banquet, a lucky diner might find "tarts of divers hues and sundry denominations, conserves of old fruits, foreign and home-bred suckets [citrus peels in syrup], codinacs, marmalades, marchpane [marzipan], sugar-breads, gingerbread, florentines . . . and sundry outlandish confections altogether seasoned with sugar," one connoisseur noted with glee. The most talented dilettantes allowed their recipes to be published: Lady Fettiplace was known for her rose petal jam. Lady Hoby distilled cordials and put up damson preserves. Elizabeth Gray, Countess of Kent, shared a recipe for candied flowers dotted with gold leaf. Lady Leicester did gumballs filled with lemon fondant. For his part, Sir Hugh Plat (1552–1608) compiled a cookbook brimming with confectionary recipes to please his genteel readers, dedicating his work to these "saints to whom I sacrifice perfumes and conserves both plum and pear." Another writer explained: "For country Ladies it is a delightful amusement, both to make the sweetmeats and dress out a dessert, as it depends wholly on fancy, and is attended with but little expense."

Meanwhile, in France, where violet marmalade and candied ribs of lettuce were popular, a Madame Héroard whipped up an excellent apricot syrup, while the Baronne de Montglat became known for her quince jelly. In that country, jam making had reached such heights by the 1640s that King Louis XIII (1601–1643) could often be found in the kitchen making fruity sweets

for the royal party. According to legend, he candied a plate of sweetmeats for Anne of Austria after their wedding, and while making preserves one afternoon he learned of the betrayal of Cinq-Mars, his former best friend (and possible lover), who had joined in a plot to assassinate the king's most important political adviser, hoping to take the post himself. "Cinq-Mars," Louis proclaimed grandly, "has a soul as black as the bottom of this pan."

Easiest Raspberry Jam

2 pints fresh raspberries (4 cups)
1⅓ cups sugar
Freshly squeezed juice from half a lime

Put a small saucer in the freezer. In a stainless-steel pot, mash together the berries, sugar, and juice and let the mash marinate for 10 minutes. Then heat it over a medium flame, stirring constantly. Once you've reached the boiling point, continue for 10–12 minutes more. Turn off the heat. Drizzle a few drops of jam onto the cold saucer and freeze it for one minute. If the texture of the jam is right when you pull the plate from the freezer, then spoon your jam into airtight jars, leaving ¼ inch of head-room at the top. If the jam's too thin, reboil the mix for another minute, stirring constantly, and try the saucer test again. Once cooled, the jam will keep in the refrigerator for a month.

The gracious porticoes enjoyed by ancient Romans so impressed sixteenth-century Venetian architect Andrea Palladio (1508–1580) that he rarely designed a palazzo without one. When the English neoclassicists fell for his style two hundred years later, they wholeheartedly adopted Palladio's signature touch—the porch, or "verandah," as they liked to call it. The English climate didn't encourage loads of lounging outdoors, of course, but in the sunny United States the front porch became a national touchstone.

The old Italian tradition and its English interpretation blended in eighteenth-century America with the influences of precolonial African architecture, and that of the Dutch, who had built porches since the medieval era and who introduced the *stoep,* or "stoop," to New York. All at once in the 1740s, every proper American house had to have a sitting porch, also known as a "piazza," a place to watch the world go by. Boston artist John Singelton Copley (1738–1815) discovered the "peazer," or "peaza," as he alternately called it, on a trip to New York, writing to his half brother, "Peazas are so cool in Summer and in Winter break off the storms so much that I think I should not be able to like a house without." Pattern books, which helped carpenters and clients select building details, promoted the plan, and by the mid-nineteenth century the porch was ubiquitous.

The myth of the American porch gained traction, as celebrated by writers—including William Faulkner, Eudora Welty, Carson McCullers, Edith Wharton, and Ernest Hemingway—who gave the porch a nostalgic, romantic aura. Washington Irving (1783–1859) loved to sit on the porch, as he wrote, "with a book in my hand, sometimes reading, sometimes musing on the landscape, and sometimes dozing and mixing all up in a pleasant dream." On balmy evenings it offered refuge from the kitchen's heat. But the porch was also the semiprivate, semidark spot where courting couples—including Zelda Sayre (1900–1948) and F. Scott Fitzgerald (1896–1940)—sipped icy lemonade and made their whispered declarations.

Scott and Zelda met on the verandah of the Montgomery, Alabama, country club in the summer of 1918, when Scott, then a dashing twenty-two-year-old army lieutenant, cut in on a dance with the beautiful and audacious Zelda. She had a face like "a saint, a Viking Madonna," Fitzgerald noted. They spent the rest of the summer on her parents' porch, swinging in the evenings, discussing poetry, and drinking in the scent of honeysuckle that wafted from the garden. And falling in love. "Without you dearest dearest I couldn't see or hear or feel or think—or live," Zelda would later tell him. "I love you so and I'm never in all our lives going to let us be apart another night."

After a tumultuous courtship, Scott and Zelda were married two years later in a quiet ceremony in New York. After not

so quietly leaving a string of hotels—they were thrown out of the Waldorf for dancing on the tables—the Fitzgeralds rented a gray-shingled farmhouse in Westport, Connecticut, where Scott began his second semi-autobiographical novel, *The Beautiful and the Damned*.

In that book, a young couple rather like the Fitzgeralds rent a little gray house in Westport. Sitting close together on the porch in the evenings, they watch the light, Scott wrote. "They would wait for the moon to stream across the silver acres of farmland, jump a thick wood, and tumble waves of radiance at their feet."

6:50 PM ✳ STREETLIGHTS FLICKER

As early as 1415, London's mayor ordered lanterns made of transparent horn to be hung in front of houses along the major roads, to light the way on winter evenings. Apart from similar efforts in other cities, the only other glow brightening dark European streets through the sixteenth century came from the occasional lantern carried by a night watchman or the fire burning outside his guardhouse. These civic efforts created a cozy feeling, sure, but could hardly be considered lighting.

Then, in the eighteenth century, the urban nightscape was

transformed. In 1736, London's administration paid for four thousand hours of night lighting, compared to only three hundred hours several decades before. Philadelphia lit up, and Boston too. New York City required every seventh house to display a candle, lit during the "Dark Time of the Moon." When candles and oil lamps gave way to gaslight, the streets became ever brighter—and nowhere more so than in Paris, where the number of gaslights grew from 203 to 12,816 over a span of four years. "Right in the middle of the heart of the city there appears a golden dot, another one here, a third there, a fourth—one cannot say how quickly they follow one another, they can no longer be counted," German poet Julius Rodenberg (1831–1914) wrote. "The whole of Paris is studded with golden dots, as closely as a velvet gown with gold glitter. Soon they wink and twinkle everywhere, and you cannot imagine anything more beautiful, and yet the most beautiful is still to come. Out of the dots emerge lines, and from the lines, figures, spark lining up with spark, and as far as the eye can see are endless avenues of light."

Even those miraculous twinklings couldn't compare with the effects of electrical lighting only a few decades later. "One could in fact have believed that the sun had risen," a journalist wrote, reporting on scientific experiments with outdoor arc lighting in Lyon in 1855. "The light, which flooded a large area, was so strong that ladies opened up their umbrellas—not as a tribute to the

inventors, but in order to protect themselves from the rays of this mysterious new sun."

As demand for the technology grew, many resisted electricity's brilliant new glow. It was just too bright. It lent a "corpse-like quality" to those subjected to its glare, one Londoner argued, and it could make a crowd look "almost dangerous and garish." Robert Louis Stevenson penned "A Plea for Gas Lamps" in 1878, hoping to dissuade London's authorities from installing obnoxious electric streetlamps like those in Paris. "A new sort of urban star now shines out nightly," he wrote, "horrible, unearthly, obnoxious to the human eye; a lamp for a nightmare!"

Stevenson did not get his way. Electricity seduced the masses, especially those who had basked in the glow of Paris's Avenue de l'Opéra, lit by giant arc lamps every 150 feet. "The effect is magnificent," wrote a visitor, "and at this moment there exists nothing in this city of splendid effects to compare with this magical scene." In 1885, the French architect Jules Bourdais (1835–1915) hoped to take France's love of electrical lighting to its logical conclusion when he proposed a twelve-hundred-foot-high Sun Column to the Universal Exposition's planning commission. His ornate granite tower, to be constructed near the Pont-Neuf, would house a museum of electricity at its base, and, topped with a giant, high-powered searchlight and parabolic mirrors, light up the entire city. Exhibition planners, perhaps wisely, decided to go with Gustave Eiffel's tower instead.

Used in ancient Egypt as early as 1500 BCE, incense sanctified religious rites throughout Asia and the Middle East, but also presented an ingenious way to measure time. Chinese sailors burnt incense at sea, using the smoldering sticks as an indicator for when to change course. The Chinese phrase meaning "in the time it takes to burn an incense stick" became popular, and smart incense-makers marked sticks with graduated timelines, which meant that an alarm clock could be fashioned by tying a small bronze bell to either end of a short silk thread draped over a slow-burning stick. The ember end burnt down until it reached the thread, then sizzled through, letting the bells fall into a bronze bowl with a rousing clang. Another kind of incense, elaborately designed lozenges, emitted differently scented or colored smoke as the time passed.

But beyond its practical uses, the true allure of incense lies in its olfactory charms. Chinese courtiers of the T'ang era (618–907 CE) crumbled bits of incense into their love potions and perfumed their homes with incense fumes, favoring anise, basil, ambergris, civet, clove, frankincense, jasmine, and sandalwood. An old sage wrote: "The use of incense gives manifold benefits. . . . At the dead of night, when the morning moon is in the sky, [those of the] artistic and sad poetical fold burn incense, and

their hearts are elated and they whistle carelessly. By the bright window copying old famous scrolls, or leisurely humming, fly-whisk in hand, or when reading at night under the lamp, incense is burned to drive away the demon of sleepiness. Therefore incense may be called the 'Old Companion of the Moon.' "

In Heian era Japan (794–1185), courtiers crafted their own incense blends, competing to develop new scents. The diarist and poet Sei Shonagon (ca.966–1013) wrote: "To wash one's hair, make one's toilet, and put on scented robes; even if not a soul sees one, these preparations still produce an inner pleasure." Those swooning in the smoke spoke of "listening" to incense, and some enjoyed the scents so deeply that sniffing the fumes became a pastime in itself.

Before long, sweet-smelling aristocrats played at identifying different types of incense from the odors alone, assigning them historically suggestive, lyrical new names. Their innocent delight became something of an obsession in the fifteenth century, when connoisseurs and collectors invented *koh-do,* the "Way of Incense," a ritualistic game that had almost as many formal rules as a tea ceremony: no one could disturb the air by opening a door or a window, for example, and polite competitors kept unneces-sary conversation to a minimum.

In preparation, participants bathed and dressed in unscented clothing and ate only light foods. Then, burning a series of sticks, the host tested their knowledge. Before hazarding a guess, true

aesthetes took no less than three inhalations of an offered scent, and no more than five. Sometimes they came up with a new name altogether, flaunting their knowledge of ancient poetry. A particularly evocative scent might be called Moonlight on the Couch, echoing a few well-known lines of verse: "Dark shadows of the moonlight / Cast athwart my couch, / Sink deep into my being." Evocative and sensuous, incense reached the height of its popularity in Japan in the eighteenth century, when courtesans traded incense sticks with their suitors at the end of the night.

7:00 PM ✳ OPERA FANS MAKE AN ENTRANCE

It wasn't chic to arrive on time, and it was unseemly to stay till the end, but attendance at the Paris Opéra was imperative for the city's fashionable swans and gentlemen of the eighteenth and nineteenth centuries. During the season, patrons poured through the opera house doors in London and later New York, perhaps stopping briefly for a shoeshine before making their way to the luxe box seats. "Society goes to the opera to see and be seen," an American proclaimed. "It goes to exchange gossip, to chatter about the things of the day, to criticise a fashion, or a book, or a new preacher." Rarely, however, did the operagoers pay much attention to the action on the stage. As the ravishing eighteenth-

century Venetian Giustiniana Wynne noted, she and her sisters were "the real show" at the opera in Turin. (Casanova, who visited her family's opera box, confirmed as much.) And why not? During the course of the season in Italy, a dedicated attendee might watch the same opera for thirty consecutive performances.

In those days, a lady treated her theater box as an extension of her salon. Meanwhile, the men worked the crowd, coming and going, and, in London, dropping by "fop allies," the aisles surrounding the orchestra section, or the "pit," where they made romantic assignations. Sometimes, in their wandering, they even bumbled out onto the stage. "Some of our young Sprigs of Fashion made a point of sporting their persons so prominent on the Stage, as to spoil the effect of the representation," an English critic huffed in 1794.

But London's young sprigs had nothing on the Italian crowd. Italy's theaters were known as the most ornate but also the rowdiest in Europe. Upper-crust patrons ate, drank, gambled, gossiped, read, and even brawled in their boxes. "The noise here during the performance was abominable," wrote an English visitor to Milan, "except while two or three airs and a duet were singing, with which every one was in raptures." Similar conditions were reported from Naples to Rome to Venice. German composer Richard Wagner (1813–1883) fretted over what he saw as the Italian audience's indifference. "During the conversation

and visits paid from box to box the music still went on, with the same office one assigns to table music at grand dinners, namely to encourage by its noise the otherwise timid talk," he snipped. Likewise, French composer Hector Berlioz (1803–1869) was stunned to witness a Milanese audience "full of people talking in normal voices," he wrote in 1832. "The singers, undeterred, gesticulated and yelled their lungs out in the strictest spirit of rivalry. At least I presumed they did, from their wide-open mouths; but the noise of the audience was such that no sound penetrated except the bass drum." As decibel levels in the box seats hit their highest pitch, pit audiences liked to shout *"Zitti, zitti"*—"Be quiet"—to the rollicking crowd above.

When they deigned to listen, the Italians expressed their approval with uproarious applause. Sometimes, after an especially rousing phrase or high note, they'd interrupt the singers to demand that the choice bit be sung once again—or even twice. "In the second act the singers themselves wept and carried their audiences along with them so that in the happy days of carnival, tears were continually being wiped away in boxes and parquet alike," an aficionado wrote of performances of *La Sonnambula* in Milan in 1830. "I, too, shed tears of emotion and ecstasy." They could be just as ruthless when they didn't like what they heard. They hissed. They whistled. They shouted. Composer Felix Mendelssohn (1809–1847) watched horrified as the Roman crowd turned on his colleague Giovanni Pacini during an 1831 premiere.

"Those in the pit stood up, began talking loudly and laughing, and turned their backs to the stage," Mendelssohn wrote.

Usually the scene was statelier when a monarch was in the house, as when Ferdinand II, King of the Two Sicilies, visited Lecce in the mid-1850s. But even his august presence couldn't guarantee decorum. "Ever and anon, as was his wont, he rose to pull up his breeches," an observer remembered. "Each time this happened, presuming he was about to retire, the audience rose with him in unison."

Only opera's true connoisseurs kept above the fray, "several clerics, several shopkeepers, several schoolboys, sucklings of the muses and soldiers just returning from or about to leave for a tour of duty," as a nineteenth-century Parisian described this rare breed. But then, even most rulers and regents were no more absorbed by the opera than their subjects. Sighed Louis XIV (1638–1715), "I do not know how opera, with such perfect music and an altogether regal expenditure, has succeeded in boring me."

7:00 PM ✳ MOVING PICTURES UNFURL

Long before the invention of the movie camera, French-born painter Philippe Jacques de Loutherbourg (1740–1812) created a spectacle that took London by storm. Hired at the Drury Lane

Theatre in the 1770s, de Loutherbourg used silk screens, transparencies, sophisticated lighting techniques, and mechanical models to create elaborate sets and a depth of perspective never seen before. Model ships were perfectly rigged. Lighting effects caused the sun and the moon to rise. "The eye of the spectator might be so effectually deceived in a playhouse as to be induced to take the produce of art for real nature," wrote one critic.

But in the winter of 1781, de Loutherbourg's light-and-pictures production, "Eidophusikon"—an "imitation of Natural Phenomena, represented by Moving Pictures"—caused a sensation of a different order. Staged in a small red-velvet-lined theater in his home, the story was told without actors, only a synthesis of moving lights, transparent panels of stained glass or painted gauze, and pasteboard scenery, embellished with cork, mosses, and lichens, that served as a backdrop for intricately crafted mechanical figurines. Captivated audiences watched an artificial dawn rise over London. They traveled by noon to Tangier, and continued on to Niagara Falls. Picturesque clouds fluttered by on an invisible cloth panel pulled across the top of the stage. One theatergoer recalled a shipwreck scene containing "horrors of wind, hail, thunder, lightning, and the roaring of the waves, with such marvelous imitation of nature, that mariners have declared, whilst viewing the scene, that it amounted to reality." Toward the end of the show, the moon set over Japan's rocky shores, and in the finale Satan massed his troops on the banks of a fiery lake, a scene in

homage to *Paradise Lost*. A critic considered de Loutherbourg's efforts a "new species of painting . . . one of the most remarkable inventions in the art, and one of the most valuable, that ever was made."

Inspired by the production, painter Thomas Gainsborough made a small wooden peep show to display landscapes he'd painted on glass, lit from behind by a candle. Other artists thought bigger, hanging larger-than-life-size transparencies of temples and other follies painted on thin canvas in London's Vauxhall Gardens, turning the place into a nightly wonderland. One artsy entrepreneur took out a patent on a technique for painting a panorama on a 360-degree surface, opening a show in Leicester Square. "I was so captivated by the sight that I held my breath, the better to take in the wonder, the sublimity of it all," raved a viewer. There were cityscapes, naval battles, and natural marvels to see.

In the same spirit in the mid-nineteenth century, American showman John Banvard (1815–1891) traveled the world with a 1,320-foot-long painting of the Mississippi River rolled onto two spindles. Over the course of two hours, he unfurled the mural and spun tales about riverboat pirates while his wife played waltzes on the piano. "You flit by a rice swamp, catch a glimpse of a jungle, dwell for an instant on a prairie," a viewer wrote, "and are lost in admiration at the varied dress, in which, in the Western world, Nature delights to attire herself." Likewise, the Mareorama,

erected near the Paris Exposition in 1900, titillated visitors, who watched painted views of the Mediterranean roll past while standing on the deck of an enormous, pitching model steamship. Sure, it was fun, but such spectacles provided "solid intellectual entertainment instead of light frivolous buffoonery," an ad promised, "something that when you shall have returned home you can say, I have added a great deal to my stock of information, I have a better idea of certain things—I am more qualified than before to give an opinion on that subject."

This was all mild amusement, however, compared to the over-the-top, three-day masquerade party—the "voluptuous festival"—that English novelist William Beckford (1760–1844) threw to celebrate his twenty-first birthday. Beckford hired de Loutherbourg to transform his family's country estate into a fantasyland, a series of grottoes and temples with an ancient Middle Eastern–cum–Egyptian bent—dim, hung with gauzy cloth, and exotically perfumed. "I still feel warmed and irradiated by the recollections of that strange, necromantic light which de Loutherbourg had thrown over what absolutely appeared a realm of Fairy or rather, perhaps, a Deamon Temple deep beneath the earth set apart from tremendous mysteries," Beckford remembered years later. That shadowy realm perfectly suited de Loutherbourg's tastes: he would eventually achieve infamy as the charlatan occultist Count Cagliostro's right-hand man, and later, after the count swindled him, too, set off on his own as a mystical healer and pharmacist until a mob shut him down.

At the Beckford fête, the artist rigged things so that not a single ray of natural light intruded on guests, who knew not the time of day, nor what day it was, for that matter. "Delightful indeed were these romantic wanderings—delightful the straying about this little interior world of exclusive happiness," Beckford recalled. "The glowing haze investing every object, the mystic look, the vastness, the intricacy of this vaulted labyrinth occasioned so bewildering an effect that it became impossible for anyone to define—at the moment—where he stood, where he had been, or to whither he was wandering."

7:00 PM ✳ SARAH BERNHARDT PLAYS HAMLET

When the English king Charles II ended a ban that kept women from the stage in the seventeenth century, he certainly didn't imagine that they'd soon take on men's parts—"breeches roles"— too. After the actress Fanny Furnival appeared as Hamlet in 1741, in Dublin, a flurry of imitators followed, with more than a hundred European and American actresses playing Shakespeare's Prince of Denmark in the nineteenth century. Such roles offered a challenge, but also an opportunity to show a little leg. "Next to wearing trousers themselves, women dote upon seeing the actresses who look well in these forbidden treasures," a writer explained, musing on the allure of a cross-dressing star. "With

eagerness painful in its intensity they watch her or him light the inevitable cigarette and strut across the stage. They turn to each other and say 'How awfully cute!' or 'Did you ever see anything so cunning?' with a fervency of admiration never bestowed upon a male favorite." The gender reversal could also affect artistic interpretation. Victorian stagings played up Hamlet's alleged feminine side, his introspectiveness, indecisiveness, and melancholy. Taking a gutsier approach, actress Charlotte Cushman (1816–1876) borrowed the costume from her chief male rival in 1861 and played Hamlet not as a sensitive, brooding romantic, but as a feisty, full-blooded male.

And yet, none made as strong an impression as French actress Sarah Bernhardt (1844–1923), who suited up in tights and a doublet to play Hamlet in 1899. "No female character has opened up a field so large for the exploration of sensations and human sor-

rows," Bernhardt claimed. To her mind, she was perfectly cast. "A boy of twenty cannot understand the philosophy of Hamlet," the fifty-five-year-old actress huffed. An older male actor "does not look the boy, nor has he the ready adaptability of the woman, who can combine the light carriage of youth with . . . mature thought."

Despite her daring career choices, Bernhardt, who kept exotic pets, posed nude for photographer Nadar, befriended famous lesbians, and liked to sleep in a coffin, could be quite conservative in her views. She wore pants while working in her sculpture studio, but scoffed at the idea of sporting fashionable pantaloons or riding a bicycle. "All my feminine instincts plead for the dress, the long dress," she told a reporter. She hardly needed to convince anyone that she was all woman, *la grande séductrice*. Artists, poets, feminists, and stuffy politicians alike worshipped her. Once, seeing her act in Sacramento, admiring cowboys went outside during the intermission to shoot off their guns. She was, as a critic explained, "a woman although she has the energy and courage of a man. And it is precisely in this that she is truly unique and incomparable."

Bernhardt's performance in *Hamlet,* in an adaptation that premiered in Paris, was a five-hour marathon that went on past midnight and was controversial from the start. Instead of reprising Cushman's swagger, Bernhardt's Hamlet was energetic and boyish. "No male actor ever came near Sarah in this part," *The New York Times* raved. "There is precisely a point of femininity in the

character which the male full-grown artist has invariably missed, and which is part and parcel of its youthfulness." Not everyone agreed. Poet Catulle Mendès (1841–1909), for example, told journalist Georges Vanor that Bernhardt, with her whippet-thin figure, was the ideal Hamlet. Vanor, however, countered that the perfect Hamlet was a portly one. Their discussion grew intense. Each man stood his ground. Finally, Mendès slapped Vanor. The two dueled, with Mendès taking a serious hit to the stomach. While he recovered, Bernhardt visited to offer comfort. "Fat!" Mendès cried, still agitated. "What heresy!"

When she took her act on the road, the critics in London were just as divided. Some cheered Bernhardt's efforts, and just as many dismissed the performance, with one claiming, "There was no more poetry in her Hamlet than there is milk in a male tiger." Another remarked that "no amount of make-believe will persuade you that Mme. Bernhardt's Hamlet is any one but Mme. Bernhardt, disguised in flaxen wig and inky cloak and customary suit of solemn black." A third spent his long hours in the theater desperately holding back his laughter. "One laugh in that dangerous atmosphere, and the whole structure of polite solemnity would have toppled down, burying beneath its ruins the national reputation for good manners. I therefore, like every one else, kept an iron control upon the corners of my lips."

For Bernhardt, of course, Hamlet was no joke. The next year, the actress sculpted her hair into a pseudo-pompadour to play

Napoleon's nephew in Rostand's *L'Aiglon*. She took the male lead in Goethe's *Werther* in 1903, and played the Prince in Maeterlinck's *Pelléas et Mélisande* the year after. "It is not sufficient to look the man, to move like a man, and to speak like a man," she told a reporter. "The actress must think and feel like a man, to receive impressions as a man, and to exert that innate something which, for want of a better word, we call magnetism, just as a man unconsciously exerts it."

7:00 PM ✳ LET THE HANKY-PANKY BEGIN

Ancient Egypt's magicians were notoriously crafty, known for their ability to conjure spirits, or at least their ability to project mirrored images onto incense smoke. During the early Christian era, jugglers and sleight-of-hand magicians suffered a bad reputation as quick-handed gamblers and pickpockets. By the reign of England's Queen Elizabeth I, they were classified officially alongside "ruffians, blasphemers, thieves, vagabonds." However, writers such as Reginald Scot (1538–1599), author of *The Discovery of Witchcraft*, attempted to disassociate the unholy supernatural from sleight-of-hand magic, describing various tricks in print. Of secreting a ball in the palm of the hand Scot wrote: "You must take heed that you be close and sly: or else you discredit the art. . . .

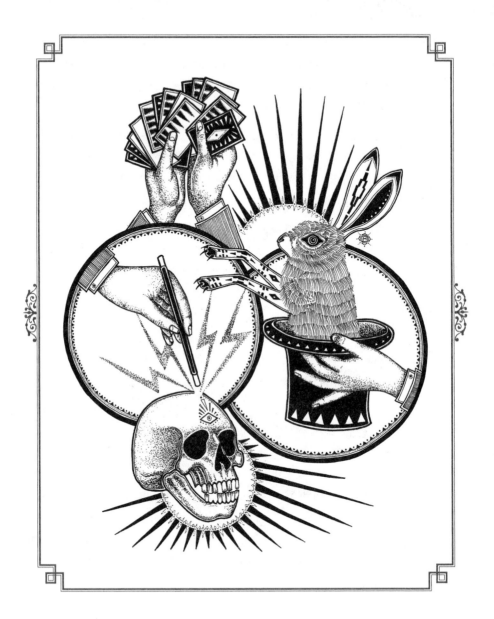

These feats are nimbly, cleanly, & swiftly to be concealed, so as the eyes of the beholders may not discern or perceive the drift." His description evoked the pleasures of what was then known as "hanky-panky," a phrase some etymologists believe was borrowed from the Romany *hakkni panki,* for "sleight of hand" or "trickery."

In the next century, as reason trounced superstition, conjurors entered Europe's royal courts, wooing the curious at theaters, taverns, and fairs with magic lantern shows, juggling, ventriloquism, automata, and good old hanky-panky. One of the most popular tricks was to make an object appear to leap with the aid of a hidden string. "This feat is the stranger if it be done by night," suggested the English magician William Vincent, aka Hocus Pocus, "a candle placed between the lookers on & the juggler for by that means their eyesight is hindered from discerning the conceit."

In the eighteenth century, the gentlemanly English conjuror Isaac Fawkes (ca.1675–1732) performed for the royal family. With his well-loved Egg-Bag trick, he showed his audience an apparently empty sack that, when turned inside out, spat forth eggs, silver, gold, and even live hens. "He was so great a Magician, that either by the Force of his Hocus-Pocus Power, or by the Influence of his Conjuring Wand, he could presently assemble a multitude of People together, to admire the Phantoms he raised before them, viz. Trees to bear Fruit in an instant, Fowls of all sorts, change Cards into Birds, give us Prospects of fine Places out of

nothing, and a merry jig without either a Fiddler or a Piper," an admirer wrote.

The next great conjuror, the Tuscan Giuseppe Pinetti de Wildale, known as Pinetti (1750–1800), afforded magic its fashionable pizzazz. Pinetti crisscrossed Europe in a carriage drawn by four white horses and wore lavish gold-trimmed suits, which he changed several times during his show. He had some talent, too, once causing the shirt of one of the men in his audience to disappear. He was a little clumsy, however, and his tricks didn't always succeed.

On the other hand, Frenchman Jean-Eugène Robert-Houdin (1805–1871), one of the most convincing magicians of all time, was both stylish and suave, drawing large crowds to his Soirées Fantastiques in Paris in 1845. Robert-Houdin's stage was decorated like a smart, Louis XV salon, and the magician, born into a family of clock makers, wore elegant evening dress and carried an ivory-tipped ebony wand, which soon became the staple prop of magicians everywhere. His show included a child-size mechanical acrobat that dangled from a trapeze, did the splits, and danced, and a mechanical pastry chef that passed out treats. Using an elaborate linguistic code and plants in the audience, as well as a secreted telegraphing apparatus, Robert-Houdin performed impressive "mind-reading" tricks, but his most spectacular stunt involved an artificial orange tree. Among its branches pistons turned to reveal real oranges hidden behind faux foliage. Flow-

ers bloomed. Butterflies flitted to the heights. And then, from a fruit that had miraculously split itself into sections, he withdrew a handkerchief borrowed earlier from the audience. It was incredible.

Still, even the magical genius Robert-Houdin had the occasional off day. Once he had borrowed a top hat from an audience member and set out to do his old Omlet-in-the-Hat trick—breaking and beating the eggs into the hat, sprinkling them with salt and pepper—when he found himself in a jam. "I placed a candle on the ground, then, holding the hat sufficiently high above it to escape the flame, I began turning it gently round," he wrote in his memoirs. The audience roared with laughter. The candle was snuffed—the hat was smoldering. The show went on, the great magician producing with a flourish the "splendidly cooked omelet," which, he wrote, "I had enough courage left to season with a few jokes."

THE MAGIC APPLE

Master conjurer Harry Houdini (1874–1926) wrote about this trick in 1861, instructing readers to pass a needle and thread under the skin of an apple, carefully stitching all the way around the circumference of the fruit in a line, and cleverly hiding each stitch by reentering the exit holes. "Then take both ends of the thread in your hands," he continued, "and carefully pull them, so as to draw the middle por-

tion of the thread through the apple, which will then divide into two parts." The skin remains intact as the taut thread splits the apple's flesh underneath. When an unsuspecting friend peels the fruit or takes a bite, he or she will find that the apple has been mysteriously pre-sliced. Magic.

7:30 PM ✳ LADIES AND GENTS DRESS FOR DINNER

The "gong-man" in any proper English country estate of the nineteenth century sounded the dressing bell at seven o'clock, signaling guests that they had an hour to dress before dinner. But during the Gilded Age, even middle-class Americans took up the habit of changing clothes before sitting down for their evening meal. The women wore low-cut gowns, and the men wore tails. "No one need deprive themselves under any conditions of the pleasure of dressing for dinner," an American etiquette writer of the era noted. "It is a mistake to think that it is a custom only meant for the wealthy, it is within the reach of all. Let people try it who are not rich. There are all ways of dressing for dinner, and the more elaborate styles can be kept for the more state occasions." She went on to note the hygienic benefits of changing out of street clothes before a meal, "even if accomplished with tired hands and irritable nerves," and touted the overall healthful effects of

dressing well. "Can it be disputed that nice surroundings keep the temper cool and smooth, calm the dreadfully-strung nerves, and hence help the digestion?"

While women seemed, for the most part, happy enough to do their duty, men questioned the practice. "It does seem rather absurd to compel a man, as at least two wives of hard-working businessmen have compelled their husbands for years, to renew his entire apparel in order to partake of a simple dinner of soup, joint, and dessert (probably pie), and served, as it is in one of these instances, by the cook," a *New York Times* writer huffed in 1893, calling those men either idiots or saints. And yet the same writer concluded that ultimately, "it is certainly desirable to make as much of the daily festival of dinner as possible."

Maneuvering in that strict milieu, it was easy enough for party-goer Griswold Lorillard to stun New Yorkers at 1886's Autumn Ball in Tuxedo Park by sporting a semiformal scarlet short jacket, like those he'd seen worn by British clubmen. He looked "for all the world like a royal footman," a gossip columnist hissed, suggesting that perhaps Lorillard should try a straitjacket next time. The trend had been inspired by the casual smoking jackets worn by the Prince of Wales, later King Edward VII (1841–1910), but, when worn to dinner, until 1920 similar jackets were deemed too casual by most. When ladies were present at the dinner table, a tailcoat and white tie were the uniform for the upper echelons. Black tie was acceptable when dining in all-male company.

Between the wars, things got loose, but it was only during World War II that haute New York began dressing down in earnest. "Dressing for dinner has reached its lowest ebb in years among New Yorkers, according to the dry cleaners, who say it must be because of the war," the *Times* reported in 1943. "People used to dress for dinner," sighed Joel Blau, owner of twelve Manhattan dry-cleaning establishments. "We used to get big loads of evening wear in our shops on Mondays. There's hardly any of that now."

AUGUST ✳ RUTH ST. DENIS HEADS EAST

AMERICAN CHOREOGRAPHER RUTH ST. DENIS (1879–1968) left New York for Asia in August of 1925, leading her edgy dance company—including eight young dancers and her husband, dancer-choreographer Ted Shawn—on a marathon fifteen-month tour that crossed Japan, China, Hong Kong, Rangoon, Burma, Malaysia, and beyond. Inspired by American Indian and Japanese folk dances, by Spanish flamenco, and above all by the dances of India, St. Denis's mystical yet seductive aesthetic helped pioneer modern dance. For five months the troupe lived in India, which St. Denis considered her spiritual home, putting on more than a hundred shows—but not without an initial sense of trepidation. Performing her Indian dances in India was a bit like "bringing coals to Newcastle," St. Denis worried. Though she'd looked at pictures and watched a "nautch" dancer at Coney Island, she'd

never seen an actual Indian dance before. Truth be told, she'd
started her career back in New Jersey as fifteen-year-old Ruthie
Dennis, shimmying and shaking in a rinky-dink variety show
alongside an albino musician and a trick dog named Lillie.

The break that took her from vaudeville to the upper tiers was
her Indian-esque *Radha*. The dance began with a bare-midriffed
St. Denis posing as the Hindu goddess, flowers in her hair,
bracelets up her arms, wearing a gauzy skirt, and, most shock-
ingly, barefoot—something polite audience members had never
seen onstage in 1906. After she climbed down from a pedestal,
she performed a series of flourishes, then gave herself over to a
long whirling sequence extolling the "Delirium of the Senses."
She jangled a string of bells. She deeply inhaled the scent of a
marigold garland. She drank from a clay bowl and then spun like
a dervish, finishing in a deep back bend. She knelt on the floor,
hands caressing her body, and ended with her fingertips pressed
to her lips.

The New York Times raved about a Jersey girl who could perform
Hindu temple dances "with a rather convincingly clear notion of
what she is doing," and she became a society darling instantly.
St. Denis produced "a slow, rhythmic succession of graduated
movements that never jerk to extremes, that melt into each other
by easy transition, and that impress one with an almost listless
ease rather than by any suggestion of effort." Another article
trumpeted: "Yes, Society Did Gasp When Radha in Incense-Laden

Air 'Threw Off the Bondage of Earthly Senses.'" Performances sold out, with hundreds of would-be spectators turned away at the door. Sure, the sight of her bare feet was titillating, but as one reviewer crowed, St. Denis herself was so seemingly pure that "every lascivious thought flees shy into the farthest corner," while she "freed our souls from the clutches of everyday life."

Her performance was met with a similarly enthusiastic response in Calcutta, where, costumed in a black wig, bangle bracelets, and an enormous emerald-green circle skirt, St. Denis danced in fluid ripples, spiraling across the stage and concluding with twenty-four spectacular flat-footed turns, anklets jingling as she stamped. Thunderous applause echoed through the Empire Theatre on opening night. "The audience simply yelled," dancer Jane Sherman (1908–2010) remembered, "especially the upper balconies where the poorer Indians sat."

In India, the troupe—a bunch of white, middle-class girls as "homogenized as a bottle of milk," according to Sherman—traveled through the bazaars, into the temples, and down the ghats, marveling at the holy men in loincloths and the women hidden under veils. Along the way, St. Denis invented new dances, like the *Nautch Ballet,* inspired by the bustle she observed at Bombay's Bunnia Bazaar, turbaned Punjabi boys, elegant Sikhs, and women in colorful saris. In her piece, the dancers chattered in loud imitation Hindi, with one carrying a cage of live birds for sale as six girls glided in wearing bright nautch costumes.

British rule had eroded the status of traditional Indian dancers, and by the 1920s, when St. Denis visited India, they were seen as prostitutes. Could it have been any wonder that her homage attracted a full house night after night? Yet, as ever, St. Denis's nautch dance merged the real with the sensual, the earthly with the divine. "In present society in India dancing is not looked upon with too favorable an eye," wrote a critic at the Lahore *Sunday Times*. "The Nautch has unfortunately fallen to the accomplishments of a particular class. But this is not to say that dancing in itself is an art to be condemned. . . . In Bombay last week I saw a remarkable performance by two American dancers, Ruth St. Denis and Ted Shawn. Among the finest of their pieces were the dances of India which deservedly brought down the house."

 8:25 PM ✳ DINNER À L'AVANT-GARDE

Great things can happen when artists, musicians, and poets apply themselves to the art of eating. In the early 1500s, the artistically inclined members of the Company of the Cauldron gathered in Florence for one of the weirdest potlucks on record. Led by the eccentric sculptor Giovanni Francesco Rustici (1474–1554), the diners took their places in a giant cooking pot made to look like a wine vat. Painter Andrea del Sarto (1486–1530) had crafted

an especially creative dish: an edible eight-sided temple supported by sausage columns topped with Parmesan cheese capitals. The structure framed a tableau of cooked birds, beaks open as if caught mid-song, reading sheet music made from lasagna noodles dotted with black peppercorn notes. Rustici, as host, had prepared a statue of Ulysses, molded out of capon meat and posed as if the mythical hero were dipping his father into a pastry kettle. As his guests settled into their own vat, "there rose up in the middle a tree with many branches bearing the supper," painter and art historian Giorgio Vasari (1511–1574) reported. "And then it descended again and brought up a second course, and afterwards a third, and so on, while the servants went around with precious wines and musicians played below."

Rustici, who kept a pet porcupine, was also a founding member of another Florentine dining club, the Company of the Trowel, which indulged in similar endeavors. One night, in the garden behind the house of a charming humpbacked piper called Fe d'Agnolo, club members dressed as workmen constructed a gigantic structure using loaves of bread as bricks and ricotta cheese as mortar, which they slathered on with trowels. "But their building being pronounced badly done, it was condemned to be pulled down," Vasari reported with a chuckle, "upon which they threw themselves upon the materials and devoured them all."

Art and food collided with the same bizarre passion four centuries later when the Futurist movement, led by another set

of Italian artists, pushed gastronomy to its limits. "This Futurist cooking of ours, tuned to high speeds like a motor of a hydroplane, will seem to some trembling traditionalists both mad and dangerous," their leader, poet Filippo Tommaso Marinetti (1876–1944) wrote in the 1930s, "but its ultimate aim is to create a harmony between man's palate and his life today and tomorrow." Honoring that harmony, the artists declared themselves against practicality and tradition, daring even to denounce pasta—that "absurd Italian gastronomic religion"—and thus igniting a national controversy.

Banquets served in Turin at the Futurists' restaurant, the Tavern of the Holy Palate, paid tribute to the unleashed imagination. Dishes were named Railway Disaster, or Keel of Infernal Vessel, or Beautiful Nude Food Portrait—which consisted of "a small crystal bowl full of fresh milk, two boiled capon thighs, the whole scattered with violets." Between courses, diners were encouraged to "let their fingertips feast uninterruptedly on their neighbor's pajamas."

The freakiest fare was "Aerofood," a culinary experience incorporating tactile elements, sounds, and scents. The Aerofood composition created by painter Luigi Fillia (1904–1936) consisted of fruits and vegetables to be eaten with the right hand, "without the help of any cutlery," while the left hand caressed swatches of sandpaper, red silk damask, or black velvet. "Meanwhile the orchestra plays a noisy, wild jazz and waiters spray the napes of diners' necks with a strong perfume of carnations."

Another Aero-dish, consisting of a quarter of a fennel bulb, an olive, and candied fruit, required a similarly eccentric accompaniment. "From some carefully hidden melodious source comes the sound of part of a Wagnerian opera, and, simultaneously, the nimblest and most graceful of the waiters sprays the air with perfume," wrote a journalist who sampled the fare. "Astonishing results: test them and see."

8:40 PM ✳ DINNER À L'ANCIENNE

At ancient Roman banquets, musicians played and dancing girls wriggled, and Emperor Nero (37–68 CE) showered guests with flower petals in his circular dining hall, which "constantly revolved day and night, like the world." It was the sort of decadent act of antiquated imperialism that made a big impression on eighteenth-century Parisian tastemakers such as court painter Élisabeth Vigée-Lebrun (1755–1842) and the notorious gourmand Grimod de La Reynière (1758–1837).

"We ought to try this tonight," Vigée-Lebrun's brother suggested one afternoon in the 1780s, having read aloud a passage in which the Athenian philosopher Anacharsis describes a grand dinner given in the sixth century BCE. With a dozen friends already on their way, Vigée-Lebrun and her brother revamped their menu to include Mediterranean fare and threw a Grecian

soirée that became legend. On arrival, guests were stripped down and re-dressed, in white muslin togas, with the men trading in their formal wigs for laurel wreaths and wiping the white powder from their faces as they "metamorphosed into veritable Athenians," Vigée-Lebrun remembered. To serve their Cyprian wine, she borrowed antique Etruscan vases and cups from a collector friend. One of the guests, a poet, decked out in his laurel crown, recited odes written by Anacreon (ca.582–ca.485 BCE). They all sang, accompanied by a lyre. "I think I never spent a more amusing evening," Vigée-Lebrun concluded. When members of Marie Antoinette's clique asked the painter to do another Greek night for them, she refused.

Her contemporary de La Reynière, however, took inspiration from the ancients' dark side, and from the murderous Roman emperor Domitian (51–96), who threw a chillingly gruesome banquet around 89 CE. In a hall draped in black, Domitian set out gravestone nameplates and served the kind of food reserved for funeral ceremonies. Naked boys painted black flitted past like phantoms "and after circling around the guests in a sinister dance took up their positions at their feet," a witness reported. Domitian spoke of nothing but gore and slaughter throughout the meal. His trembling guests had to wonder if they'd make it out alive.

In homage to Domitian's fearsome vision, in 1783 de La Reynière sent out black-bordered invitations decorated with

a funeral bier, a cross, and candles. As guests entered his ghastly party, a judge tallied the merits of each, then sent them through a pitch-dark room and into the dining hall, which was draped in black and lit by 365 candles. Choirboys wafted funeral incense, and in the center of the table stood a giant sarcophagus. After the meal, for fun, an Italian scientist demonstrated the latest electrical experiments, and the party roared on until seven the next morning.

Thirty years later, de La Reynière went to extremes once more when friends received notices of his death, and a request that they gather for his memorial. The solemn crowd congregated in de La Reynière's sitting room, sharing their sadness and memories, and discussing their friend's peculiarities. Suddenly the dining room doors swung open wide, revealing a sprawling, splendid feast on the table, where de La Reynière himself sat waiting. A tiny coffin stood in front of each guest's plate.

8:55 PM ✳ DESSERTS AFLAME

"Here's the stuff to make you jump! Hokey pokey, a penny a lump!" The cry rang through the summer streets of nineteenth-century New York, as vendors offered up a mini-scoop of sweetened ice milk served on a scrap of paper. ("Hokey pokey" is

thought to be an Americanized version of the Italian *"O, che poco,"* meaning "Oh, how cheap!" or "just a bit.") But while the masses slurped their hokey pokey, the rich gathered at Delmonico's restaurant, where Baked Alaska was the ultimate in sophistication. English writer George Augustus Sala (1828–1895) gave the novel dish a try in 1879. "The nucleus or core of the *entremets* is an ice cream. This is surrounded by an envelope of carefully whipped cream, which, just before the dainty dish is served, is popped into the oven, or is brought under the scorching influence of a red hot salamander," he explained. "So you go on discussing the warm cream soufflé til you come, with somewhat painful suddenness, on the row of ice."

Others found the experience anything but painful. The ice cream novelties of chef Charles Ranhofer (1836–1899) were a specialty of the house at Delmonico's. Ranhofer made mushroom-shaped treats of maraschino ice cream, studding their stalks with grated chocolate in imitation of natural grime. He served "potatoes" of chestnut ice cream and "asparagus" ice cream spears tied with a pink ribbon. His Baked Alaska, or Alaska-Florida, as he called it—a frozen cake topped with banana and vanilla ice creams hidden under a toasted meringue crust—vied for supremacy with the Omelette Norvégienne, another fancy French dessert with a layer of jelly sandwiched between the cake and the ice cream and the meringue.

The novelty of hot-and-cold creations and flaming desserts

piqued the creativity of top chefs in those years. In France, Auguste Escoffier (1846–1935) introduced a flaming ice cream dish called Bombe Nero, and at Monaco's Café de Paris, chef Henri Charpentier (1880–1961) came upon Crêpes Suzette one afternoon when the Prince of Wales, later Edward VII, arrived with a group of friends, including a young girl named Suzette. It should have been a routine lunch, but then something spectacular happened. Charpentier prepared the dessert tableside for the esteemed guests, but in his nervousness while warming the crêpes in orange liqueur sauce over a flame, he sloshed it so that it all caught fire. "I thought I was ruined," he wrote in his memoirs. Then he tried the caramelized concoction. "It was, I thought, the most delicious melody of sweet flavors I had ever tasted." For decades to come, hosts and hostesses would imitate his lucky mistake. Mid-twentieth-century American cooks swooned over flaming desserts like Bananas Foster (bananas and ice cream in a flaming rum sauce), Cherries Jubilee (flambéed cherries with brandy), Grapefruit Flambé, and, once again, Baked Alaska—now ignited.

Still, none were as deceptively simple and as fabulously dramatic as Crêpes Suzette, with its glorious haze of blue flames. As one wit wrote in the 1940s:

No food is quite so debonair,
Nor so imbedded with savoir-faire.

It goes with pearls 'round swan-like necks,
With limousines, five-figure checks.
It matches coats of mink and sable,
And priceless silver on the table.
And yet, withal its rich appeal,
So fitting for a prince's meal,
The fact remains—and what a shame!—It's only
pancakes set aflame.

Crêpes Suzette

FOR THE BATTER, IN A BLENDER OR FOOD PROCESSOR MIX:
1 cup of all-purpose flour (or gluten-free substitute plus
 xanthan gum)
¾ cup whole milk
¼ cup water
2 eggs
2 tablespoons melted butter
Dash of salt
2 teaspoons sugar
¾ teaspoon almond extract

Add another ¼ to ½ cup of water a bit at a time until the batter has the
consistency of heavy cream. Store the batter in a jar and let sit for at least
2 hours.

12 sugar cubes

2 beautiful organic oranges

4 tablespoons sugar

1 stick of butter, cut into pieces, plus more for pan

1 tablespoon orange liqueur, such as Grand Marnier

Rub the skins of the oranges with the sugar cubes—six cubes for each—working to incorporate all of the precious orange oil into the sugar. Then peel the oranges with a vegetable peeler, taking the flavorful rind, and not the white pith. In a food processor, grind down the two sugars plus the rind, until the mixture is grainy and as fine as can be. Add the butter and the liqueur and process until just smooth.

Make the crêpes in a buttered crêpe pan, or a good frying pan, pouring ¼ to ⅓ cup of batter into the center, then quickly rotating the pan over medium heat to spread the batter into a thin round. Flip the crêpe to cook for a minute or so on both sides until it is flecked with golden brown. Fold each crêpe in half, and then in half again, and set aside.

When the crêpes are all made, use a rubber spatula to smear a teaspoon-size dollop of the orange butter into the center of each. Then refold the crêpes.

FOR THE FINAL STEP:

More butter

More sugar

⅓ cup good cognac

2 tablespoons orange liqueur, such as Grand Marnier

Choose a pan large enough to fit the folded crêpes so that they overlap slightly. (You may need to do two batches—requiring the full amount of liqueur for each—or you may want to use two pans, as an overcrowded pan means bad results.)

In the larger pan (or pans) heat the remaining knob of the orange butter until it's foamy. (It's okay to supplement with regular butter if you've run out of the other.) Arrange the crêpes in the pan, each slightly overlapping with the next. Keep the crêpes heating for a minute or two until everything is all warm and bubbly, but without burning the butter.

Mix the two cooking liqueurs in a cup. Sprinkle the crêpes with sugar. Get a match handy. Sprinkle the crêpes with the cooking liqueurs and then set your dessert on fire! (Please use caution and do not singe your brows!) Have someone flick off the lights immediately as you proudly march into the dining room so that everyone can admire this mysterious halo of blue flames. Voilà!

Makes 18–24 crêpes, serving 6

Gluten-free tip: This is one recipe that is actually better without the wheat. At home we use Bob's Red Mill gluten-free all-purpose baking flour plus ½ teaspoon Bob's Red Mill xanthan gum.

In a transparent vinyl gazebo exploding with rock music, balloons, and confetti, guests at multimedia artist Gerd Stern's 1968 installation *Fanflashstick* writhed under megawatt strobe lights that turned the scene into a series of freeze-frame vignettes. "It's more fun than anything legal I've ever done," a breathless coed in a micro-miniskirt told *The New York Times*. Stern, a groovy, bearded ad agency dropout, was traveling with the piece from one college campus to another and explained that it was meant to expand consciousness and intensify perceptions. "The sensory bombardment tends to break down old patterns," he said.

That very summer, Thomas Wilfred (1889–1968)—the *Times*'s "Giotto of light painting"—died in West Nyack, New York. He'd become famous in the 1920s for his Clavilux, a "color-organ," which, as Wilfred played its keys, projected twinkling shards and dreamy swaths of colored light onto a screen. "Light is the silent universal expression of the greatest force our senses can grasp," Wilfred declared. The audiences at his light concerts were mesmerized. The Clavilux produced "cadenzas of color," a reviewer wrote, "ceaseless rhythmic motions of various colored lights, the changing and fusing of colors, now soft and now intense, whirling and swirling, curling, twisting, gliding and folding." Another claimed loftily that this was "the beginning of the greatest, the

most spiritual and radiant art of all," a genre that promised viewers "that feeling of detachment, of ecstasy, which is a response only to the most solemn religious or aesthetic experience." Wilfred dedicated his life to promoting the new art form, "lumia," as he named it, opening New York's Art Institute of Light in 1930 to teach the discipline that he hoped would grow and thrive. He never found a successor. However, artist James Turrell (1943–), who stunned the art world with his projected light shapes and shadow slabs in Los Angeles that very same summer of 1968, has used light as an artistic medium ever since.

On the promise of Turrell's earliest works, New York gallerist Arne Glimcher (1938–) of Pace Gallery lent the artist enough cash to see him through a year's worth of creation. The result was *Mendota Stoppages,* which the twenty-six-year-old Turrell showed Glimcher the next year. His raw material was the old Mendota, a former Los Angeles motel, whose interior illumination he'd systematically controlled through its windows and doors. These engineered "stoppages" allowed light to enter, or shut it out, casting patterns of light and shadow that played across the motel's walls. It was revolutionary, risky work, and so hopelessly noncommercial that Turrell had to pay back the gallery's advance. Still, during the summer of 1969, Turrell, who would become one of the most important artists of his generation, produced a very different sort of art happening at the Mendota, a kind of anti-*Fanflashstick*.

At 9:00 p.m., viewers arriving at the Mendota were ushered into a room where they sat on chairs. Over the course of the next two hours, Turrell performed the *Stoppages* in ten episodes. First, he turned off the overhead lights. Then he slowly opened the shades of the south window, allowing the colored taillights from passing cars to splash across the walls. During the second episode, he drew up another shade, and light from a streetlamp streamed in to illuminate one corner of the room, "making for more subtle blushes of light," as Turrell explained. Each episode lasted ten to fifteen minutes, depending on how he gauged his audience's waxing or waning attention. Next, he led the viewers to a second, darker room, where they sat on the floor on Japanese tatami mats, watching the ethereal show, swirling with street-lights, stoplights, and the occasional taillights of a bus, which passed with dazzling effect most evenings. Eventually he shut down every stoppage, leaving the audience in complete, silent darkness, an atmosphere that allowed them to experience a physiological phenomenon in which random retinal firings pro-duce chaotic phosphorescent images that keep the eye prepared to perceive light. Some viewers "became very involved in the experience, while others became impatient after a relatively short period," Turrell later recalled. "Those who were more interested saw a better performance."

Eighteenth- and nineteenth-century visitors on the Grand Tour flocked to see Rome's Colosseum by moonlight—preferably under a full moon, in order to best evoke Lord Byron's poetical Manfred, who was transformed by the sight,

> *till the place*
> *Became religion,*
> *and the heart ran o'er*
> *With silent worship of the great of old. . . .*

With a reverence for those great old days, German poet Johann Wolfgang von Goethe (1749–1832) took in the famed ruins under a full moon in 1787. "Of the beauty of a walk through Rome by moonlight it is impossible to form a conception, without having witnessed it," he wrote. "All single objects are swallowed up by the great masses of light and shade, and nothing but grand and general outlines present themselves to the eye." Goethe came across a hermit living inside the Colosseum and beggars sleeping around a fire they'd lit beneath its crumbling arches. The romantic scene was, he noted, "exceedingly glorious."

In the next century, American writer Ralph Waldo Emerson (1803–1882) picked his way among the shadowy stones, as did

scores of others, each detailing the mournful nightscape—the flitting bats, the sound of a carriage rolling away in the distance, the convent bell. Moonlight poured in "through a hundred rents in the broken walls—through a hundred lonely arches, and blackened passage-ways, it streamed in, pure, bright, soft, lambent, and yet distinct and clear, as if it came there at once to reveal, and cheer, and pity the mighty desolation," an American visitor wrote. "I can only say that I came away paralyzed, and passive as a child."

For British chemist Sir Humphry Davy (1778-1829), the old arena triggered a more extreme reaction in the autumn of 1819. His experience was mystical, or maybe hallucinatory. He saw "a bright mist in one of the arcades," Davy remembered. "I approached towards it, when suddenly it enveloped me; an aromatic smell, like that of fresh orange flowers, seemed to penetrate not only into my nostrils, but even into my respiratory organs,

accompanied with sweet sounds, so low that they seemed almost ideal; and a sort of halo, of intense brilliancy, and of all the hues of the rainbow above which appeared a female form of exquisite beauty." He swooned meeting this spectral Roman goddess, but later admitted it might have been a daydream.

Expectations ran high for French writer Stendhal (1783–1842), who'd hoped to have the place to himself for the night. "As soon as other sightseers arrive at the Colosseum, the pleasure of the traveler is almost entirely eclipsed," he huffed. "Instead of losing himself in sublime and affecting reverie, he will, despite himself, observe the absurdities of the newcomers, and it always seems that they have plenty to observe." Similarly, intrepid British travel writer Anna Jameson (1794–1860) came away disappointed, not with the Colosseum per se, which, she wrote, "surpassed all I had anticipated," but with how crowded it had become. "I returned home vowing that while I remained at Rome, nothing should induce me to visit the Colosseum by moonlight again."

Not to be left out, Henry James (1843–1916) weighed in with his lukewarm assessment. "The Colosseum itself was all very well," he wrote after viewing it one night under a radiant starlit sky. But while James seemed unimpressed, he couldn't deny the cultural magnitude of his outing. The pivotal scene in his contro-versial novel *Daisy Miller* (1879) takes place during a nocturnal tour of the Colosseum. His heroine, a young and reckless Ameri-can, dares to visit the monument unescorted, that is to say, alone

with a rakish Italian man. "I was bound to see the Colosseum by moonlight," she reasons. "I shouldn't have wanted to go home without that."

Considering the dangerous freedom she tastes that moonlit night, it's hardly surprising when Daisy catches a deadly case of malaria there, payment for her indiscretion. But undaunted, doomed though she is, she won't deny the pleasure of her jaunt. "Well, I *have* seen the Colosseum by moonlight!" she chirrups from her sickbed. "That's one good thing."

10:00 PM ✳ SHANGHAI DANCES THE FOXTROT

China's largest harbor opened its doors during the 1930s to all manner of exotic vices, from chewing gum to Hollywood movies. While Nanking Road blazed with the neon lights of coffeehouses, dance halls, and cabarets, Shanghai oozed with the gritty kind of glamour that film noir was made of. It was "the place to give a bachelor all the fun he could possibly ask for," according to one denizen.

High-class ballrooms like the Paramount, the Black Cat, and Ciro's drew an elite clientele during those years, daring women who had brilliantined hair and wore the latest Western fashions with plenty of makeup to match. The bohemians went to the Peach

Blossom Palace. The film crowd went to the Ambassador. By 1936, there were more than three hundred cabarets within the Concessions, the territories run by the English, Americans, and French. The city's brazen new attitude sparked an urban literature all its own, smoky, jazz inflected, and cinematic.

One of the movement's brightest lights, Mu Shiying (1912–1940), began at the age of eighteen publishing stories notable for their steamy bravado and use of working-class slang. In his well-pressed Western suit, he haunted Shanghai's cabarets by night, especially the Moon Palace, where he alternately danced a mean foxtrot and sat at his table, pen in hand, waiting for inspiration to strike. "At the center, on the smooth floor, fluttering skirts and drifting gowns, exquisite heels, heels, heels, heels, heels," he wrote in 1932. "Fluffy hair and a man's face. A man's white shirt collar and a woman's laughter, arms extended, green jade earrings dragging onto the shoulders . . . The aroma of wine, the scent of perfume, the smell of English ham and eggs, the taste of cigarettes." It was that fabulous.

At one of the clubs, Mu Shiying fell in love with a dance hostess, whom he then chased all the way to Hong Kong. Eventually they were married. His was the voice of a generation, and his writing, swirling with fedora-wearing gunmen and femmes fatale, clanging trams, and speeding Buicks, all moving in time to the "whoowhoo" of the saxophone, conferred a lasting hard-boiled image on the city. "Shanghai," he wrote, "a heaven built on hell."

"Early to bed, early to rise" was for the dull. At London's Vauxhall Gardens on the south bank of the Thames, fashionable people liked to show up two hours after the scene was thought to be over. "The present folly is late hours," Horace Walpole (1717–1797) wrote in 1777. "Everybody tries to be so particular by being too late, and as everybody tries it, nobody is so." What made Vauxhall such a draw wasn't its long formal alleys, but the late hours and novel attractions—a lovers' walk, fireworks, acrobats, music, carousels, and dancing.

The first amusement parks grew from public gardens like Vauxhall, where a battery of breathtaking new rides was eventually added to the mix. Most exciting of all were the roller coasters, which were inspired by the towering and fearsome ice slides that had been popular around St. Petersburg since the sixteenth century. Constructed in the same manner, Les Montagnes Russes, a wooden roller coaster that opened in Paris in 1804, sent thrill seekers in wheeled carts barreling along a track at almost 40 mph while they feigned sangfroid. Some forty years later, monkeys rode the city's first loop-the-loop coaster during safety trials before a brave workman volunteered to take the plunge. "While going down he could see everything around him," one newspaper reported, "but when within the loop he was unable to see any-

thing. Going upgrade, he had clapped his hands as he ascended. He had no trouble breathing and during the loop proper experienced such a delicious feeling that he wanted to try again."

Similarly, a love of newfangled nightlife—and of falling—entranced those who sampled the roller coasters at New York's Coney Island between 1880 and 1920. The Switchback Railway there powered around a six-hundred-foot track at "a frightful rate of speed," a journalist reported in 1884. Two months later, there were four more coasters at Coney Island, and by 1907 there were more than twenty, including Serpentine Railroad, Flip-Flap, Snow and Ice Railway, and Shoot-the-Chutes. "They ride before eating to stir up an appetite, they ride after eating to soothe the 'hot dogs,' they ride when exuberant for the fun of riding, they ride when jaded to buck themselves up," a visitor noted.

The most imposing of all was the Cyclone, a ride that aviator Charles Lindbergh (1902–1974) was said to have deemed more fun than flying in an airplane. It's not certain whether pioneering pilot Orville Wright (1871–1948) found the experience as giddy, but he did confirm that riding the Cyclone was like "being pushed off a 10-story building." Once, when a man who hadn't spoken a word in six years rode the Cyclone, he got off and said, "I feel sick."

Queasiness was a necessary risk—and a welcome one for those who came to the park with romantic notions. A reporter for the *Brooklyn Eagle* got it right when reviewing Coney's rides, includ-

ing a giant swing that accommodated nearly a hundred people buckled into little boats. "No matter how frightened they get, the girls have to stay there once the machine is started and that gives glorious opportunity to rescue them with both arms," the writer noted. "Hence, the thing has made a hit."

september * MOON GAZERS CONVENE

IN ANCIENT CHINA, AUTUMNAL MOON VIEWING was an artful occasion. At September's full moon, T'ang dynasty (618–907 CE) courtiers and other glittering guests drifted through picturesque gardens, where swaying bamboo cut perfect silhouettes across the bright orb, and where quaint pavilions overlooked tranquil ponds. Musicians played, sweet and doughy mooncakes were eaten, and poets held forth, extolling every aspect of the shining moon's beauty.

Few loved the moon as famously, or as violently, as the poet Li Po (701–762). He was known for his wondrous way with words, and for his dedication to the practice of spontaneity—the code of *wu wei,* or "doing nothing"—that guided his aimless rambling across China. During these journeys he composed reams of verse, dedicating nearly half his poems to the wondrous moon. Li Po's

tactical approach to writing was to drink enough wine to suppress his restless ego and to clarify his focus, then to gaze deeply into the night sky. Inspired, in his poem "Drinking Alone Beneath the Moon" he wrote:

> *I sing, and moon rocks back and forth;*
> *I dance, and shadow tumbles into pieces.*

Li Po roamed south of the Yangtze River toward the end of his life. It's said he drowned one night when he fell out of a boat while trying to embrace the moon.

10:50 PM ✱ HAYDN PLAYS A SERENADE

On a cold November day in 1749, the Austrian composer Franz Joseph Haydn (1732–1809) left choir school wearing three old shirts and a worn-out coat to keep warm. His sweet soprano voice had begun to break, and the choir had no use for boys who no longer sounded angelic. And so he set off to seek his fortune in Vienna, where a fellow musician had offered him a place to sleep in the tiny garret apartment he shared with his wife and newborn baby. A kindly lace maker lent the promising young man enough money to see him through the lean times. And though Haydn

considered joining a monastery in order to stave off hunger, he eked out a living giving music lessons, playing in three churches on Sunday mornings, and, at night, roving the city streets with his friends, serenading the local beauties with some of his own compositions. Vienna loved its musicians. "On fine summer nights you may come upon serenades in the streets at all hours," an eighteenth-century visitor wrote. "However late a serenade is given, all windows are soon filled and in a few minutes the musicians are surrounded by an applauding crowd."

The nineteen-year-old composer's fortunes changed one night when Haydn and his friends played under the window of an especially pretty actress. Her husband, actor Johann Josef Felix von Kurz (1717–1784), liked the song wafting up from the street so well that he rushed down and invited Haydn up to join him. They might put together a show, Kurz suggested upstairs, instructing Haydn to accompany his pantomime. As Kurz flung himself across a chair on his stomach while pretending to drown, kicking and paddling his arms and legs, Haydn sat at the clavier. Kurz told him to picture a tempest out at sea. Hadyn had never seen the ocean. Kurz hadn't, either, but he said, "Imagine a mountain rising and then a valley sinking, and then another mountain and another valley." Hadyn still couldn't get the gist. Finally giving up, he cried, "The devil take the tempest!" running his hands together from one end of the keyboard to the other in a long glissando. It was exactly what Kurz was looking for and he leapt up and gave

the young composer a kiss. "Haydn, you're the man for me!" he crowed. So began their collaboration on Haydn's first opera, *Der krumme Teufel,* or *The Lame Devil,* a musical burlesque performed in the spring of 1753 and quickly banned from the stage for being vulgar and obscene. (Some years later the duo collaborated on a revival, *Return of the Lame Devil.*)

Playing and composing in those early days didn't make Haydn rich, but it made him happy. "When I sat at my old, worm-eaten clavier," he later remembered, "I envied no king his good fortune."

10:55 PM ✳ SKY WATCHERS NAME THE STARS

As a sixteenth-century English scholar explained, humans named the stars because "things cannot be taught without names." The bright stars hanging in the night sky seem to form pictures, rendering the seas navigable by night and providing sky watchers with a primitive handle on the wonders of outer space.

Some constellations still in use in the modern system, like Lyra (Lyre) and Cygnus (Swan), were first picked out by the ancient Greeks. But the Greeks weren't the only ones to see patterns in the stars. Ancient Chinese stargazers called the brightest star in their sky "the Emperor," and the second-brightest "the

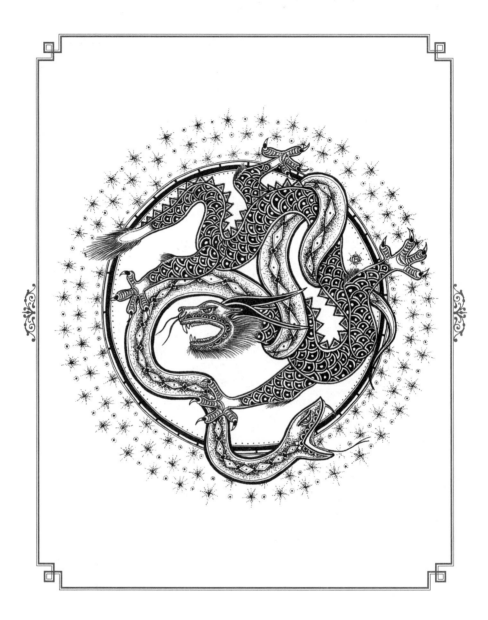

Crown Prince." Two long chains of stars represented the walls of the imperial palace, while others within the confines of that Purple Forbidden Enclosure stood in for concubines, eunuchs, and court officials. They named stars for temples, philosophical ideas, markets, warriors, and farmers. Our Big Dipper was their Bushel, or Plough, and was thought to regulate the seasons. Ancient Egyptians, too, developed a constellation system based on their mythology, naming stars after gods and animals, as did the Sumerians, the Babylonians, the Mesopotamians, and the Berbers. The ancient Greek configuration, based primarily on the Mesopotamian model, included forty-eight constellations, from the goat-fish Capricorn to the great twins of Gemini.

"Why did not somebody teach me the constellations," the Scottish writer Thomas Carlyle (1795–1881) lamented, "and make me at home in the starry heavens, which are always overhead, and which I don't half know to this day?" But during the seventeenth and eighteenth centuries, knowing the night sky became a complex undertaking. The period's far-flung explorers and surveyors competed to chart new constellations in the southern skies, information useful to their navigation, introducing Lacerta (Lizard), Vulpecula (Little Fox), Phoenix, and Chamaeleon. A French explorer cruising the south celestial polar region named one star Pictor (Easel) and another Microscopium (Microscope), while his contemporaries named stars in honor of various rulers and regents. A German astronomer added Machina Electrica

(Electrostatic Generator), as well as Officina Typographica (Printing Office). And on it went until the last remaining gaps overhead were a tangle of ancient mythology and cutting-edge mechanics.

The result was "derangement and confusion," a nineteenth-century writer complained, "serpents and dragons trailed their perplexing convolutions through hour after hour of right ascension." Even worse, "palpable blunders, unsettled discrepancies, anomalies of all imaginable kinds, survive in an inextricable web of arbitrary appellations," she went on, "until it has come to pass that a star has often as many aliases as an accomplished swindler." In 1922, members of the International Astronomical Union came together to purge the sky of extraneous constellations, limiting the number of constellations to the eighty-eight now considered official.

11:00 PM ✳ ALLEN GINSBERG LETS LOOSE WITH *HOWL*

When, in 1955, a few friends asked Allen Ginsberg (1926–1997), then a gangly, unknown twenty-nine-year-old poet living in San Francisco, to put together a reading at a local art gallery, he declined, "not knowing of any poetry worth hearing." Yet, right around that time, he composed part 1 of his magnificent poem *Howl* in a fiery burst, typing it out "madly in one afternoon,"

he remembered. "I thought I wouldn't write a *poem,* but just write what I wanted to without fear, let my imagination go, open secrecy, and scribble magic lines from my real mind—sum up my life—something I wouldn't be able to show anybody, writ for my own soul's ear and a few other golden ears." He sent the first six pages to his golden-eared friend Jack Kerouac (1922–1969) down in Mexico City.

And luckily, something changed his opinion about the San Francisco scene, because that October Ginsberg arranged for six seriously decent unknown poets to read at the Six Gallery on Fillmore Street. The invitation promised "Allen Ginsberg blowing hot; Gary Snyder blowing cool," as well as "abandon, noise, strange pictures on walls, Oriental music, lurid poetry. Extremely serious." The place was packed with North Beach beatniks. Kerouac, back in town, brought the wine. Poet Kenneth Rexroth (1905–1982) stepped in as master of ceremonies. The evening was Beat history in the making. Ginsberg, dressed in his best gray suit, began reading the first part of *Howl* just after eleven o'clock. "Scores of people stood around in the darkened gallery straining to hear every word," Kerouac wrote.

Ginsberg's masterwork told of all he'd seen on the gritty, groovy scene: "the best minds of my generation destroyed by madness, starving hysterical naked"—"angelheaded hipsters" who burned "for the ancient heavenly connection to the starry dynamo in the machinery of night" and who "copulated ecstatic and insatiate

with a bottle of beer a sweetheart a package of cigarettes a candle and fell off the bed, and continued along the floor and down the hall and ended fainting . . ." Reading the piece, Ginsberg, who'd started out slightly tipsy, became clear and sober, and later admitted that as the poem progressed he was overtaken by a "strange ecstatic intensity." *Howl* was an anthem, a rebel yell, and an affront to the "system of academic poetry, official reviews, New York publishing machinery, national sobriety and generally accepted standards to good taste," he later wrote. And it was a sensation. "Everyone was yelling 'Go! Go! GO!' " Kerouac remembered, though others reported that Kerouac himself yelled loudest of all. Afterward, the whole crew—Ginsberg, Kerouac, and fellow Beats Neal Cassady, Natalie Jackson, and Peter Orlovsky—went to the Nam Yuen restaurant in Chinatown, then on to The Place, where they drank and talked into the morning.

The genie was out of its bottle. Reviewing the San Francisco poetry scene, *The New York Times* dubbed *Howl* the "most remarkable poem of the young group," a work that received a "furor of praise or abuse whenever read or heard." It sparked enough controversy to draw the attention of federal authorities. In 1956, the San Francisco police seized printed copies of Ginsberg's *Howl and Other Poems,* and publisher-poet Lawrence Ferlinghetti (1919–) was brought to trial for obscenity.

A professor of English at the University of California defended the poem during the proceedings, arguing it "uses necessarily the

language of vulgarity." The prosecutor demanded, "Do you understand what 'angelheaded hipsters burning for the ancient heavenly connection to the starry dynamo in the machinery of night' means?" "Sir, you can't translate poetry into prose," the professor quipped. "That's why it's poetry." The courtroom crowd—full of fellow writers and angelheaded hipsters—burst into laughter. Next, the prosecutor brought in a woman who taught at a church school for girls. Her take: "You feel like you are going through the gutter when you have to read that stuff," she said. "I didn't linger on it too long, I assure you." After two weeks' deliberation, the judge found *Howl* not obscene. Ferlinghetti was acquitted.

Kerouac claimed to be the founder of the Beat movement, which emerged around 1953, the year Ginsberg and friends followed him from New York to San Francisco. He explained that "beat" meant living low, down on your luck, but he later realized that it also meant "beatific." By 1959, weekend beatniks thronged city streets everywhere from New York to Atlanta to Prague to Paris, wearing goatees and sunglasses and, invariably, carrying poetry books, while the women wore heavy bangs and heavier eye makeup. Even the comic strip *Popeye* introduced a beatnik character. "A Beat-inspired fad for public recitation of verse has not only caught on in big cities and college towns but has given the very word, poetry, a new and abrasive connotation," *Life* magazine reported. "A calculated vulgarity is part of the Beat act, and a good many of these performances are conducted in an atmosphere not

unlike that which attended the bare-knuckle prizefights of the last century." Ginsberg, of course, was dubbed the magazine's "Shelley of the Beat poets."

As he later said, he was simply in the right place at the right time when *Howl* came raging through his typewriter, creating a whirlwind of emotion in everyone that it touched. "You have to be inspired to write something like that," Ginsberg explained. "It's not something you can very easily do just by pressing a button. You have to have the right historical situation, the right physical combination, the right mental formation, the right courage, the right sense of prophecy, and the right information."

11:25 PM ✳ WALTZERS TURN IN ECSTASY

Though the waltz evolved from quaint spinning German folk dances, when the two princesses of Mecklenburg dared to waltz at a court ball in Berlin in 1794, the Prussian queen, appalled, averted her gaze and prohibited her own daughters from joining them. The waltz, the biggest sensation dancing Europe had ever seen, ignited passions and scandals in ballrooms across the continent, from Vienna to Paris and London. Unlike, say, the ultra-refined minuet, the waltz was wild, unfettered, and—for the first time—it brought partners face-to-face in a prolonged

snug embrace. Woozy dancers clung to one another, making tight clockwise turns while traveling counterclockwise around the perimeter of the dance floor. "Never have I moved so lightly," remembered Goethe, who danced the waltz in Strasbourg when he was young. "I was no longer a human being," he sighed. "To hold the most adorable creature in one's arms and fly around with her like the wind, so that everything around us fades away . . ." His diary entry for one night in 1777 notes: "Evening with the ladies, danced from 6 until 3 in the morning."

Not everyone was so convinced. In the waltz, "there is something in the close approximation of persons, in the attitudes, and in the motion, which ill agrees with the delicacy of women," the English author of *The Mirror of the Graces* wrote in 1811. Married women were warned that they should waltz only with their husbands, and unmarried women were advised

against dancing the waltz altogether. "A woman especially ought to be very sure that the man she waltzes with is one worthy of so close an intimacy," cautioned an early-nineteenth-century etiquette manual. A gentleman wore gloves on the dance floor, to avoid accidentally grazing any part of his partner's body with bare hands. Doctors fretted over the vertigo brought on by all that twirling, as one critic explained, because the "rapid turnings, the clasping of the dancers, their exciting contact, and the too quick and too long continued succession of lively and agreeable emotions, produce sometimes, in women of a very irritable constitution, syncopes, spasms and other accidents which should induce them to renounce it." The motion could be "injurious to the brain and spinal marrow," another detractor cried, and the overexertion could shorten a woman's lifespan. Someone cautioned that the distance covered by each turn, added to every length of the ballroom traversed during ten waltzes, meant that the couple traveled fourteen miles over the course of one night. To avoid tripping, waltzing women lifted the hems of their dresses with tongs, which hung from a cord at their waists, occasionally flashing a forbidden glimpse of petticoat.

It was all so thrilling. In Vienna, birthplace of the waltz, supersized lavish ballrooms competed for dancers. At the Apollo, couples danced under a chandelier blazing with five thousand candles. At the Monschein, it was all about speed. "Each couple tried to outdo the others," wrote playwright Adolf Bäuerle (1786–1859), "and it was no rare thing for an apoplexy of the lungs to

end the madness." Austrian composer Johann Strauss and his sons Johann II, Josef, and Eduard composed hundreds of waltzes to keep them all turning, including the younger Johann's classic "Blue Danube" (1867).

Though the waltz hit London in 1790, more than twenty-five years later it was still wonderfully shocking. "So long as this obscene display was confined to prostitutes and adulteresses, we did not think it deserving of notice," read an article in the London *Times* after the dance was introduced at a royal ball in 1816, "but now that it is attempted to be forced on the respectable classes of society by the civil examples of their superiors, we feel it a duty to warn every parent against exposing his daughter to so fatal a contagion.

"National morals depend on national habits," the article went on, "and it is quite sufficient to cast one's eyes on the voluptuous intertwining of the limbs and close compressure of the bodies, in their dance, to see that it is indeed far removed from the modest reserve which has hitherto been considered distinctive of English females."

11:45 PM ✳ SUFI MYSTICS TASTE THE DIVINE

Before coffee was a morning drink, medieval Sufi mystics in Yemen drank a brew made from *Coffea arabica* beans to stay awake

for their midnight prayer sessions, coming together to sing poetry and to seek *dhawq,* or a "taste of the divine." "They drank it every Monday and Friday eve, putting it in a large vessel made of red clay," one witness reported. "Their leader ladled it out with a small dipper and gave it to them to drink, passing it to the right, while they recited one of their usual formulas, 'There is no God but God, the Master, the Clear Reality.'"

Soon, drinking intoxicating, heady coffee, which provided its own kind of clear reality, was no longer reserved for religious rituals. Coffeehouses where one could sip for the pleasure of it sprang up across the Middle East. With the Red Sea port of Mocha, in Yemen, supplying beans to Medina, Cairo, Damascus, and Baghdad, coffee soon took its place alongside wine, hashish, and other forbidden delights. Coffee was first banned in Mecca in 1511, and banned again in 1526. The cafés of Cairo were destroyed in 1535. It didn't stem the tide. "The Turks have a brew, the colour of which is black," wrote an Italian traveling in Egypt in 1580. "It is drunk in long draughts, and not during the meal, but afterwards . . . as a delicacy and in mouthfuls, while taking one's ease in the company of friends, and there is hardly any gathering among them where it is not drunk."

Though the authorities in Constantinople once warned that those caught drinking coffee would be drowned in a sack in the Bosporus, there were already six hundred coffee shops there in the mid-sixteenth century. The finest were outfitted with terraces where patrons could lounge on divans covered with rich carpets

to watch a fountain or to stare out at the sea while sipping coffee scented with saffron, cardamom, opium, or ambergris. Such places were "thronged night and day," a visitor noted, with "the poorer classes actually begging money in the streets for the sole object of purchasing coffee."

Slowly, during the mid-seventeenth century, Europeans got hooked on the exotic drink. In 1669, Suleiman Aga, the Turkish sultan's glamorous ambassador in Paris, dressed in a turban and diamond jewels, his eyes rimmed with kohl, plied his guests with the dark brew, offering male visitors voluminous dressing gowns to wear as they luxuriated in his Ottoman-style salon. French doctors warned that coffee induced exhaustion and paralysis, but it was so fashionable that no one cared.

Before long, a sturdy Greek coffee-seller could be heard going door-to-door through the streets of Paris selling coffee made on his miniature cookstove and singing:

O drink that I adore,
You rule the universe!
O drink that I adore,
You rule the universe!
You wean the faithful from the vine.
You're more delectable than wine.

As the Sufis first discovered, coffee delivered a taste of the divine.

At midnight, Britain's moody mid-eighteenth-century poets brought the graveyard to life. One of the earliest to plumb its depths was Irish poet Thomas Parnell (1679–1718), who wrote "A Night-Piece on Death," describing tombs where the "nameless heave the crumpled ground," which was appropriately published after his death. English poet Edward Young (1683–1765) picked up the thread with his wistful *Night Thoughts* (1742), a series of nine poems written after the death of his wife and of two friends, and praised across Europe. During his college days at Oxford, Young had composed poetry after midnight by the light of a candle stuck in a skull. He preferred dark to day, he explained in verse, because it evoked a comforting melancholia:

> *How like a widow in her weeds, the night,*
> *Amid her glimmering tapers, silent sits!*
> *How sorrowful, how desolate, she weeps*
> *Perpetual dews, and saddens nature's scenes!*

In the deepest dark, the supernatural was never far from the artistic imagination. Another poet followed, describing his nocturnal encounters in the churchyard, from the scared school-

boy sprinting past to the newly made widow: *"Listless, she crawls along in doleful black, / Whilst bursts of sorrow gush from either eye."* A seventeen-year-old prodigy contributed to the genre with "On the Pleasures of Melancholy," calling "raven-colour'd" midnight the "solemn noon of night," and detailing his creepy visions of graveyard gloom, which included a ghostly figure inviting eternal rest "with beckoning hand." Thomas Gray (1716–1771) penned "Elegy Written in a Country Church-Yard." And on it went.

So why all the gloom and doom? Philosopher Edmund Burke (1729–1797) attributed the fascination to the irresistible allure of the Sublime, which conveyed a certain heart-quickening terror without posing any real threat. But writer Anna Laetitia Barbauld (1743–1825) noted that the pursuit of terror was also an antidote to monotony. "The more wild, fanciful and extraordinary are the circumstances of a scene of horror, the more pleasure we receive from it," she explained. Fear was a kick.

"Passion and fancy co-operating elevate the soul to its highest pitch; and the pain of terror is lost in amazement."

Whatever his reasons, Horace Walpole (1717–1797), author of the first Gothic novel, *The Castle of Otranto* (1764), went further than any of his peers, living and breathing Gothic gloom, or "gloomth"—a word he coined to describe both the cozy warmth and the dark gloom of his beloved mock-medieval castle. Though his home was filled with antique suits of armor, and topped by a plethora of arches and plaster battlements, Walpole would travel any distance to see a prettily ruined cathedral or dilapidated crypt. And if his carriage couldn't make it down some wayward country road, he'd climb onto one of the horses and blunder on through the mud to get there.

Spine-tingling gloom wasn't just a thrill. For Walpole it offered a sense of freedom from a too-predictable world. "The great resources of fancy," Walpole wrote, "have been dammed up by strict adherence to the common life."

OCTOBer ✳ *INSTANTANÉISME* IS BORN

ARTIST FRANCIS PICABIA (1879–1953) in the fall of 1924
touted the concept of *instantanéisme,* French for "instantaneity,"
renaming his Parisian art magazine the *Journal de l'Instantanéisme*
for the October issue. His post-Dadaist crusade promoted the
exhilaration of living in the moment, granting "liberty for all,"
not believing in "anything except today," or "anything except
life."

The of-the-moment movement lasted just long enough for
Picabia and composer Erik Satie (1866–1925) to create the *instan-
tanéiste* ballet *Relâche,* commissioned by the ultraexperimental
Ballets Suédois and performed in Paris several months later. The
piece was an assault upon the artificiality of the theater—and on
the audience—crafted by two sly old artists who loved to shake up
the bourgeoisie.

Picabia was a pillar of Dadaism. Satie was a born provocateur who ironically named his first published score "Opus 62." Dressed in black, wearing his signature pince-nez and toting an umbrella under his arm, no matter what the weather, every Sunday he went to Picabia's suburban villa so the two could collaborate on what Satie saw as the most important theatrical project of his career.

On opening night, the chic audience didn't know what to expect, though Picabia's *Journal* had advised all to bring earplugs and to wear sunglasses. Inside the theater, whistles were distributed, and a wall of large reflector discs, each with a lightbulb at its center, gave off a brilliance that "only the sun could then look at directly," according to a witness. During their choreographed show, performers and dancers emerged from the audience and made their way to the stage, acting like curious spectators who had suddenly decided to get a closer look. Once in the spotlight, they carted one another around in a wheelbarrow. A chain-smoking fireman ambled about. The climax came when, vamping vaudeville, a pack of men in evening dress circled around a woman in an evening gown as she undressed, finally stepping away to reveal her glorious form, sheathed in a snug pink bathing suit. Then the men stripped down to their spangled long johns and hunched over so the woman could walk across their backs as if over a bridge. A poster hanging above the fray suggested: "If you're not satisfied, go to Hell!" But what did it all mean?

"Relâche goes strolling through life with a grand burst of laughter," Picabia wrote in the program notes. "Relâche is aimless movement. Why think?" Underpinning the irreverent mood, Satie's score was built from snatches of the music hall songs of his younger days—dance music, waltzes, and once-familiar tunes, which he spliced, twisted, and warped—and if the "reactionary mutton-heads" didn't like it, he wrote, too bad. "I shall tolerate only one judge: the public."

Fueling the fire, director René Clair's short film *Entr'acte* was screened between the two acts. In the first scene, Picabia, hair mussed and looking wild, and Satie, distinguished in his bowler, loaded a cannon and fired it at the camera. In another scene, a ballerina twirled on a pane of glass while filmed from below, offering the audience more than a glimpse under her tutu. As the film played, "boos and whistles mingled with Satie's comical tunes," Clair (1898–1981) remembered. "He, no doubt, took a connoisseur's pleasure in the sonic reinforcement which the protesters brought to his music." Amid the mayhem at the end of the night, Satie and Picabia drove onstage in a tiny Citroën to take a bow.

Reviews of *Relâche* were merciless. "Its essence is nothingness," one wrote, "it boasts of it, and I am very embarrassed." Another called it "nothingness, a laborious nothingness in two acts." And a third complained, " 'Relâche' cannot be discussed, cannot be recounted, cannot be analyzed. It's nothing." Even

Satie's former protégé weighed in, claiming the production was "the most boring and stupidly depressing thing in the world." Artist Fernand Léger (1881–1955) was one of the few to defend the duo, applauding their anti-art stance and recognizing that with *Relâche* "the water-tight division between ballet and music-hall has burst." Satie fell ill a few days later. His premiere-night cruise was his last public appearance. He would die within several months.

Many called the *instantanéiste* ballet a failure, too obscure, and too random to be worth the time. On the contrary, Satie based his definition of success on the beauty of artistic vision, rather than on its artful execution. His was the ultimate avant-gardist stance, one that allowed for a cacophony of show tunes, floodlights, and chain-smoking firemen to triumph as art. "Great Masters are brilliant through their ideas, their craft is a simple means to an end, nothing more," he once said. "Let us mistrust Art: it is often nothing but virtuosity."

12:10 AM ✳ LOVE UNDER THE ANDALUSIAN STARS

Medieval rulers of Islamic Spain gathered their closest friends in lush, high-walled gardens for secret parties called *majlis,* where pretty servants sang and danced, and kept the choice wines flow-

ing right through the night. The vibe was one of refinement, and of deep sensuality. Within the privacy of such intimate company, the caliph could relax and unwind, unrestrained by strict courtly protocols. Stretched out on rare carpets or brocade cushions, he and his guests took in the stars, philosophized about love, and spun couplets to memorialize those good times, when a dancing girl might finally slip out of her dress, "like a bud unfolding from a cluster of blossoms."

The epic soirées are thought to have begun earlier in Iraq and in Persia, but they reached their height in eleventh-century Andalusia, when the era's poetic power couple, Ibn Zaydūn (1003–1071) and his love, Wallada bint al'Mustakfi (1001–1091), the rebellious daughter of the Caliph al'Mustakfi, made attending such events, and crafting heart-aching verses about each other, their priority.

"How many nights we passed drinking wine," Zaydūn wrote of their nocturnal bliss. But Wallada was no mere muse. A powerful provocateur at the center of the Córdoba scene, she proudly wore her own verses embroidered down the sleeves of her robe, one of which read, "I am, by God, made for glory."

She was happy to count herself among the many who found it impossible to resist the sensuous temptations of the Córdoba night. "Pleasure and licentiousness were brought together there, and the stars of its wine were ignited," another *majlis* regular remembered. "The face of the moon was manifested from among

the flowers, and they passed their night, and sleep did not over-
come them."

1:00 AM ✳ BROADWAY GOES DARK

New York City's nightlife crept uptown at the turn of the twentieth
century—from Union Square to Madison Square to Herald Square
and finally to Times Square—bringing with it a dazzling display of
lights. On Broadway, soon to be known as "the Street of the Mid-
night Sun," electric ads lit up every inch of available real estate.
The first shone with 1,475 bulbs, spelling "Manhattan Beach,
Swept by Ocean Breezes," and winked on and off as an atten-
dant sitting on a nearby rooftop flicked a switch. Soon, ketchup
magnate H. J. Heinz raised a glaring ad for his vivid green pickles.
In 1905, the sign for Trimble Whiskey could be seen from a mile
away. The biggest ads were called "spectaculars," and before long
they included animated billboards controlled by punched-paper
rolls like those that powered a player piano. A lit-up kitten chased
a spool of string. Roman charioteers raced across the sky, and a
whip-wielding Eskimo drove a team of huskies.

But writer William Dean Howells (1837–1920) preferred
Broadway without its flashy lights. "The darkness does not shield
you from them," he lamented, "and by night the very sky is starred

with the electric bulbs that spell out, on the roofs of the lofty city edifices, the frantic announcement of this or that business enterprise." Maybe he was a curmudgeon. Most visitors seemed to love the free entertainment. "With eyes distracted by kaleidoscopic mysteries, they good-naturedly jostle and stumble against each other along the friendly sidewalks of New York," a reporter wrote in 1927. That year, Broadway's sponsors invested $20 million in lighting, allowing nearly twenty thousand incandescent bulbs to burn from sunset until 1:00 a.m.

But Manhattan's glow was dampened considerably on May 1, 1942, when authorities called for a twenty-minute blackout across the city—a wartime precaution, and a harbinger of things to come. Thousands poured into Times Square to watch the lights go out. The drill was "highly successful and chillingly eerie," wrote a witness. The army and the police force worked in concert over the next months to protect Allied boats near the coast from the "fatal backdrop" of a too brightly glowing sky. Neon was shaded or extinguished. Theater owners dimmed their marquees. "In almost every instance orders were obeyed, but with much sighing," *The New York Times* reported as the district switched off 265,000 lamps and sixty-five miles of neon. "When night comes great hulks of shadow ponderously move into Times Square like an invasion of pre-historic monsters," a reporter noted. Broadway's dance halls, theaters, and bars were gloomy. The streets were hushed.

That is, until three years later, on May 9, 1945, when a spontaneous celebration of the official end to World War II in Europe erupted in the streets. A crowd of 250,000 marched into a brightly lit Times Square, banging drums, blowing bugles, singing, shouting, and ringing cowbells. "In noise-making, uproar, high-jinks and real enthusiasm, it almost duplicated a peace-time New Year's Eve," the *Times* announced. As Broadway's blazing bulbs lit up the sky, the revelers all but swept one police sergeant off his feet. "They're light-happy," he declared.

 1:05 AM ✳ SCHOLARS RETIRE TO THE STUDY

While his neighbors slept, the Roman scholar known as Pliny the Elder (23–79 CE) went to work in a small, dark room in his Tuscan villa. The hushed isolation and tranquility made it easier to focus on writing his encyclopedic survey of the known natural world, *Historia naturalis.* "He always began to work at midnight when the August festival of Vulcan came round, not for the good omen's sake, but for the sake of study, in winter generally at one in the morning, but never later than two," his son, known as Pliny the Younger, wrote.

For his part, Pliny the Younger (61–112) sought studious solitude in a *diaeta,* a small study built in his villa's garden, and

situated so he could gaze at the sea and at the woods, and smell the violets blooming in springtime. "When I retire to this suite I feel as if I have left my house altogether and much enjoy the sensation especially during the Saturnalia when the rest of the roof resounds with festive cries in the holiday freedom," he explained, "for I am not disturbing my household's merrymaking nor they my work."

Yet not all ancient scholars agreed that easy access to nature aided their focus. While "the absence of company and deep silence are most conducive to writing," Roman rhetorician Quintilian (ca.35–ca.100) argued, working in a grove or in the woods, where "the freedom of the sky and the charm of the surroundings produce sublimity of thought and wealth of inspiration," was a "pleasant luxury, rather than a stimulus to study." All that beauty could prove a distraction, naturally. "Therefore," he concluded, "let the burner of the midnight oil seclude himself with but a solitary lamp to light his labours."

Though he lived centuries later, the Italian poet Petrarch (1304–1374) took inspiration from both Plinys when establishing his secluded retreat. At home in Avignon, his ears "were battered and [his] mind afflicted by the city's tumult," he complained. At his country hideaway in Vaucluse, in Provençe, he spent his days alone with his books and his thoughts, "wandering among the meadows, hills, springs and woods" and writing many of his major works, including some of his celebrated love poems to the

elusive Laura, and the treatise *De vita solitaria* (1346), on solitary living. "I flee men's traces, follow the birds, love the shadows, enjoy the mossy caves and the greening fields, curse the cares of the Curia, avoid the city's tumult, refuse to cross the thresholds of the mighty, mock the concerns of the mob," he wrote of life there. "I am equidistant from joy and sadness, at peace day and night. I glory in the Muse's company, in bird-song and the murmur of the water nymphs."

After Petrarch, and as greater numbers of ordinary citizens learned to read, constructing a small, monkish thinking room in one's house became fashionable. Such a space, called a *studiolo* (study) or *cubiculum lucubratorium* (night study), required a large collection of books, and a writing desk, an item previously found only in monasteries, as well as a view, or at least a decent land-scape painting.

But above all, it required utter peace and quiet. "Solitude is indeed something holy," Petrarch proclaimed, "innocent, incorruptible, and the purest of human possessions."

1:50 AM ✳ LAST CALL AT LA ROTONDE

When a young Gyula Halász, the wild-haired Hungarian artist who would become the famed photographer Brassaï (1899–1984), arrived in Paris in 1924, he headed straight to La Rotonde, the

buzzing café at the center of the city's avant-garde ex-pat scene, and the place where everyone from Picasso to Hemingway passed the days and nights. "This is the artists' haunt in Montparnasse," he wrote home to his parents, "a place where my hair was duly appreciated at last. What lovely, charming women—my God!"

He made just enough money to scrape by, working as a journalist, selling drawings, caricatures, portraits, and articles, candidly sending word home of all his disappointments and his conquests, like Lisette from Alsace—"We danced through the night of New Year's Eve, like two crazy people, in the street, in bed, at the bar. I had a red top hat on my head: who knows how it got there."

With eager fascination, he ventured beyond Montparnasse to carouse the city's seedy underworld alongside the budding American novelist Henry Miller, who wrote about his friend in *Tropic of Cancer*. But Brassaï also sampled the pleasures of the Parisian high life during those early years, retrieving his best suit from the pawnshop whenever he was asked to a concert or a ball. "It did happen that, having spent the night among workers (railroad employees, rail cleaners, loaders at the market) and vagabonds, roughnecks and streetwalkers, I would be invited the next day to a soirée or masked ball of the aristocracy at the salon of Count Etienne de Beaumont or Vicomtesse Marie-Laure de Noailles," he remembered.

Brassaï's photos of every aspect of nocturnal Paris would become iconic during the 1930s—the trashmen toiling through the night, the lovers kissing in the shadows, the prostitutes

strutting with their hands on their hips, or the girls backstage at the Folies Bergère. "Sometimes, impelled by an inexplicable desire, I would even enter some dilapidated house, climb to the top of its dark staircase, knock on a door and startle strangers awake, just to find out what unsuspected face Paris might show me from their window," he later admitted.

In the mid-1920s, however, he had yet to find his future calling, or to make the link between his love of the night and his artistic vision. He was having too much fun. Around two in the morning, "all the night creatures driven out of the cafés are scurrying around in panic," Brassaï wrote. They asked one another: Is the Rotonde still open? Is the Dôme? "I have been drawn too deeply into the magnetic atmosphere of the cafés and, whether I wanted it or not, I would always stumble into someone and end up spending my nights in the cafés instead of doing my work," he wrote to his parents. In an effort to get serious, he moved a whole "eight minutes from the Rotonde" in 1925.

Distractions that winter included the beautiful South American Oliva, who tucked a bouquet of violets into his buttonhole on the night they met. "It's two o'clock in the morning. We have had three *fines à l'eau*. Taxi. Oliva is taking charge," he wrote to his parents, relating one of their escapades. They danced in a Montmartre nightclub, didn't have enough money to pay their bill, and tumbled into a hansom cab to head "home to Montparnasse," Brassaï wrote. "It is dawn. Oliva is in my lap, intoxicated by champagne

and cognac. She's tearing at my hair like a kitten. . . . Horse and coachman are dozing off. . . ." Few wrung more pleasure from the Parisian night.

1:55 AM ✳ ADRIFT IN *DORVEILLE*

For thousands of years, writers have described their sleeping hours as divided into two parts: "dead sleep" and "morning sleep." The dreamy span between the sleeps was known as *dorveille,* a period of quiet wakefulness that sailed along the perimeter of heightened semiconsciousness. (The word combines the French *dormir,* "to sleep," and *reveiller,* "to wake.") Researchers say that only after the advent of gas lighting did humans condense their sleep into one uninterrupted span. However, in contemporary sleep studies, once a person is deprived of artificial light for several weeks, he or she naturally slips right back into the old two-sleeps pattern, and the *dorveille* emerges once again.

Dorveille was a time for hatching new ideas, maybe smoking a pipe or tending the fire, though most people probably never left their beds. Often, they would write. In 1769, an English inventor advertised a gadget he called the "Nocturnal Remembrancer," a paper tablet inside a wooden box with a slit in it to guide a pen across paper in the dark, enabling "philosophers, statesmen,

poets, divines and every person of genius, business or reflection" to preserve the revelations that came to them during *dorveille*.

It was "one hour to be spent in thought, with the mind's eye half shut," as American writer Nathaniel Hawthorne (1804–1864) explained in 1835. As the clock strikes two, "yesterday has already vanished among the shadows of the past; tomorrow has not yet emerged from the future," he enthused. "You have found an intermediate space, where the business of life does not intrude; where the passing moment lingers, and becomes truly the present; a spot where Father Time, when he thinks nobody is watching him, sits down by the wayside to take breath."

2:00 AM ✳ HENRIETTE D'ANGEVILLE CONQUERS MONT BLANC

From her Geneva home, Henriette d'Angeville (1794–1871) could see the tantalizing slopes of Mont Blanc in the distance. "It seemed to me that I was in exile in Geneva and that my real country was on that snowy, golden peak that crowned the mountains. I was late for my wedding, for my marriage . . . for the delicious hour when I could lie on his summit," she wrote. "Oh! When will it come!" The moment came at two o'clock one still-dark autumn morning in 1838, when the forty-four-year-old aristocrat's guides

woke her to begin the party's final ascent of the mountain.

During the previous summer, d'Angeville had prepared by climbing lesser peaks, but when she announced her plan to scale Mont Blanc, "a general outcry of amazement and disapproval" went up among her neighbors. A guidebook declared that curious adventurers who scaled the mountain were "hardly justified in risking the lives of the guides." "It is a somewhat remarkable fact," the text went on, "that a large proportion of those who have made the ascent have been persons of unsound mind." D'Angeville didn't let such sentiments dampen her resolve. "Each of us must arrange his life according to his moral or intellectual inclinations," she offered. The only other woman known to have accomplished the feat was a young maidservant, Maria

Paradis, who was barely conscious when her companions dragged her to the top. At the foot of the mountain, the citizens in Chamonix laid bets on whether d'Angeville would make it, and as she climbed, every telescope in town was trained on the sight.

What they would have seen was a woman wearing a plaid bonnet trimmed with fur, a black feather boa, a fur-lined cape, and a voluminous Scotch plaid jacket and matching trousers—her ridiculously eccentric self-designed getup. She slowly made her way through the snow with thirteen guides and porters. Among their provisions for the three-day trek were two legs of mutton, two sides of veal, twenty-four roast chickens, six loaves of bread, and eighteen bottles of wine, along with cognac, sugar, lemons, chocolate, prunes, blancmange, lemonade, and bouillon. In her own luggage, d'Angeville packed cucumber face cream, a small vial of eau de cologne, and "an enormous fan in case I had to be given air."

At first the guides had to warn her to slow down, advising the intrepid lady to "walk as if you did not want to reach the top." But on the last day, after nearly twelve hours of climbing, and as they passed 13,000 feet and faced a steep 354-step ice staircase leading to the snowfields at the peak, she felt a "heaviness in the eyes" that soon overpowered her with a need for sleep. After every twenty steps, she'd slump down into the snow to rest. The guides would wake her after a minute or two, and then they pressed on together. She felt she'd suffocate. Her limbs became weak. She

suffered a raging thirst and heart palpitations. "Look at her, asleep again," one guide complained. "This is the last lady I take up Mont Blanc." Finally, the men offered to carry her the rest of the way. With that, d'Angeville sprang back to life. "I will not be carried!" she cried, summoning all her pluck and moving steadily once again until reaching the summit. "The fear of such a humiliation gave me renewed strength, and I outdid myself."

At 15,771 feet she released a carrier pigeon and sat down again to write letters to her friends, "to serve as a constant reminder that I had not forgotten them even on the summit of Mont Blanc." Then she took a moment to marvel at the serene spectacle spread all around her. "This astonishing sky," she wrote, "the desolation of colossal mountains, the fretwork of clouds and grey peaks, the eternal snows, the solemn silence of the wastes, the absence of any sound, any living being, any vegetation, and above all of a great city that might recall the world of men: all combined to conjure up an image of a new world or to transport the spectator to primitive times."

november ✳ EUROPE DEVELOPS A TASTE FOR PINEAPPLE

ARRIVING IN GUADELOUPE IN THE AUTUMN of 1493, explorer Christopher Columbus (1451–1506) became the first European to try a pineapple, which he described as a melon, though "of much sweeter and delightful aroma and flavor." It was the beginning of an intercontinental love affair. Explorers rushed their ships home from the New World to bring the fruit to eager patrons. King Ferdinand of Spain deemed pineapple the best thing he had ever tasted. Spanish explorer Gonzalo Fernandez de Oviedo y Valdes (1478–1557) scrawled out page after page singing the fruit's praises. "I do not suppose that there is in the whole world any other of so exquisite and lovely appearance," he wrote in 1535. "My pen and my words cannot depict such exceptional qualities, nor appropriately blazon this fruit so as to particularize the case fully and satisfactorily, without the brush or the sketch."

During the late seventeenth century, top European gardeners experimented with growing the fruit in specialized steamy hot-houses, called "pineries." Building the glasshouses and feeding the stoves needed to warm the plants, which bore fruit only in the second or third year, was an enormous expense—so much so that the pineapple became a status symbol. By 1730, English brokers rented out pineapples to ambitious party hosts to display as table centerpieces.

But the pineapple wasn't Europe's first superstar fruit. Its exotic predecessor, the orange tree, was grown in Italy from the Renaissance onward, and during the late seventeenth century was cultivated in opulent European orangeries, like the one at Versailles, which was stocked with orange and lemon trees, jasmine shrubs, pomegranates, oleanders, and tropical birds. England's Queen Anne (1665–1714), enchanted by the overgrown spectacle of her greenhouse at Kensington Palace, regularly ate supper there in the early 1700s.

Other monarchs had grandiose theaters or ballrooms attached to their orangeries. King Leopold II of Belgium (1835–1909) liked to stroll through an entire town, a "fairy world" of glass and iron he'd commissioned, which included a church built to house his orange trees, palm trees, and tropical plants. Bavaria's King Ludwig II (1845–1886) boasted a winter garden brimming with incredible foliage from far-flung places, a small waterfall, a tiny lake rippling with artificially made waves, and, along one wall, painted vistas of the Himalaya. Under a blue silk tent covered in roses, he dined there one evening with a Spanish infanta while a hidden choir sang.

Sampling tasty, strange fruit and basking in the glasshouse's sultry breezes was a wintertime delight for the well-to-do. In France, Empress Joséphine installed a nursery to house three hundred pineapple trees at Malmaison in 1800, often serving her guests fresh pineapple, mangoes, and bananas for dessert. "There is an inherent wonderful fascination in being able, in the middle of winter, to open the window of a salon and feel a balmy spring breeze instead of the raw December or January air," Napoléon's niece, Princess Mathilde de Bonaparte (1820–1904), noted years later. "It may be raining outside, or the snow may be falling in soft flakes from a black sky, but one opens the glass doors and finds oneself in an earthly paradise that makes fun of the wintry showers."

It began as a riff on the simple nineteenth-century English children's game called "paper chase," in which two "hares" tore across the countryside laying a paper trail for the "hunters" to follow. But the treasure hunt, invented in the early 1920s by London's socialite sisters Zita Jungman (1903–2006) and Teresa "Baby" Jungman (1907–2010) and their oh-so-sophisticated friends, was an instant hit with the city's Bright Young Things. At first, tracking down clues and chasing one another across the city offered a way for the bored girls to "amuse ourselves on blank afternoons," a friend explained. "None of us had much money so we went by bus or underground as speedily as we could." Soon enough, however, the game became evening entertainment for the social set, and "the hunts got rather out of hand with Rolls-Royces jostling each other down mewses and people fighting for the clue." Zita convinced the owner of a Hovis bread factory to bake clues into loaves of brown bread for one hunt. For another, she asked William Maxwell Aitken, Lord Beaverbrook, owner of the *Evening Standard,* to print a special edition with sham headlines and clues hidden in the text.

When police apprehended the young Honorable Lois Sturt during a hunt in 1924, the group's antics became international news. In hot pursuit of treasure, she'd sped through a Stop sign

in the Regent's Park at 51 mph. The hunters that night included actors, actresses, socialites, Lady Diana Manners, and the Prince of Wales. Clues were tacked on lampposts, tucked away on fire escapes, and hidden in the cloisters of St. James's Palace and at the foot of Cleopatra's Needle. The last—and best—treasure hunt of the season began at 2:00 a.m., after a costume ball, and ended with the costumed revelers slumping in the coffee stalls for breakfast.

On the other side of the Atlantic, Manhattanites picked up the game in 1925, baffling the city's policemen as three hundred well-heeled guests flooded down the streets in their limousines and in taxis during a treasure hunt party. "Traffic policemen were well-nigh speechless and Fifth Avenue shoppers were amazed," wrote a reporter for *The New York Times*. Police gave two warnings during the scrum, and the damages incurred included a flat tire and a shattered taxicab window. "Chauffeurs got gray hairs" as the hunters urged them onward, the writer noted. "But the competition was terrific."

By the early 1930s, treasure hunts were passé in the United States, but scavenger hunts were in. The legendary American party planner Elsa Maxwell (1883–1963) introduced the newer game in 1933, challenging New York's glamorous partygoers to search for hard-to-find items on her ridiculous laundry list, which included a live goat, the city's most beautiful woman, and one of actor Jimmy Durante's shoes. No one could refuse her.

The hunters set off from the Waldorf-Astoria. One man couldn't find a goat, but returned to the party with a bear cub he'd found at a Broadway nickelodeon instead.

As with the treasure hunt, the scavenger hunt encouraged quite a few traffic violations. Some players counted on it. In 1935, reveler Michael J. Ferron of Evanston, Illinois, was pulled over for speeding during one such game. "That's just what I needed!" he excitedly told the policeman issuing him a ticket.

3:00 AM ✳ WAITS PIPE THE HOUR

As early as the thirteenth century, English castles were guarded by nightwatchmen who piped out the hours. But by 1400 small bands of guards patrolled towns across England, while taking on a variety of musical duties as well, waking certain people at appointed times by playing outside their doors, and providing through the night a little street music for the townspeople. The musicians/guards, called "waits," typically played the hornpipe or the shawm, an oboe-like instrument, as they marched through the dim streets, looking out for fires and for robbers. (The musicians, the music they played, and their instruments were all called "waits," from the Old English *wæccan*, "to be awake," and the antiquated German *wachten*, "to watch.")

Each of London's wards had its own company of six to eight waits. By day, as part of their duties, they piped any illustrious visitor from the town gates to the door of his lodgings, while at night they played tunes and announced the time and weather conditions as they strolled and patrolled. "Past one of the clock, and a cold, frosty, windy morning," one called out, startling diarist Samuel Pepys as he sat up writing one winter night. They were "a parcel of strange hobgoblins, covered with long frieze rugs and blankets, hooped round with leather girdles from their cruppers to their shoulders, and their noddles buttoned up into caps of martial figure," reported a writer who crossed paths with a pack of waits in the early eighteenth century.

Their presence offered, if anything, a psychological sense of security, and even in the sixteenth century, the waits' security detail was far less important than their musical duties. The troupes often took private commissions to serenade young ladies. "As the custom prevails at present, there is scarce a young man of any fashion in the corporation, who does not make love with the town-music," noted an eighteenth-century observer. "One would think they hoped to conquer their mistresses' hearts as people tame hawks and eagles, by keeping them awake, or breaking their sleep when they are fallen into it."

The waits were more active during the dark months, often starting at two in the morning and sometimes playing on until daybreak, performing seasonal tunes, and, on the day after

Christmas, waking each household on their route by name, while angling for tips. At St. Mary's Convent, for example, they sang out: "Good Morning to the Lady Abbess! Good morning to the nuns! Good morning to the young ladies! Three o'clock in the morning: a fine morning! Good morning to the chaplain! Good morning to all! Good morning! Good morning!" No one seemed to mind the ill-timed greeting, and the tradition continued until nearly the end of the nineteenth century. "The music of the Waits—rude as may be their minstrelsy," observed American writer Washington Irving, "breaks upon the mid-watches of the night with the effect of perfect harmony."

3:50 AM ✳ DREAMERS TAKE FLIGHT

Greeks and Romans of ancient times spent the night in temples dedicated to the healing god Asclepius, where they were awakened periodically by priests, who analyzed their dreams and used the findings to formulate medical diagnoses. Famous physicians including Hippocrates and Galen prescribed cures based on dream imagery, involving the weather, for instance. Occasionally, however, their services weren't needed, as, according to the dreamers, Asclepius put in a personal appearance within the dream and healed the dreamer there on the spot.

Similarly, the Marquis d'Hervey de Saint-Denys (1822–1892) had himself woken up throughout the night with the hope of extracting sense from his dream visions, which he recorded beginning at the age of thirteen. The aristocratic French scholar especially liked to ponder the dreamer's moral quandary: As an upright gentleman of standing, how could he maintain his will-power, refraining from doing anything sinful or unseemly while asleep? Hervey de Saint-Denys was convinced that through pre-sleep autosuggestion, the elevated dreamer could practice dream control, keeping himself within polite bounds.

But he was also intrigued by the faint geometric visual hallu-cinations that swirl when one's eyes are closed, just on the cusp of sleep, and he filled twenty-two notebooks with the dots of color and tiny suns that swam through his inner vision. "White smoke passes like a cloud driven before the wind," he wrote of one night's reverie. "Flames shoot out in spurts impinging painfully upon my retina. Soon they have dissolved the cloud, their explo-siveness subsides. They spin, forming broad blooms, black in the center, orange and red at the edges. After a moment they open gradually from the center becoming a thin golden ring, a sort of frame in which I see the portrait of one of my friends."

His passion for dreaming was matched some decades later by that of English psychologist Mary Arnold-Forster (1861–1951), who, like Hervey de Saint-Denys, used autosuggestion during her waking hours to train herself to remember her dreams and to develop lucid control over them, which she called the "art of happy

dreaming." Dreams were a new frontier, offering "the same kind of quiet pleasure that we feel when journeying through an unfamiliar country, when each little hill we surmount and each bend of the road that we turn reveals to us something new," she wrote.

Arnold-Forster's true midslumber delight, however, was the flying dream. "I found that if I steadily thought about such a dream as the flying dream it would soon come back," she trilled. Since childhood she'd dreamt of being able to hover midair by fluttering and flapping her hands like little wings. "It was a long time before I could fly higher than five or six feet from the ground, and it was only after watching and thinking about the flight of birds, the soaring of the larks above the Wiltshire Downs, the hovering of a kestrel, the action of the rooks' strong wings, and the glancing flights of swallows, that I began to achieve in my dreams some of the same bird-like flights," she wrote.

Again, the power of autosuggestion gave her new lift. "After I had thought long and often about flying over high trees and buildings," Arnold-Forster explained, "I found that I was getting the power to rise to these heights with ever lessening difficulty and effort."

4:00 AM ✳ DUCHAMP CUTS LOOSE

The actress-artist and bohemian Beatrice Wood (1893–1998) was twenty-four years old when she met French artist Marcel

Duchamp, then twenty-seven and basking in the glow of his provocative painting *Nude Descending a Staircase*. Duchamp (1887–1968) agreed to take Wood under his wing and into his studio, where he critiqued her sketches. She fell for him right away. He had "penetrating blue eyes that saw all," she wrote. "When he smiled the heavens opened."

A bathtub in the center of his studio, used for his frequent ablutions, a visitor remembered, was situated an arm's length from a hanging rope, which allowed him to open the door without getting up. The place was strewn with clothes and canvases, and utterly undone, down to its unmade bed, allowing Wood an escape from the "crowded luxury" of her parents' San Francisco home in 1916. American painter Georgia O'Keeffe (1887–1986) could hardly stand the thick grime covering the surfaces in Duchamp's studio. "I was so upset over the dusty place," she said after a visit, "that the next day I wanted to go over and clean it." Wood, on the other hand, seemed to find the scene alluring, noting that the place "gave the impression of being in various stages of undress." After working all afternoon together, she and Duchamp would go out to dinner. "Except for the physical act," wrote Wood, "we were lovers." (And from Wood's account, it seems he wasn't interested in pursuing a physical relationship.)

Duchamp was on the jury for the Society of Independent Artists exhibition the next year, a show that, unlike others of its kind, promised to accept any and all work. The idea was that the artist, not the critics, would decide what art was. Duchamp advised

Wood on her *Un peu d'eau dans du savon,* a racy painting of a nude in a tub with a piece of soap glued in the "tactical" position (Duchamp's touch). Meanwhile, under the name R. Mutt, he submitted *Fountain,* his iconic found-object urinal. It would become one of the most influential works in the history of Western art, but in 1917 *Fountain* was too far-out for the other jury members, and no one had ever heard of R. Mutt. For the duration of the exhibition, the piece was hidden behind a partition, out of sight. "I didn't know where it was," Duchamp later recalled. "I couldn't say that I had sent the thing, but I think the organizers knew it through gossip. No one dared mention it." He resigned from the organization, but a small magazine he coedited with friends, *The Blind Man,* ran an article in defense of the piece titled "The Buddha of the Bathroom."

To celebrate the magazine's efforts, and Duchamp's edgy artwork, a wild "Pagan romp"—the Blindman's Ball—was unleashed at Webster Hall in Greenwich Village that summer. Wood drew the poster, a marching stick figure thumbing his nose at the world. Guests came in the most eccentric costumes they could muster. Artist Clara Tice was costumed as a steam radiator, while her friend came as a hard-boiled egg. Poet Mina Loy was a strange Pierrot. Duchamp arrived in a woman's dress. Wood, wearing a Russian peasant costume, did a folk dance. "Marcel climbed up on a chandelier," Wood remembered. "Joseph Stella had a duel over me, though I never found out why."

At three in the morning, Duchamp, Wood, and a few game

friends wound up at someone's apartment, snacking on scrambled eggs and wine. Then, at dawn, Duchamp and a pack of revelers who were too tired to go home went back to his place, piling into his bed "like a collection of worn-out dolls," Wood wrote. Loy took the bottom of the bed, pressing against actress Arlene Dresser. Painter Charles Demuth draped himself at a right angle to the pair, flinging a leg over the side and revealing a garter. Duchamp squeezed in against the far wall, and Wood wedged herself in next to him, "an opportunity of discomfort that took me to heaven because I was so close to him," she remembered. "Lying practically on top of him, I could hear his beating heart and feel the coolness of his chest. Divinely happy, I never closed my eyes to sleep."

December * THE LORD OF MISRULE REIGNS

THE LORD OF MISRULE, KNOWN ALSO AS the Master of Merry Disports, ignited the Christmastime festivities from the late thirteenth through the early seventeenth century in England's grand households. These mock officials were voted into service or chosen by the head of the household, and charged with delighting one and all during the winter season, arranging "fine and subtle disguisings, masks and mummeries, with playing at cards for counters, nayles and points, in every house, more for pastimes than for gain," a reveler noted. There were feasts, concerts, silly plays, and dancing.

And with great pomp, the Christmas lords made it their duty to incite chaos. Dressed in fool's baubles, and riding canvas hobbyhorses, they commanded all residents of the house. In 1551, courtier George Ferrers (1500–1579) played Lord of Misrule for

Edward VI's lavish holiday parties. Wearing a gold robe trimmed with fur, he rode into London with a troupe of trumpeters, then thundered on to spend more than £500 on entertainment, which included a Drunken Masque, a joust, and a mock Midsummer Night party. In the early seventeenth century, Sir Richard Evelyn gave his friend and trumpeter an equally free hand as Lord of Misrule, drafting a document to ensure that the temporary regent would hold sway in Evelyn's house, insisting "every person or persons whatsoever, as well servants as others, to be at his command whensoever he shall sound his trumpet or music, and to do him good service, as though I were present myself, at their perils." No one was spared the man's merriment. "I give full power and authority to his lordship to break up all locks, bolts, bars, doors, and latches," Evelyn went on, "and to fling up all doors out of hinges, to come at those who presume to disobey his lordship's commands."

Beyond castle walls, villagers elected their own Christmas lords, who seemed especially prone to interrupting church services, usually accompanied by a raucous band of partiers dressed in scarves and laces, with jangling bells tied to their legs. The merry crew would storm in, "their pipers piping, their drummers thundering, their stumps dancing, their bells jingling, their handkerchiefs swinging about their heads like madmen, their hobbyhorses and other monsters skirmishing amongst the throng." Then they danced—a tradition that dated back to the ancient Roman Saturna-

lia, when similar rituals turned the everyday world upside down, with masters acting as servants while the servants ruled the day. Zealous seventeenth-century Puritans were appalled, of course, railing against the "reveling, epicurisme, wantonesse, idlenesse, dancing, drinking, stage-plaies, masques, and carnall pompe and jollity," as one grumbled, and against all else that accompanied the fanciful season of "Christmas disorders." Everyone else had a fine time.

4:20 AM ✳ BEBOP HEADS UPTOWN

Harlem's jazz musicians of the early 1940s traveled downtown to play West Fifty-second Street's nightclubs, but that big band swing didn't leave a lot of room for experimentation, and midtown's uptight bandleaders didn't suffer showy solos. At closing time—3:00 a.m.—virtuoso musicians such as trumpeter Dizzy Gillespie, drummer Kenny Clarke, pianist Thelonious Monk, and saxophonist Charlie Parker rushed back uptown for some fun. Bebop was the new style that emerged during their late-night jam sessions, as each flaunted an inimitable personal flair, warping traditional tempos and tweaking old techniques. It wasn't about entertainment or danceability. Bebop was strange, aggressive, and intentionally hard to play.

In the wee hours, they met at Minton's Playhouse on West 118th Street, a swanky supper club owned by Henry Minton, who, luckily, was also a delegate to Local 802 of the American Federation of Musicians. The 802 tried to keep musicians from playing in venues where they weren't getting paid, such as after-hours clubs. Wandering delegates shadowed musicians leaving work, trailing them to any place where they might jam. "There were big fines for playing jam sessions," Gillespie (1917–1993) remembered. "So we were taking a big risk." Those caught were charged a $100 to $500 fine. Minton's union position kept his club off-limits, so the musicians could do their thing.

As the night rolled on, if Monk (1920–1982) fell asleep at his piano, Gillespie mashed his finger and woke him up quick. It wasn't time for bed yet. When Minton's closed, the whole gang headed over to Monroe's Uptown House on West 134th Street, a hole-in-the-wall basement hangout that got going around four in the morning and kept rolling until nine. The scene was competitive, with each musician showing up the one before, and with old-school soloists pitted against eager up-and-comers. "The musicians used to go there and battle like dogs, every night, you know, just playing for nothing and having a good time," one patron remembered. Clark Monroe, a former tap dancer, made sure the musicians ate something. They'd need their strength. "When those guys came in to play, they wouldn't play one number or two numbers and get up and go," a Brooklyn saxophon-

ist remembered. "They'd be there all night long. . . . And when they'd finish, man, they'd be soaking wet."

All the while, they were creating a musical revolution. "What we were doing at Minton's was playing, seriously, creating a new dialogue among ourselves, blending our ideas into a new style of music," Gillespie explained. "You only have so many notes, and what makes a style is how you get from one note to the other. . . . We invented our own way of getting from one place to the next." Their new music didn't have a name in the early 1940s. They called it "modern," and musicians such as Gillespie and Monk dressed to match, not in cheesy swing band dinner jackets, but in berets, dark glasses or horn rims, and wide-lapelled suits. Their slang—"hip" and "cool"—infiltrated the mainstream just as their music did. When bebop traveled south from Minton's and Monroe's after 1944, and moved from late night to prime time downtown, its new fans called the music "bop."

Their work in the laboratory was done. "We needed to play to a wider audience," Gillespie said simply, "and Fifty-second Street seemed ready to pay to hear someone playing something new."

Living in Arizona as a teenager in the late 1920s, Eastern scholar Theos Bernard (1908–1947) could learn only so much yoga from books. Yet, anticipating the day when he'd be able to travel to India to study with the masters, Bernard slowly built up his stamina, locking himself in his room to practice various esoteric exercises and purifications, such as nasal cleansing, and swallowing long pieces of surgical gauze to clean his digestive tract. His favorite practice was the yogic headstand. He started slowly. For a week he stood on his head for only a minute at a time, three times a day. Slowly and gradually, he increased the time.

Then, in 1936, Bernard set off for an extensive trip through Asia and India, delving deeply into yoga, and encountering itinerant holy men and gurus, as he related in his book *Heaven Lies Within Us* (1939), one of the first explicit yoga texts written in English. His exuberance and rigorous preparations paid off when he undertook a three-month training with an exacting Indian maharishi. "I had scarcely sunk into sleep, when four o'clock came and I had to be up," he wrote. After his cleansing rituals and breathing exercises came the first of three one-hour headstands executed during the twelve hours of his practice. He didn't find it strenuous, though. While resting in a headstand, "it is possible to experience a peace of relaxation unavailable in any other form,"

Bernard wrote. "There is no other practice which enables one to experience such complete relaxation. The inner consciousness floods the mind; this is its greatest advantage. With this practice comes a strong tendency toward philosophical inquiry and perception which brings joy in its wake."

After India, Bernard pressed on to Lhasa, where Tibetan monks initiated him as the first "white lama." He returned to New York to write his PhD dissertation at Columbia University, and he became one of America's foremost authorities on Eastern spirituality. (His glamorous second wife, opera star Ganna Walska, complained of his constant headstanding when she filed for divorce.) Though Bernard disappeared during a return visit to the East in 1947, his writing influenced a growing number of yoga devotees. In those days, even Eleanor Roosevelt liked to start her day with an invigorating headstand.

BERNARD'S INSTRUCTIONS

Start slowly, wrote Bernard, and know when to stop. "When you first go up on your head, you will experience a feeling of complete relaxation, but as you begin to approach your capacity you will inevitably feel a nervous tension creeping over the body." As soon as small beads of perspiration begin to appear, it's time to come down.

Use the headstand to enter deep meditation. "Forget everything and try objectively to watch the mind," Bernard explained. "At first,

you will hear sounds and find the mind racing in all directions. Let
it race. Now try to follow some line of thought. . . . After I developed
the practice I found that all time was banished, yet some little inner
mechanism kept track of its passing.

"If the student desires to discover the unsteady state of the mind
in which he is living, there is no better way than to stand on the
head and observe what takes place. You will be amazed," he wrote.
"Try it and see."

4:50 AM ✳ FRESH MILK ON THE DOORSTEP

"Insomnia is the main cause of death in Rome," the poet Juve-
nal declared in 100 CE. "The thunder of wagons in those narrow
twisting streets, the oaths of the draymen caught in a jam, would
shatter the sleep of a deaf man—or a lazy walrus." Centuries later,
not much has changed. City-dwellers still complain about street
noise, the roar of the traffic, the sounds of garbage collection and
construction work, but few characters figured more centrally in
the noise debate of the nineteenth and early twentieth centuries
than the milkman.

"Every morning before 7 o'clock ten milkmen yell frantically,"
an English writer protested, detailing the morning racket on his
London street in 1880. "Then come two milk-carts, who drive

as if milk were the proper fluid with which to extinguish
the distant fire to which they seem hastening. Three strange
milkmen follow, who shout on alternate sides of the street
as if the residents of Marlborough road did nothing but drink
milk."

The same was true in New York City, where milkmen started
their rounds at 3:00 a.m., the sound of their clanking bottles and
rattling carts competing with early-morning church bells and car
horns. To anyone who might propose that milk deliveries begin
later, one New Yorker suggested that the whiner "go to bed at a
reasonable hour instead of playing the piano, screeching, and
banging the door till midnight." In doing so "he would confer a
great favor on those who like to sleep at night and get their milk
early in the morning."

Medical professionals over the centuries have agreed with
Juvenal that the noisy onslaught is bad for health. "The injury to
nervous and sick people resulting from unnecessary noises, and
especially annoying and exciting noises, cannot be measured
in the form of damages," a doctor explained in 1911. "There is a
nerve waste; there is a lowering of tone; and there is a susceptibil-
ity to alcoholic stimulant and a desire for it." New York, deemed
the noisiest city in the world, was so loud it could drive you to
drink. "Nowhere can the clanging and clashing, the scraping and
the shoving, the grinding and tooting and the whistling and the
screeching of this city be duplicated," the city's commissioner

of health huffed in 1920. "It is little wonder that we are a people of nerves and temper. Lack of sleep and lack of rest are the ideal conditions to bring on a state of neurasthenia."

The city's milk companies eventually refitted steel-wheeled delivery wagons with rubber tires, their horses with rubber shoes, and their milk bottle baskets with rubber shock absorbers. But the debate went on. Their efforts didn't go far enough for those who woke up to the sound of milk bottles rattling in the dumb-waiters. Others, though fewer in number, defended the delivery-men. "Just why is it necessary to pick on the tiny and not at all obnoxious noise made by the milkman, when absolutely nothing is done to stop the fiendish and perfectly useless shrieking of auto horns which goes on all night long and robs thousands of people of their needed rest?" a concerned citizen wrote to *The New York Times* in 1932.

In 1940, New Yorkers still drank 3,500,000 quarts of milk daily, 2,000,000 of which were privately delivered by a fleet of seven thousand milkmen, employing some two thousand horses. But the convenient new cardboard milk container had just been introduced, and antinoise campaigns had all but succeeded in turning the milkman—who now arrived almost silently in the dark—into "somewhat of a mystery man," according to the *Times*. Already, people waxed nostalgic for the old days when the milk-man jingle-jangled through the predawn streets. He'd become, as one reporter noted, just another "phantom figure of the night."

Waking to the dawn chorus is heavenly. "The birds sing at dawn,"
wrote Henry David Thoreau. "What sounds to be awakened by!
If only our sleep, our dreams, are such as to harmonize with the
song, the warbling, of the birds, ushering in the day." In many
cases, the birds' message is aggressive, though it might charm the
human ear. Male birds sing to ward off rivals and to woo females
in the early morning, trilling as many as thirty songs in a half
hour, rather than the usual five or six.

Still, since long ago, we've been entranced and have tried to
imitate the birds' morning sounds. The earliest piece of English
secular music is a thirteenth-century song in which the cuckoo
welcomes summer. German scholar Athanasius Kircher first
transcribed complex birdsong as music in 1650, scoring the
tweeting of a nightingale he'd heard. Beethoven mimicked the
songs of the cuckoo, nightingale, and quail in his Pastoral Sym-
phony, while Bartók's Piano Concerto no. 3 was inspired by the
birds the Hungarian composer heard singing in the mountains of
North Carolina.

Likewise, poets through the ages have lauded songbirds in
verse, and no bird more so than the nightingale, whose trill was at
the heart of English peasant-poet John Clare's work. As a coun-
try boy, Clare (1793–1864) was shy to reveal his love of poetry,

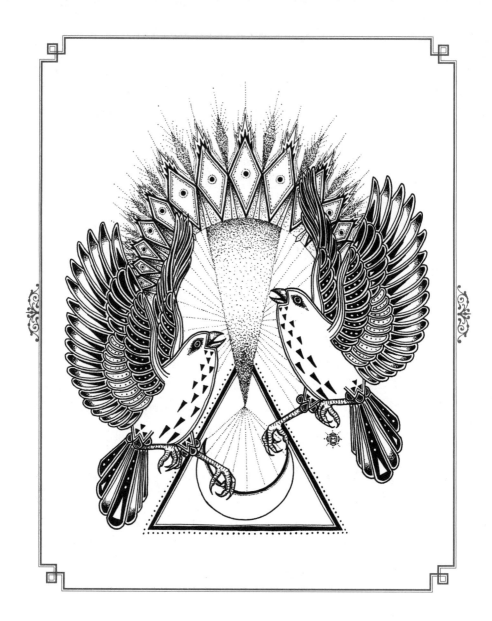

but listening to the birds gave him the courage to lay claim to his literary "right to song." He wrote:

And so it cheered me while I lay
Among their beautiful array
To think that I in humble dress
Might have a right to happiness
And sing as well as greater men;
And then I strung the lyre again

Clare transcribed the song of a nightingale perched in an apple orchard outside his window while living in Northborough in 1832, later inserting a flurry of pretty squawks into one of his poems. "I attempted to take down her notes but they are so varied that every time she starts again after the pauses seems to be something different to what she uttered before," he explained, "and many of her notes are sounds that cannot be written in the alphabet having no letters that can syllable the sounds." Yet, without a doubt, his deft attempt is both cheery and strangely hypnotic when read aloud (and please, do try it). It went like this:

Chew-chew chew-chew
Cheer-cheer cheer-cheer
Cheer-up cheer-up cheer-up
'tweet tweet jug jug jug

Wew-wew wew-wew, chur-chur chur-chur
Woo-it woo-it
Tee-rew tee-rew tee-rew tee-rew
Chew-rit chew-rit
Will-will will-will, grig-grig grig-grig

ACKNOWLEDGMENTS

It's true what they say about writing books: it's never as easy the second time around. I'm grateful to all those who have offered their kind support and encouragement, in the obvious ways and in ways unseen, including Nan Talese, Ronit Feldman, David Kuhn, Nico Jenkins, Susan Kerwin, Nancy Harmon Jenkins, Hampton Fancher, Eve MacSweeney, Joanna Bober, Jaya Ashmore, and Gemma Polo. I'd like to thank Eric Blake and Rosie Chabon for being enthusiastic supporters at a crucial moment. Thanks to Larry Rosenwald for so beautifully channeling the spirit of Wolfram von Eschenbach. Thanks to Molly Blake for all her magic. Thanks to Marie Alice Hurvitt and Peggy Watson for their golden ears. And thanks to Katurah Hutcheson for always being in sync.

Additionally, I'm grateful for the use of the University of Maine's Folger Library, and for the libraries at Colby, Bates, and

Bowdoin and at Husson University, as well as the Blue Hill Public Library, and those of the Maine State Library System. To those working in the Google Books program, a deep bow. I'm always amazed at the out-of-print treasures I find buried deep in the digital archives.

BIBLIOGraPHY

INTRODUCTION

Randall, Lilian M. C. "Games and the Passion in Pucelle's 'Hours of Jeanne d'Évreux.' "
 Speculum 47, no. 2 (April 1972): 246–257.

THE CIRCUS COMES TO TOWN

Davis, Janet M. *The Circus Age: Culture & Society Under the American Big Top*. Chapel Hill: Univer-
 sity of North Carolina Press, 2002.
Fenner, Mildred Sandison, and Wolcott Fenner, eds. *The Circus Lure and Legend*. Englewood
 Cliffs, N.J.: Prentice-Hall, 1970.
Frost, Thomas. *Circus Life and Circus Celebrities*. 1875. Detroit: Singing Tree Press, 1970.
Kirk, Rhina. *Circus Heroes and Heroines*. Maplewood, N.J.: Hammond, 1972.
Renoff, Gregory J. *The Big Tent: The Traveling Circus in Georgia, 1820–1930*. Athens: University
 of Georgia Press, 2008.
Ringling, Alfred T. *Life Story of the Ringling Brothers*. Chicago: R. R. Donnelley, 1900.
Sandburg, Carl. *Always the Young Strangers*. New York: Harcourt, Brace, 1953.

LOVERS PART

Battles, Paul. "Chaucer and the Traditions of Dawn-Song." *Chaucer Review* 31, no. 4 (1997):
 317–338.

Colaco, Jill. "The Window Scenes in 'Romeo and Juliet' and Folk Songs of the Night Visit." *Studies in Philology* 83, no. 2 (Spring 1986): 138–157.

Frankel, Hermann Ferdinand. *Ovid: A Poet Between Two Worlds.* Berkeley: University of California Press, 1945.

Hatto, Arthur Thomas, ed. *Eos: An Enquiry into the Theme of Lovers' Meetings and Partings at Dawn in Poetry.* The Hague: Moulton, 1965.

Ovid. *Heroides and Amores.* Translated by Grant Showerman. New York: G. P. Putnam's Sons, 1921.

Pearcy, Lee T. *The Mediated Muse: English Translations of Ovid, 1560–1700.* Hemden, Conn.: Archon Books, 1984.

Saville, Jonathan. *The Medieval Erotic Alba: Structure as Meaning.* New York: Columbia University Press, 1972.

Sigal, Gale. *Erotic Dawn Songs of the Middle Ages: Voicing the Lyric Lady.* Gainesville: University Press of Florida, 1996.

Thorne-Thomsen, Sara. "'Adam's Aubade' and the Medieval Alba." *South Atlantic Review* 54, no. 1 (January 1989): 13–26.

THE KABUKI DRUMS BOOM

Brandon, James R. "Kabuki and Shakespeare: Balancing Yin and Yang." *TDR* 43, no. 2 (Summer 1999): 15–53.

Clark, Timothy T., Osamu Ueda, Donald Jenkins, and Naomi Noble Richard. *The Actor's Image: Print Makers of the Katsukawa School.* Chicago: Art Institute of Chicago, in association with Princeton University Press, 1964.

Ernst, Earl. *The Kabuki Theatre.* Honolulu: University of Hawaii Press, 1974.

Hickman, Money L. "Views of the Floating World." *MFA Bulletin* 76 (1978): 4–33.

Hume, Nancy G., ed. *Japanese Aesthetics and Culture: A Reader.* Albany: State University of New York Press, 1995.

Scott, A. C. *The Kabuki Theatre of Japan.* 1955. Mineola, N.Y.: Dover, 1999.

Shively, Donald H. "Bakufu Versus Kabuki." *Harvard Journal of Asiatic Studies* 18, no. 3/4 (December 1955): 326–356.

SKATERS GLIDE ON ICE

Andrews, William. *Famous Frosts and Frost Fairs in Great Britain: Chronicled from the Earliest to the Present Time.* London: G. Redway, 1887.

Anisimov, Evgeni Viktorovich. *Five Empresses: Court Life in Eighteenth-Century Russia.* Translated by Kathleen Carol. Westport, Conn.: Praeger, 2004.

Cunningham, Peter, and Henry Benjamin Wheatley. *London Past and Present: Its History, Associations, and Traditions.* Cambridge: Cambridge University Press, 2011.

Dier, J. C. *A Book of Winter Sports*. New York: Macmillan, 1912.

Fitz-Stephen's description of the city of London. By An Antiquary. London: B. White, 1772.

Gosnell, Mariana. *Ice: The Nature, the History, and the Uses of an Astonishing Substance*. New York: Alfred A. Knopf, 2005.

Hibbert, Christopher, and Ben Weinreb. *The London Encyclopaedia*. New York: St. Martin's Press, 1986.

Shvidkovsky, Dimitry Olegovich. *Russian Architecture and the West*. Photographs by Yekaterian Shorban. Translated by Antony Wood. New Haven: Yale University Press, 2007.

MATISSE BOWS TO CÉZANNE

Andersen, Wayne V. *The Youth of Cézanne and Zola: Notoriety at Its Source; Art and Literature in Paris*. Boston: Editions Fabiart, 2003.

Bois, Yve-Alain, and Rosalind Krauss. "Cézanne: Words and Deeds." *October* 84 (Spring 1998): 31–43.

Cézanne, Paul. *Conversations with Cézanne*. Edited by P. M. Doran. Translated by Julie Lawrence Cochran. Berkeley: University of California Press, 2001.

Garb, Tamar. "Visuality and Sexuality in Cézanne's Late 'Bathers.' " *Oxford Art Journal* 19, no. 2 (1996): 46–60.

Krumrine, Mary Louise. "Cézanne's 'Restricted Power': Further Reflections on the 'Bathers.' " *Burlington Magazine* 134, no. 1074 (September 1992): 586–595.

Mack, Gerstle. *Paul Cézanne*. New York: Alfred A. Knopf, 1942.

McPhee, Laura. *A Journey into Matisse's South of France*. Berkeley: Roaring Forties Press, 2006.

Rewald, John. *Cézanne, the Steins, and Their Circle*. New York: Thames & Hudson, 1987.

Spurling, Hilary. *Matisse the Master: A Life of Henri Matisse; the Conquest of Colour, 1909–1954*. New York: Alfred A. Knopf, 2005.

———. *The Unknown Matisse: A Life of Henri Matisse; the Early Years, 1869–1908*. New York: Alfred A. Knopf, 1998.

MARIGOLDS AWAKE

Blunt, Wilfrid. *Linnaeus: The Compleat Naturalist*. Princeton, N.J.: Princeton University Press, 2001.

Caddy, Florence. *Through the Fields with Linnaeus: A Chapter in Swedish History*. London: Longmans, Green, 1887.

Coren, Stanley. *Sleep Thieves*. New York: Free Press, 1996; Simon & Schuster, 1997.

Darwin, Charles. *The Life and Letters of Charles Darwin, Including an Autobiographical Chapter*. Edited by Francis Darwin. Vol. 3. London: John Murray, 1888.

———. *More Letters of Charles Darwin*. Edited by Francis Darwin and A. C. Seward. Vol. 2. London: John Murray, 1903.

Ladies' Companion. "Wild Flowers of June." Vol. 4. Bradbury & Evans, 1851.

Poulton, Sir Edward Bagnall. *Charles Darwin and the Origin of Species: Addresses, etc., in America and England in the Year of the Two Anniversaries.* London: Longmans, Green, 1909.

Reingold, Edward M., and Nachum Dershowitz. *Calendrical Calculations: The Millennium Edition.* Cambridge: Cambridge University Press, 2001.

FINDING ONESELF

Garelick, Rhonda K. *Electric Salome: Loie Fuller's Performance of Modernism.* Princeton, N.J.: Princeton University Press, 2007.

Goodman-Soellner, Elise. "Boucher's 'Madame de Pompadour at Her Toilette.'" *Simiolus: Netherlands Quarterly for the History of Art* 17, no. 1: 41–58.

Kappel, Caroline J. "Labyrinthine Depictions and Tempting Colors: The Synaesthetic Dances of Loie Fuller as Symbolist Choreographer." PhD dissertation, College of Fine Arts, University of Ohio, November 2007.

McCarren, Felicia. "The 'Symptomatic Act' circa 1900: Hysteria, Hypnosis, Electricity, Dance." *Critical Inquiry* 21, no. 4 (Summer 1995): 748–774.

Melchior-Bonnet, Sabine. *The Mirror: A History.* New York: Routledge, 2001.

Pendergrast, Mark. *Mirror, Mirror: A History of the Human Love Affair with Reflection.* New York: Basic Books, 2004.

Sommer, Sally R. "Loie Fuller's Art of Music and Light." *Dance Chronicle* 4, no. 4 (1980): 389–401.

PANCAKES AND DOUGHNUTS ARE PILED HIGH

Barnard, Eunice Fuller. "Our Filling Station: The Soda Fountain." *New York Times,* February 2, 1930.

Barnes, Donna R. *Matters of Taste: Food and Drink in Seventeenth-Century Dutch Art and Life.* Albany, N.Y.: Albany Institute of History and Art; Syracuse, N.Y.: Syracuse University Press, 2002.

Barnhart, David K., and Allan A. Metcalf. *America in So Many Words: Words That Have Shaped America.* Boston: Houghton Mifflin, 1997.

Clarke, J. Erskine, ed. *Chatterbox.* Boston: Estes & Lauriat, 1896.

Conlin, Joseph R. "Old Boy, Did You Get Enough of Pie? A Social History of Food in Logging Camps." *Journal of Forest History* 23, no. 4 (October 1979): 164–185.

Edge, John T. *Donuts: An American Passion.* New York: G. P. Putnam's Sons, 2006.

Feldman, David. *Why Do Clocks Run Clockwise?* New York: Harper & Row, 1987.

Hynes, Mary Ellen. *Companion to the Calendar.* Chicago: Liturgy Training, 1993.

Idler, and Breakfast-Table Companion. "Shrove Tuesday." February 24, 1838.

MacKenzie, Catherine. "Shrove Tuesday Brings Pancakes." *New York Times,* March 3, 1935.

Marks, Gil. *Encyclopedia of Jewish Food.* Hoboken, N.J.: Wiley, 2010.

New York Times. "Down-East Dinners. May 8, 1881.

Steinberg, Sally Levitt. *The Donut Book: The Whole Story in Words, Pictures & Outrageous Tales.* North Adams, Mass.: Storey, 2004.

———. "How Doughnuts Won America." *New York Times,* May 6, 1981.

KING LOUIS XIV RISES

Dollar Magazine. "A Day of Louis XIV." Wilson, 1842.

Farmer, James Eugene. *Versailles and the Court Under Louis XIV.* New York: Century, 1905.

France d'Hézecques, Félix, comte de. *Recollections of a Page at the Court of Louis XVI.* London: Hurst & Blackett, 1873.

Hunter, Penelope. "A Royal Taste: Louis XV—1738." *Metropolitan Museum Journal* 7 (1973): 89–113.

Mansel, Philip. *Dressed to Rule: Royal and Court Costume from Louis XIV to Elizabeth II.* New Haven: Yale University Press, 2005.

Mitford, Nancy. *Madame de Pompadour.* New York: Harper & Row, 1968.

Purdy, Daniel L., ed. *The Rise of Fashion: A Reader.* Minneapolis: University of Minnesota Press, 2004.

KEATS LOVES AND LOSES

Casson, T. E. Review of *Letters of Fanny Brawne to Fanny Keats (1820–1824),* ed. F. Edgcumbe; *Life of John Keats,* by Charles Armitage Brown; *Some Letters and Miscellanea of Charles Brown, Friend of John Keats and Thomas Richards,* ed. Maurice Buxton Forman. *Review of English Studies* 14, no. 56 (October 1938): 490–492.

Finney, C. L. Review of *Letters of Fanny Brawne to Fanny Keats (1820–1824),* ed. F. Edgcumbe; *Life of John Keats,* by Charles Armitage Brown; *Some Letters and Miscellanea of Charles Brown, Friend of John Keats and Thomas Richards,* ed. Maurice Buxton Forman. *Modern Language Notes* 54, no. 2 (February 1939): 153–154.

Hancock, Albert Elmer. *John Keats: A Literary Biography.* Boston; New York: Houghton Mifflin, 1908.

Keats, John. *The Complete Poetical Works and Letters of John Keats.* Edited by Horace Elisha Scudder. Boston: Houghton Mifflin, 1899.

———. *Selected Letters of John Keats.* Edited by Grant F. Scott. rev. ed. Cambridge, Mass.: Harvard University Press, 2002.

Rollins, Hyder Edward, and Stephen Maxfield Parrish, eds. *Keats and the Bostonians: Letters and Papers, 1889–1931.* Cambridge, Mass.: Harvard University Press, 1951.

Smith, Hillas. "John Keats: Poet, Patient, Physician." *Clinical Infectious Diseases* 6, no. 3 (May/June 1984): 390–404.

THE PRE-RAPHAELITES GET TO WORK

Beerbohm, Max. *Rossetti and His Circle*. new ed. New Haven: Yale University Press, 1987.
Bryden, Inga. *The Pre-Raphaelites: Writings and Sources*. Vol. 2. London; New York: Routledge/ Thoemmes Press, 1998.
Grylls, Rosalie Glynn. *Portrait of Rossetti*. London: Macdonald, 1964.
MacCarthy, Fiona. *William Morris: A Life for Our Time*. New York: Alfred A. Knopf, 1995.
Morris, William. *The Collected Letters of William Morris*. Edited by Normal Kelvin. Vol. 1, *1848– 1880*. Princeton, N.J.: Princeton University Press, 1984.
Rossetti, Dante Gabriel. *The Correspondence of Dante Gabriel Rossetti*. Edited by William E. Fredeman. Vol. 2, *The Formative Years, 1835–1862*. Cambridge, U.K., and Rochester, N.Y.: D. S. Brewer, 2004.
———. *His Family Letters; with a Memoir by William Michael Rossetti*. Vol. 1. 1895. New York: Kirtas Books, 2011.

THE 20TH CENTURY LIMITED ARRIVES AT GRAND CENTRAL

Beebe, Lucius. "The Greatest Train in the World." *New York Times*, June 10, 1962.
Behrend, George. *Luxury Trains: From the Orient Express to the TGV*. New York: Vendome Press, 1981.
Belle, John, and Maxinne Rhea Leighton. *Grand Central: Gateway to a Million Lives*. New York: Norton, 2000.
Loeb, August. "Hot on the Trail of Celebrities." *New York Times*, January 29, 1939.
New York Times. "A Film Star Arrives: Clever Actress's New Role." February 2, 1930.
———. "New 18-Hour Flier Speeding to Chicago." June 19, 1905.
O'Doherty, Brian. "Train Is Honored on 60th Birthday." *New York Times*, June 16, 1962.
Sanders, Craig. *Limiteds, Locals, and Expresses in Indiana, 1838–1971*. Bloomington: Indiana University Press, 2003.
Solomon, Brian. *Railway Masterpieces*. Iola, Wis.: Krause Publications, 2002.
Stilgoe, John R. *Metropolitan Corridor: Railroads and the American Scene*. New Haven: Yale University Press, 1983.
Welsh, Joe. *The American Railroad*. Osceola, Wis.: MBI, 1999.
Williamson, Charles. *Lady Betty Across the Water*. Edited by A. M. Williamson. New York: McClure, Phillips, 1906.
Zimmerman, Karl R. *20th Century Limited*. St. Paul, Minn.: MBI, 2002.

THE WORLD IS BORN

Cipolla, Carlo M. *Clocks and Culture*. London: Collins, 1967; New York: Norton, 1977.

Gatty, Alfred. *The Bell: Its Origin, History, and Uses*. London: G. Bell, 1848.

Lachieze-Rey, Marc. *Celestial Treasury: From the Music of the Spheres to the Conquest of Space*. Cambridge: Cambridge University Press, 2001.

Landes, David S. *Revolution in Time: Clocks and the Making of the Modern World*. Cambridge, Mass.: Harvard University Press / Belknap Press, 1983.

Macey, Samuel L. *Clocks and the Cosmos: Time in Western Life and Thought*. Hamden, Conn.: Archon Books, 1980.

Percy, Martyn. *Clergy: The Origin of Species*. London and New York: Continuum, 2006.

HOT CHOCOLATE SERVED WITH FLAIR

Boime, Albert. *Art in an Age of Bonapartism, 1800–1815*. Chicago: University of Chicago Press, 1990.

Fisher, Frederick Augustus. "Travels Through Spain in 1797 and 1798." *The European Magazine, and London Review* 42 (December 1802).

Goodrich, Charles A. *The Universal Traveller*. Hartford, Conn.: Canfield & Robins, 1836.

Grivetti, Louis Evan, and Howard-Yana Shapiro, eds. *Chocolate: History, Culture, and Heritage*. Hoboken, N.J.: Wiley, 2009.

Martin Gaite, Carmen. *Love Customs in Eighteenth-Century Spain*. Berkeley: University of California Press, 1991.

Stirling, Anna Maria Diana Wilhelmina Pickering. *Memoirs of Anna Maria Wilhelmina Pickering, Edited by Her Son, Spencer Pickering, F.R.S.; Together with Extracts from the Journals of Her Father, John Spencer Stanhope, F.R.S. . . .* Translated by Maria G. Tomisch. London: Hodder & Stoughton, 1903.

Townsend, Joseph. *A Journey Through Spain in the Years 1786 and 1787*. London: C. Dilly, 1791.

MODELS DISROBE

Becker, Jane R., and Gabriel P. Weisberg, eds. *Overcoming All Obstacles: The Women of the Académie Julian*. New York: Dahesh Museum; New Brunswick, N.J.: Rutgers University Press, 1999.

Collier, Peter, and Robert Lethbridge, eds. *Artistic Relations: Literature and the Visual Arts in Nineteenth-Century France*. New Haven: Yale University Press, 1994.

Jiminez, Jill Berk, ed., and Joanna Banham, assoc. ed. *Dictionary of Artists' Models*. Chicago: Fitzory Dearborn, 2001.

Lathers, Marie. *Bodies of Art: French Literary Realism and the Artist's Model*. Lincoln: University of Nebraska Press, 2001.

Prieto, Laura R. *At Home in the Studio: The Professionalization of Women Artists in America.* Cambridge, Mass.: Harvard University Press, 2001.

Waller, Susan. *The Invention of the Model: Artists and Models in Paris, 1830–1870.* Burlington, Vt.: Ashgate, 2006.

THE ROYAL TABLECLOTH IS LAID

Aslet, Clive. *The Story of Greenwich.* Cambridge, Mass.: Harvard University Press, 1999.

Coffin, Sarah, ed. *Feeding Desire: Design and the Tools of the Table, 1500–2005.* New York: Assouline, in association with Cooper Hewitt, National Design Museum, 2006.

Crook, Charles Williamson, and William Henry Weston. *Our English Home.* London and Edinburgh: T. C. & E. C. Jack, 1904.

Fletcher, Nichola. *Charlemagne's Tablecloth: A Piquant History of Feasting.* New York: St. Martin's Press, 2005.

Hazard, Mary E. *Elizabethan Silent Language.* Lincoln: University of Nebraska Press, 2000.

Meads, Chris. *Banquets Set Forth: Banqueting in English Renaissance Drama.* Manchester, U.K.: Manchester University Press, 2001.

Montagu, Lady Mary Wortley. *The Complete Letters of Lady Mary Wortley Montagu.* Edited by Robert Halsband. Oxford: Clarendon Press, 1965–1967.

Murphy, Claudia Quigley. *The History of the Art of Tablesetting, Ancient and Modern, from Anglo-Saxon Days to the Present Time.* New York: De Vinne Press, 1921.

Pepys, Samuel. *The Diary of Samuel Pepys.* Edited by Robert Latham, William Matthews, et al. Berkeley: University of California Press, 1983.

Toussaint-Samat, Maguelonne. *A History of Food.* Chichester, U.K., and Malden, Mass.: Wiley-Blackwell, 2009.

Visser, Margaret. *Rituals of Dinner: The Origins, Evolution, Eccentricities, and Meaning of Table Manners.* New York: Grove Weidenfeld, 1991.

Von Drachenfels, Suzanne. *Art of the Table: A Complete Guide to Table Setting, Table Manners, and Tableware.* New York: Simon & Schuster, 2000.

Williams, Robert Folkestone. *Domestic Memoirs of the Royal Family and the Court of England.* London: Hurst & Blackett, 1860.

PILGRIMS EMBARK

Allen, Rosamund. *Eastward Bound: Travel and Travellers, 1050–1550.* Manchester, U.K.: Manchester University Press, 2004.

Chard, Chloe. *Pleasure and Guilt on the Grand Tour: Travel Writing and Imaginative Geography, 1600–1830.* Manchester, U.K.: Manchester University Press; New York: St. Martin's Press, 1999.

Chareyron, Nicole. *Pilgrims to Jerusalem in the Middle Ages*. Translated by W. Donald Wilson. New York: Columbia University Press, 2005.

Coleman, Simon, and John Elsner. *Pilgrimage: Past and Present in World Religions*. Cambridge, Mass.: Harvard University Press, 1995.

Craig, Leigh Ann. *Wandering Women and Holy Matrons: Women as Pilgrims in the Later Middle Ages*. Boston: Brill, 2009.

Dietz, Maribel. *Wandering Monks, Virgins, and Pilgrims: Ascetic Travel in the Mediterranean World, AD 300–800*. University Park: Pennsylvania State University Press, 2005.

Schaus, Margaret, ed. *Women and Gender in Medieval Europe: An Encyclopedia*. New York: Routledge, 2006.

Zacher, Christian K. *Curiosity and Pilgrimage: The Literature of Discovery in Fourteenth-Century England*. Baltimore: Johns Hopkins University Press, 1976.

BECKETT AND JOYCE STROLL ALONG THE SEINE

Beckett, Samuel. *Beckett Remembering, Remembering Beckett: A Centenary Celebration*. Edited by James Knowlson and Elizabeth Knowlson. New York: Arcade, 2006.

Cronin, Anthony. *Samuel Beckett: The Last Modernist*. New York: HarperCollins, 1997.

Gluck, Barbara Reich. *Beckett and Joyce: Friendship and Fiction*. Lewisburg, Pa.: Bucknell University Press, 1979.

Gordon, Lois G. *The World of Samuel Beckett, 1906–1946*. New Haven: Yale University Press, 1996.

Knowlson, James. *Damned to Fame: The Life of Samuel Beckett*. New York: Simon & Schuster, 1996.

SOCIETY VISITS THE POOR

Brontë, Emily. *Wuthering Heights*. New York: Harper & Brothers, 1858.

Gestrich, Andreas, Steven King, and Lutz Raphael, eds. *Being Poor in Modern Europe: Historical Perspectives 1800–1940*. Die Deutsche Bibliothek, 2006.

Hervey, George Winfred. *The Principles of Courtesy: With Hints and Observations on Manners and Habits*. New York: Harper, 1852.

Hill, Octavia. *Our Common Land (and Other Short Essays)*. London: Macmillan, 1877.

Langland, Elizabeth. *Nobody's Angels: Middle Class Women and Domestic Ideology in Victorian Culture*. Ithaca, N.Y.: Cornell University Press, 1995.

Perkin, Joan. *Victorian Women*. New York: New York University Press, 1995.

Perrot, Philippe. *Fashioning the Bourgeoisie: A History of Clothing in the Nineteenth Century*. Princeton, N.J.: Princeton University Press, 1994.

Prochaska, F. K. *Women and Philanthropy in Nineteenth-Century England*. Oxford: Clarendon Press; New York: Oxford University Press, 1980.

Quinlan, Maurice James. *Victorian Prelude: A History of English Manners, 1700–1830*. 1941. London: Frank Cass, 1965.

Stokes, Rose H. Phelps. "The Condition of Working Women, From the Woman's Viewpoint." *Annals of the American Academy of Political and Social Science* 27 (May 1906): 165–175.

Vicinus, Martha. *Independent Women: Work and Community for Single Women, 1850–1920*. Chicago: University of Chicago Press, 1985.

OSCAR WILDE TAKES NEW YORK

Ellmann, Richard. *Oscar Wilde*. New York: Alfred A. Knopf, 1987.

O'Brien, Kevin H. F. " 'The House Beautiful': A Reconstruction of Oscar Wilde's American Lecture." *Victorian Studies* 17, no. 4 (June 1974): 395–418.

Ricketts, Charles S. *Oscar Wilde, Recollections*. 1932. Folcroft, Pa.: Folcroft Press, 1969.

Shafer, Elizabeth. "The Wild, Wild West of Oscar Wilde." *Montana: The Magazine of Western History* 20, no. 2 (Spring 1970): 86–88.

THE MARQUISE DE POMPADOUR PAINTS HER FACE

Annales: Cercle Huitois des Sciences et Beaux Arts, Tome VII. Paris: Huy, 1886.

Auricchio, Laura. Review of *Making Up the Rococo: François Boucher and His Critics,* by Melissa Hyde; *Rethinking Boucher,* eds. Melissa Hyde and Ledbury. *Art Bulletin* 89, no. 3 (September 2007): 597–601.

Bremer-David, Charissa. *Paris: Life & Luxury in the Eighteenth Century*. Los Angeles: J. Paul Getty Museum, 2011.

Garb, Tamar. *The Painted Face*: *Portraits of Women in France, 1814–1914*. New Haven: Yale University Press, 2007.

Goodman-Soellner, Elise. "Boucher's 'Madame de Pompadour at Her Toilette.' " *Simiolus: Netherlands Quarterly for the History of Art* 17, no. 1 (1987): 41–58.

Hyde, Melissa. "The 'Makeup' of the Marquise: Boucher's Portrait of Pompadour at Her Toilette." *Art Bulletin* 82, no. 3 (September 2000): 453–475.

Lever, Evelyne. *Madame de Pompadour: A Life*. New York, Farrar, Straus & Giroux, 2002.

TOURISTS TAKE THE SUN

Corbin, Alain. *The Lure of the Sea: The Discovery of the Seaside in the Western World, 1750–1840*. Translated by Jocelyn Phelps. Berkeley: University of California Press, 1994.

Crouch, David, and Nina Lubbren, eds. *Visual Culture and Tourism*. New York: Berg, 2003.

Gray, Fred. *Designing the Seaside: Architecture, Society and Nature*. London: Reaktion, 2006.

Lencek, Lena, and Gideon Bosker. *The Beach: The History of Paradise on Earth*. New York: Viking, 1998.

Löfgren, Orvar. *On Holiday: A History of Vacationing*. Berkeley: University of California Press, 1999.

McBrien, William. *Cole Porter: A Biography*. New York: Alfred A. Knopf, 1998.

Richardson, John, with Marilyn McCully. *A Life of Picasso: The Triumphant Years, 1917–1932*. New York: Random House, 1991; Alfred A. Knopf, 2007.

Valli, Amanda. *Everybody Was So Young: Gerald and Sara Murphy, a Lost Generation Love Story*. New York: Broadway Books, 1999.

Walton, John K. *The British Seaside: Holidays and Resorts in the Twentieth Century*. Manchester, U.K.: Manchester University Press; New York: St. Martin's Press, 2000.

SHADE IN THE GARDEN GROTTO

Aubrey, John. *Aubrey's Brief Lives: Edited from the Original Manuscripts*. . . . Foreword by Edmund Wilson. Ann Arbor: University of Michigan Press, 1957.

Baird, Rosemary. *Goodwood House*. Chichester: Goodwood Estate Company, 2004.

Bracher, Frederick. "Pope's Grotto: The Maze of Fancy." *Huntington Library Quarterly* 12, no. 2 (February 1949): 141–162.

Carruthers, Robert. *The Life of Alexander Pope, Including Extracts from His Correspondence*. London: H. G. Bohn, 1857.

Dance, Peter. "Delights for the Eyes and the Mind: A Brief Survey of Conchological Books." www.bio-nica.info/biblioteca/DanceBibliophile.pdf (accessed October 30, 2012).

Jackson, Hazelle. *Shell Houses and Grottoes*. Princes Risborough, U.K.: Shire, 2001.

Knox, Tim. "The Artificial Grotto in Britain." *The Magazine Antiques,* June 2002.

McGee, C. E. "The Presentment of Bushell's Rock: Place, Politics, and Theatrical Self-Promotion." *Medieval & Renaissance Drama in England* 16 (January 2003): 39.

Miller, Naomi. *Heavenly Caves: Reflections on the Garden Grotto*. New York: Braziller, 1982.

Sade, Jacques-François-Paul-Aldonce de. *The Life of Petrarch: Collected from Memoires pour la vie de Petrarch*. 1775. Philadelphia: Samuel A. Mitchell & Horace Ames, 1817.

Stutman, Laura Klein. "Two Philadelphia Shadow-Box Grottoes." *The Magazine Antiques,* March 2002.

LUNCH ON HIGH

Berman, John S. *The Empire State Building*. New York: Barnes & Noble Books, 2003.

Douglas, George H. *Skyscrapers: A Social History of the Very Tall Building in America*. Jefferson, N.C.: McFarland, 2004.

Korom, Joseph J. *The American Skyscraper: 1850–1940: A Celebration of Height*. Boston: Branden Books, 2008.

Langmead, Donald. *Icons of American Architecture: From the Alamo to the World Trade Center.* Westport, Conn.: Greenwood Press, 2009.

Moudry, Roberta, ed. *The American Skyscraper, Cultural Histories.* New York: Cambridge University Press, 2005.

Vischer, Peter. "Every Day's Work a Gamble with Death." *Popular Science,* November 1925.

CHERRY BLOSSOMS FALL

Berry, Mary Elizabeth. *Hideyoshi.* Cambridge, Mass.: Harvard University Press, 1982.

Brazell, Karen. "Towazugatari: Autobiography of a Kamakura Court Lady." *Harvard Journal of Asiatic Studies* 31 (1971): 220–233.

Brown, Steven T. *Theatricalities of Power: The Cultural Politics of Noh.* Stanford, Calif.: Stanford University Press, 2001.

Ikeda, Janet. "Memorialized in Verse: Hideyoshi's Daigo Hanami of 1598." *Oboegaki* 5, no. 1 (April 1995): 1–6.

Ikegama, Eiko. *Bonds of Civility: Aesthetic Networks and the Political Origins of Japanese Culture.* Cambridge: Cambridge University Press, 2005.

Keene, Donald. "Japanese Aesthetics." *Philosophy East and West* 19, no. 3 (July 1969): 293–306.

———. "The Japanese Idea of Beauty." *Wilson Quarterly* 13, no. 1 (New Year's 1989): 128–135.

Sosnoski, Daniel, ed. *Introduction to Japanese Culture.* Rutland, Vt.: Tuttle, 1996.

Viglielmo, V. H. "On Donald Keene's 'Japanese Aesthetics.'" *Philosophy East and West* 19, no. 3 (July 1969): 317–322.

Watsky, Andrew Mark. *Chikubushima: Deploying the Sacred Arts in Momoyama Japan.* Seattle: University of Washington Press, 2004.

Weston, Mark. *Giants of Japan: The Lives of Japan's Greatest Men and Women.* New York: Kodansha International, 2002.

THOREAU BREAKS FOR LUNCH

Maynard, W. Barksdale. *Walden Pond: A History.* New York: Oxford University Press, 2004.

Myerson, Joel, ed. *Critical Essays on Henry David Thoreau's "Walden."* Boston: G. K. Hall, 1988.

Salt, Henry Stephens. *Life of Henry David Thoreau.* Edited by George Hendrick, Wilene Hendrick, and Fritz Oehischlaeger. Urbana: University of Illinois Press, 1993.

Thoreau, Henry David. *Thoreau and the Art of Life: Precepts and Principles.* Edited by Roderick MacIver. North Ferrisburg, Vt.: Heron Dance Press, 2006.

———. *Walden: A Fully Annotated Edition.* Edited by Jeffrey S. Cramer. New Haven: Yale University Press, 2004.

———. *Walden and Other Writings.* Edited by Brooks Atkinson. New York: Modern Library, 1950.

Wagenknecht, Edward. *Henry David Thoreau, What Manner of Man?* Amherst: University of Massachusetts Press, 1981.

Clunas, Craig. "The Art of Social Climbing in Sixteenth-Century China." *Burlington Magazine* 133, no. 1059 (June 1991): 368–375.

Dardess, John W. Review of *Return to Dragon Mountain: Memories of a Late Ming Man,* by Jonathan D. Spence. *American Historical Review* 113, no. 4 (October 2008): 1135.

Freedman, Paul H., ed. *Food: The History of Taste.* Berkeley: University of California Press, 2007.

Hanan, Patrick. *The Invention of Li Yu.* Cambridge, Mass: Harvard University Press, 1988.

Lockard, Craig A. *Societies, Networks and Transitions: A Global History.* Boston: Houghton Mifflin, 2008.

Spence, Jonathan D. *Return to Dragon Mountain: Memories of a Late Ming Man.* New York: Viking, 2007.

NAPTIME

Burns, John. "A Fondness for Naps Persists in Maoist China." *New York Times,* September 30, 1973.

Coren, Stanley. *Sleep Thieves: An Eye-Opening Exploration into the Science and Mysteries of Sleep.* New York: Free Press, 1996.

De Mente, Boye. *Chinese Etiquette & Ethics in Business.* 2nd ed. Lincolnwood, Ill.: NTC Business Books, 1994.

Horne, Jim. *Sleepfaring: A Journey Through the Science of Sleep.* New York: Oxford University Press, 2007.

Kroemer, Karl H. E., and Anne, Kroemer. *Office Ergonomics.* London: Taylor & Francis, 2001.

MacLean, Renwick. "For Many in Spain, Siesta Ends." *New York Times,* January 1, 2006.

Solomon, Irvin D. *Thomas Edison: The Fort Myers Connection.* Charleston, S.C.: Arcadia, 2001.

Steger, Brigitte, and Lodewijk Brunt, eds. *Night-Time and Sleep in Asia and the West: Exploring the Dark Side of Life.* London: Routledge Curazon, 2003.

Stone, Gene. *The Secrets of People Who Never Get Sick.* New York: Workman, 2010.

PAGES TURN, PLOTS THICKEN

Binhammer, Katherine. "The Persistence of Reading: Governing Female Novel-Reading in Memoirs of Emma Courtney and Memoirs of Modern Philosophers." *Eighteenth-Century Life* 27, no. 2 (Spring 2003): 1–22.

Burney, Fanny. *A Known Scribbler: Frances Burney on Literary Life.* Edited by Justine Crump. New York: Broadway Press, 2002.

Flint, Kate. *The Woman Reader, 1837–1914.* Oxford: Clarendon Press; New York: Oxford University Press, 1993.

Pearson, Jacqueline. *Women's Reading in Britain, 1750–1835: A Dangerous Recreation*. Cambridge: Cambridge University Press, 1999.

Spacks, Patricia Ann Meyer. *Boredom: The Literary History of a State of Mind*. Chicago: University of Chicago Press, 1995.

Taylor, Karen L. *The Facts on File Companion to the French Novel*. New York: Facts on File, 2006.

JOSEPH BEUYS EYES THE COYOTE

Adams, David. "Joseph Beuys: Pioneer of a Radical Ecology." *Art Journal* 51, no. 2, *Art and Ecology* (Summer 1992): 26–34.

Gessert, George. *Green Light: Toward an Art of Evolution*. Cambridge, Mass.: MIT Press, 2010.

Russell, John. "Joseph Beuys, Sculptor, Is Dead at 64." *New York Times,* January 25, 1986.

——. "A Vagabond Magus Whose Specialty Was Iconoclasm." *New York Times,* February 9, 1986.

Tisdall, Caroline. *Joseph Beuys, Coyote*. London: Thames & Hudson, 2008.

PROUST STEADIES HIMSELF FOR A DUEL

Alden, Douglas W. "Marcel Proust's Duel." *Modern Language Notes* 53, no. 2 (February 1938): 104–106.

Cambor, Kate. *Gilded Youth: Three Lives in France's Belle Époque*. New York: Farrar, Straus & Giroux, 2009.

Carter, William C. *Marcel Proust: A Life*. New Haven: Yale University Press, 2000.

Collins, Randall. *Violence: A Micro-Sociological Theory*. Princeton, N.J.: Princeton University Press, 2008.

Jullian, Philippe. *Prince of Aesthetes: Count Robert de Montesquiou, 1855–1921*. New York: Viking Press, 1968.

Murray, J. "Marcel Proust." *Modern Language Review* 21, no. 1 (January 1926): 34–43.

Nye, Robert A. *Masculinity and Male Codes of Honor in Modern France*. New York: Oxford University Press, 1993.

Proust, Marcel. *Marcel Proust, Selected Letters*. Edited by Philip Kolb. Garden City, N.Y.: Doubleday, 1983.

White, Edmund. *Marcel Proust*. New York: Viking, 1999.

THE BATHS BUILD STEAM

Ariès, Philippe, and Georges Duby, gen. eds. *A History of Private Life*. 5 vols. Cambridge, Mass.: Harvard University Press/Belknap Press, 1987–1991.

Boswell, James. *Boswell in Holland, 1763–1764; Including His Correspondence with Belle de Zuylen (Zélide).* Edited by Frederick A. Pottle. London: Heinemann, 1952.

Cowan, Brian William. *The Social Life of Coffee: The Emergence of the British Coffeehouse.* New Haven: Yale University Press, 2005.

Cruickshank, Dan. *London's Sinful Secret: The Bawdy History and Very Public Passions of London's Georgian Age.* New York: St. Martin's Press, 2010.

Faas, Patrick. *Around the Roman Table.* New York: Palgrave Macmillan, 2003.

Fagan, Garrett G. *Bathing in Public in the Roman World.* Ann Arbor: University of Michigan Press, 1999.

Laurence, Ray. *Roman Pompeii: Space and Society.* London: Routledge, 1994.

Perrottet, Tony. *Pagan Holiday: On the Trail of Ancient Roman Tourists.* New York: Random House Trade Paperbacks, 2002.

Starkey, Janet, and Paul Starkey. *Interpreting the Orient: Travellers in Egypt and the Near East.* Reading, U.K.: Ithaca Press, 2001.

Thompson, C.J.S. *The Quacks of Old London.* London: Brentano's, 1928.

Timbs, John. *Curiosities of London.* London: D. Bogue, 1855.

Ward, Edward. *The London Spy.* Edited by Peter Hyland from the 4th ed. of 1709. East Lansing: Colleagues Press, 1993.

DESERT ROSES BLOOM

Adamson, Melitta Weiss. *Food in Medieval Times.* Westport, Conn.: Greenwood Press, 2004.

Beckmann, Johann. *History of Inventions and Discoveries.* Translated by William Johnston. Vol. 3. London: J. Bell, 1797.

Dumbarton Oaks Colloquium on the History of Landscape Architecture (28th: 2004). *Botanical Progress, Horticultural Innovation, and Cultural Change.* Edited by Michel Conan and W. John Kress. Washington, D.C.: Dumbarton Oaks Research Library and Collection, 2007.

Hobhouse, Penelope. *Gardens of Persia.* Edited by Erica Hunnigher. San Diego: Kales Press, 2004.

Lehrman, Jonas Benzion. *Earthly Paradise: Garden and Courtyard in Islam.* London: Thames & Hudson, 1980.

Meri, Josef W., ed. *Medieval Islamic Civilization: An Encyclopedia.* 2 vols. New York: Routledge, 2006.

Peterson, T. Sarah. *Acquired Taste: The French Origins of Modern Cooking.* Ithaca: Cornell University Press, 1994.

Simmons, Shirin. *A Treasury of Persian Cuisine.* Reprint. Peterborough, U.K.: Stamford House, 2007.

Thacker, Christopher. *The History of Gardens.* Berkeley: University of California Press, 1979.

Touw, Mia. "Roses in the Middle Ages." *Economic Botany* 36, no. 1 (January–March, 1982): 71–83.

Albert, Herman. *W. A. Mozart*. Translated by Stewart Spencer. Edited by Cliff Eisen. New Haven: Yale University Press, 2007.

Coggin, Philip. " 'This Easy and Agreeable Instrument': A History of the English Guittar." *Early Music* 15, no. 2 (May 1987): 204–218.

Hadlock, Heather. "Sonorous Bodies: Women and the Glass Harmonica." *Journal of the American Musicological Society* 53, no. 3 (Autumn 2000): 507–542.

Holman, Peter. *Life after Death: The Viola da Gamba in Britain from Purcell to Dolmetsch*. Woodbridge, U.K.: Boydell Press, 2010.

Johnson, Deborah J., and David Ogawa, eds. *Seeing and Beyond: Essays on Eighteenth- to Twenty-first Century Art in Honor of Kermit S. Champa*. New York: Peter Lang, 2005.

King, A. Hyatt. "The Musical Glasses and Glass Harmonica." *Proceedings of the Royal Musical Association* 72, no. 1 (1945): 97–122.

Leppert, Richard. *Music and Image: Domesticity, Ideology, and Socio-Cultural Formation in Eighteenth-Century England*. Cambridge: Cambridge University Press, 1987.

Lew, Kristi. *Lead*. New York: Rosen Publishing Group, 2009.

Matthews, Betty. "The Davies Sisters, J. C. Bach, and the Glass Harmonica." *Music & Letters* 56, no. 2 (April 1975): 150–169.

Pohl, Charles Ferdinand. *Cursory Notices of the Origin and History of the Glass Harmonica*. London: Petter & Galpin, 1862.

Rosenthal, Michael. "Thomas Gainsborough's Ann Ford." *Art Bulletin* 80, no. 4 (December 1998): 649–665.

NEEDLES TAKE TO CLOTH

Alford, Marianne Margaret Compton Cust, Vicountess, 1817–1888. *Needlework as Art*. New York: Garland, 1978.

Gioia, Ted. *Work Songs*. Durham, N.C.: Duke University Press, 2006.

Hiner, Susan. *Accessories to Modernity: Fashion and the Feminine in Nineteenth-Century France*. Philadelphia: University of Pennsylvania Press, 2010.

Klinck, Anne L., and Ann Marie Rasmussen, eds. *Medieval Woman's Song: Cross-Cultural Approaches*. Philadelphia: University of Pennsylvania Press, 2002.

Lester, Katherine Morris, and Bess Viola Oerke. *Accessories of Dress*. Peoria, Ill.: C. A. Bennett, 1940.

Lewis, Charles Bertram. "The Origin of the Weaving Songs and the Theme of the Girl at the Fountain." *PMLA* 37, no. 2 (June 1922): 141–181.

Maines, Rachel. *Hedonizing Technologies: Paths to Pleasure in Hobbies and Leisure*. Baltimore: Johns Hopkins University Press, 2009.

Mazzola, Elizabeth. *Women's Wealth and Women's Writing in Early Modern England: "Little Legacies" and the Materials of Motherhood.* Farnham, U.K.: Ashgate, 2009.

Sammis, Kathy. *The Era of Expanding Global Connections.* Portland, Maine: J. Weston Walch, 2002.

A WHOLE LOT OF NOTHING

Albright, Thomas. "New Art School: Correspondence." *Rolling Stone,* April 1972.

Bourdon, David. "Cosmic Ray." *Art in America* 83 (October 1995): 106–111.

———. "Returned to Sender, Remembering Ray Johnson." *Flue Magazine* 4 (1984).

Constable, Rosalind. "The Mailaway Art of Ray Johnson." *New York,* March 2, 1970.

Friedman, Ken. "Mail Art History: The Fluxus Factor." *Detroit Artists Monthly,* February 1978.

Glueck, Grace. "What Happened? Nothing." *New York Times,* April 11, 1964.

———. "Witty Master of the Deadpan Spoof." *New York Times,* February 19, 1984.

Johnson, Ray. *Ray Johnson Correspondences.* Edited by Donna De Salvo and Catherine Gudis. Columbus Ohio: Wexner Center for the Arts, Ohio State University; Paris and New York: Flammarion, 1999.

Martin, Henry. "Should an Eyelash Last Forever?" *Artforum,* April 1995.

Osterwold, Tilman. *Pop Art.* 1991. Cologne: Taschen, 1999.

Wallach, Amei. "Dear Friends of Ray, and Audiences of One." *New York Times,* February 28, 1999.

Wilson, William S. "NY Correspondance [*sic*] School." *Art and Artists* 1, no. 1 (April 1996): 54–57.

WALKING FOR SPORT AND PLEASURE

Burwick, Frederick, ed. *The Oxford Handbook of Samuel Taylor Coleridge.* Oxford: Oxford University Press, 2009.

Gilpin, William. *Three Essays: "On Picturesque Beauty," "On Picturesque Travel," and "On Sketching Landscape."* London: T. Cadell & W. Davies, 1808.

Howe, Percival Presland. *The Life of William Hazlitt.* 1928. London: H. Hamilton, 1947.

Hudson, Henry Norman, comp. *Text-Book of Poetry.* Boston: Ginn Brothers, 1875.

Robinson, Jeffrey Cane. *The Walk: Notes on a Romantic Image.* Norman: University of Oklahoma Press, 1989.

Solnit, Rebecca. *Wanderlust: A History of Walking.* New York: Viking, 2000.

Stevenson, Robert Louis. 1879. *Travels with a Donkey in the Cévennes.* Waiheke Island, N.Z.: Floating Press, 2009.

———. *Walking Tours.* Girard, Kans.: Haldeman-Julius, 1924.

Thompson, Carl. *The Suffering Traveller and the Romantic Imagination.* Oxford: Clarendon Press, 2007.

Benham, W. Gurney. *Playing Cards: History of the Pack and Explanations of Its Many Secrets*. 1931. London: Spring Books, 1957.

Casanova, Giacomo. *History of My Life*. Translated by William R. Trask. Vols. 7–8. Baltimore: John Hopkins University Press, 1997.

Hicklin, Frances. *Playing Cards*. London: H.M. Stationery Office, 1976.

Kavanagh, Thomas. "The Libertine's Bluff: Cards and Culture in Eighteenth-Century France." *Eighteenth-Century Studies* 33, no. 4 (Summer 2000): 505–521.

Parlett, David Sidney. *The Oxford Guide to Card Games*. Oxford: Oxford University Press, 1990.

Wilkins, Sally. *Sports and Games of Medieval Cultures*. Westport, Conn.: Greenwood Press, 2002.

Wilkinson, W. H. "Chinese Origin of Playing Cards." *American Anthropologist* 8, no. 1 (January 1895): 61–78.

Bly, Nellie. *Nellie Bly's Book: Around the World in 72 Days*. Edited by Ira Peck. Brookfield, Conn.: Twenty-First Century Books, 1998.

Kroeger, Brooke. *Nellie Bly: Daredevil, Reporter, Feminist*. New York: Times Books, 1994.

Lutes, Jean Marie. "Into the Madhouse with Nellie Bly: Girl Stunt Reporting in Late Nineteenth-Century America." *American Quarterly* 54, no. 2 (June 2002): 217–253.

Macy, Sue. *Bylines: A Photobiography of Nellie Bly*. Washington, D.C.: National Geographic Society, 2009.

Roggenkamp, Karen. "Dignified Sensationalism: 'Cosmopolitan,' Elizabeth Bisland, and Trips Around the World." *American Periodicals* 17, no. 1 (2007): 26–40.

Arthur's Home Magazine. "Great Fetes of the Middle Ages." Vol. 55. May 1887.

Chambers's Journal. "Blondin." Vol. 72. May 4, 1895.

———. "Medieval Blondins," April 26, 1862.

Depping, Guillaume. *Wonders of Bodily Strength and Skill in All Ages and All Countries*. Translated by Charles Russell. New York: Scribner, Armstrong, 1871.

Fenner, Mildred Sandison, and Wolcott Fenner, eds. *The Circus: Lure and Legend*. Englewood Cliffs, N.J.: Prentice-Hall, 1970.

New York Times. "Blondin at Home." November 20, 1884.

———. "Blondin Carries a Man Across Niagara River on His Shoulders." August 22, 1859.

———. "Blondin Crosses the Niagara River with a Cook-Stove, and Cooks an Omelet." August 26, 1859.

———. "Blondin, the Rope Walker." June 5, 1888.
———. "Blondin's Last Performance." July 18, 1859.
———. "An Exciting Scene: M. Blondin's Feat at Niagara Falls." July 4, 1859.
———. "A Fool and His Feat." June 28, 1859.
———. "The Prince at Niagara." September 17, 1860.
———. "Ropewalker Blondin Dead." February 23, 1897.

BICYCLES OVERTAKE THE BOIS

Crane, Diana. *Fashion and Its Social Agendas.* Chicago: University of Chicago Press, 2000.
Herlihy, David V. *Bicycle: The History.* New Haven: Yale University Press, 2006.
Illustrated American. "On the Fascinating Wheel." June 4, 1892.
Montgomery, Maureen E. *Displaying Women: Spectacles of Leisure in Edith Wharton's New York.* New York: Routledge, 1998.
New York Times. "Paris as Seen by an American Girl." March 18, 1900.
———. "Woman, the Tolerant Sex." October 3, 1897.
Olian, JoAnne, ed. *Victorian and Edwardian Fashions from "La Mode Illustrée."* Mineola, N.Y.: Dover, 1998.
Perrot, Philippe. *Fashioning the Bourgeoisie: A History of Clothing in the Nineteenth Century.* Translated by Richard Bienvenu. Princeton, N.J.: Princeton University Press, 1994.
Proust, Marcel. *Swann's Way.* Translated by C. K. Scott Moncrieff. New York: Modern Library, 1928.
Smith, Robert A. *A Social History of the Bicycle, Its Early Life and Times in America.* New York: American Heritage Press, 1972.
Stedman, Edmund Clarence. *The Complete Pocket-Guide to Europe.* New York: William R. Jenkins, 1913.
Steele, Valerie. *Paris Fashion: A Cultural History.* New York: Oxford University Press, 1988.

RAINBOWS BRIGHTEN THE HORIZON

Bloom, Harold, ed. *William Wordsworth.* New York: Chelsea House, 1985.
Epstein, Julia L., and Mark L. Greenberg. "Decomposing Newton's Rainbow." *Journal of the History of Ideas* 45, no. 1 (January–March, 1984): 115–140.
Hart-Davis, Adam, ed. *DK Science: The Definitive Visual Guide.* New York: DK Publishing, 2009.
Hughes-Hallett, Penelope. "The Mystery of the Rainbow." *New England Review* 23, no. 4 (Fall 2002): 131–145.
Milner, Thomas. *The Gallery of Nature: A Pictorial and Descriptive Tour Through Creation.* London: Wm. S. Orr, 1852.

Pendergrast, Mark. *Mirror, Mirror: A History of the Human Love Affair with Reflection.* New York: Basic Books, 2004.

Werrett, Simon. "Wonders Never Cease: Descartes's 'Météores' and the Rainbow Fountain." *British Journal for the History of Science* 34, no. 2 (June 2001): 129–147.

POETS OF THE ORCHID PAVILION

Addiss, Stephen. *Old Taoist: The Life, Art and Poetry of Kodōjin.* New York: Columbia University Press, 2000.

Fu, Li-tsui Flora. *Framing Famous Mountains: Grand Tour and Mingshan Paintings in Sixteenth-Century China.* Hong Kong: Chinese University Press, 2009.

Japanese and Chinese Poems to Sing: The "Wakan rōei shū." Translated and edited by Thomas J. Rimer and Jonathan Chaves. New York: Columbia University Press, 1997.

Johnston, R. Stewart. *Scholar Gardens of China: A Study and Analysis of the Spatial Design of the Chinese Private Garden.* Cambridge: Cambridge University Press, 1991.

Keswick, Maggie. *The Chinese Garden: History, Art & Architecture.* New York: Rizzoli, 1978.

Mair, Victor H., ed. *The Shorter Columbia Anthology of Traditional Chinese Literature.* New York: Columbia University Press, 2000.

Minford, John, and Joseph S. Lau, eds. *Classical Chinese Literature.* New York: Columbia University Press, 2000.

Thacker, Christopher. *The History of Gardens.* Berkeley: University of California Press, 1979.

TRAMP POETS SEEK SHELTER

Brevda, William. *Harry Kemp, the Last Bohemian.* Lewisburg: Bucknell University Press, 1986.

Lindsay, Vachel. *Adventures While Preaching the Gospel of Beauty.* New York: M. Kennerley, 1914.

———. *A Handy Guide for Beggars.* New York: Macmillan, 1916.

———. *Letters of Vachel Lindsay.* Edited by Marc Chénetier. New York: B. Franklin, 1978.

Lummis, Charles F. *A Tramp Across the Continent.* 1892. Los Angeles: Southwest Museum, 1985.

Massa, Ann. "The Artistic Conscience of Vachel Lindsay." *Journal of American Studies* 2, no. 2 (October 1968): 239–252.

THE MINIATURE WORLD COMES INTO FOCUS

Catlow, Agnes. *Drops of Water.* London: Reeve & Benham, 1851.

Gooday, Graeme. " 'Nature' in the Laboratory: Domestication and Discipline with the Microscope in Victorian Life Science." *British Journal for the History of Science* 24, no. 3 (September 1991): 307–341.

Gosse, Philip Henry. *Evenings at the Microscope.* 1859. New York: Collier, 1902.

Hager, Thomas. *The Demon Under the Microscope: From the Battlefield Hospitals to Nazi Labs, One Doctor's Heroic Search for the World's First Miracle Drug.* New York: Three Rivers Press, 2006.

Hooke, Robert. *Micrographia.* 1665. New York: Dover, 1961.

Kent, Paul, and Allan Chapman, eds. *Robert Hooke and the English Renaissance.* Leominster, U.K.: Gracewing, 2005.

Schickore, Jutta. *The Microscope and the Eye: A History of Reflections, 1740–1870.* Chicago: University of Chicago Press, 2007.

Turner, Gerard L'E. "Scientific Toys." *British Journal for the History of Science* 20, no. 4 (October 1987): 377–398.

THE SHADOWS COME ALIVE

Keene, Donald. *Five Modern Japanese Novelists.* New York: Columbia University Press, 2003.

———. *Landscapes and Portraits: Appreciations of Japanese Culture.* New York: Kodansha International, 1971.

Lopate, Philip, ed. *The Art of the Personal Essay: An Anthology from the Classical Era to the Present.* New York: Anchor Books, 1994.

Tanizaki, Jun'ichirō. *In Praise of Shadows.* Translated by Thomas J. Harper and Edward G. Seidensticker. New Haven: Leete's Island Books, 1977.

DIARISTS TAKE NOTE

Ariès, Philippe, and Georges Duby, gen. eds. *A History of Private Life.* Vol. 3, *Passions of the Renaissance,* edited by Roger Charier. Cambridge, Mass.: Harvard University Press/Belknap Press, 1989.

Century, The. "Diaries and Journals." Vol. 25. 1883.

Jerome, W. S. "How to Keep a Journal." *St. Nicholas,* 5, no. 12. (October 1878).

Speake, Jennifer. *Literature of Travel and Exploration: An Encyclopedia.* New York: Fitzroy Dearborn, 2003.

Woolf, Virginia. *The Diary of Virginia Woolf.* Edited by Anne Olivier Bell. Vol. 1, *1915–1919.* London: Hogarth Press, 1977.

———. *A Writer's Diary: Being Extracts from the Diary of Virginia Woolf.* Edited by Leonard Woolf. New York: Harcourt, Brace, [1954]1982.

GONDOLAS DRIFT

Art Journal. "Every-Day Life at Venice." Vol. 7. 1881.

Berendt, John. *The City of Falling Angels.* New York: Penguin Press, 2005.

Chambers's Journal of Popular Literature, Science and Arts. "A Day in a Gondola." Vol. 42. May 6, 1865.

Dearborn, Mary V. *Mistress of Modernism: The Life of Peggy Guggenheim.* Boston: Houghton Mifflin, 2004.

Doty, Robert C. "Whither the Gondola." *New York Times,* May 22, 1965.

Gill, Anton. *Art Lover: A Biography of Peggy Guggenheim.* New York: HarperCollins, 2003.

New York Times. "Gondolas Give Way to Motor Boats." July 21, 1909.

———. "Peggy Guggenheim, Modern Art Collector, Dies in an Italian Hospital at 81." December 24, 1979.

———. "Venice, Queen of the Sea." November 1, 1880.

Toth, Susan Allen. "Venice's Trove to Ties to the Sea." *New York Times,* November 7, 1993.

Weld, Jacqueline Bograd. *Peggy, the Wayward Guggenheim.* New York: Dutton, 1986.

FRUIT MAKES JAM

Foden, Giles. "Nostradamus and His Pot of Jam." *Guardian,* March 31, 2006.

Glasse, Hannah. *The Complete Confectioner.* London: J. Cooke, 1770.

Patmore, Katherine Alexandra. *The Court of Louis XIII.* London: Methuen, 1910.

Richardson, Tim. *Sweets: A History of Candy.* New York: MJF Books, 2005.

Shephard, Sue. *Pickled, Potted, and Canned: The Story of Food Preserving.* London: Headline, 2000.

Spencer, Colin. *British Food.* London: Grub Street, 2002.

Toussaint-Samat, Maguelonne. *A History of Food.* Translated by Anthea Bell. Chichester, U.K., and Malden, Mass.: Wiley-Blackwell, 2009.

Wilson, C. Anne. *The Book of Marmalade.* rev. ed. Totnes, U.K.: Prospect Books, 1999.

Ziedrich, Linda. *The Joy of Jams, Jellies, and Other Sweet Preserves.* Boston: Harvard Common Press, 2009.

PORCH DWELLERS LINGER

Cline, Sally. *Zelda Fitzgerald: Her Voice in Paradise.* 1st U.S. ed. New York: Arcade, 2003.

Dolan, Michael. *The American Porch: An Informal History of an Informal Place.* Guilford, Conn.: Lyons Press, 2002.

Fitzgerald, F. Scott, and Zelda Fitzgerald. *Dear Scott, Dearest Zelda: The Love Letters of F. Scott and Zelda Fitzgerald.* Edited by Jackson R. Bryer and Cathy W. Barks. New York: St. Martin's Press, 2002.

Gourley, Catherine. *Flappers, and the New American Woman: Perceptions of Women from 1913 Through the 1920s.* Minneapolis, Minn.: Twenty-First Century Books, 2008.

Gressor, Megan. *An Affair to Remember: The Greatest Love Stories of All Times.* Gloucester, Mass.: Fair Winds Press, 2004.

Maynard, William Barksdale. *Architecture in the United States 1800–1850*. New Haven: Yale University Press, 2002.

Out on the Porch: An Evocation in Words and Pictures. Introduction by Reynolds Price. Chapel Hill, N.C.: Algonquin Books of Chapel Hill, 1992.

STREETLIGHTS FLICKER

Ackroyd, Peter. *London: The Biography*. New York: Nan A. Talese, 2000.

Ambrosini, Richard, and Richard Dury, eds. *Robert Louis Stevenson: Writer of Boundaries*. Madison: University of Wisconsin Press, 2005.

Jakle, John A. *City Lights: Illuminating the American Night*. Baltimore: Johns Hopkins University Press, 2001.

Jonnes, Jill. *Eiffel's Tower: And the World's Fair Where Buffalo Bill Beguiled Paris, the Artists Quarreled, and Thomas Edison Became a Count*. New York: Viking, 2009.

Schivelbusch, Wolfgang. *Disenchanted Night: The Industrialization of Light in the Nineteenth Century*. Translated by Angela Davies. Berkeley: University of California Press, 1988.

Schlör, Joachim. *Night in the Big City: Paris, Berlin, London 1840–1930*. London: Reaktion Books, 1998.

Scientific American. "The Sun Column Designed for Lighting Entire Paris." April 11, 1885.

Stevenson, Robert Louis. *Virginibus Puerisque*. New York: C. Scribner's Sons, 1905.

INCENSE IN THE AIR

Bedini, Silvio A. "The Scent of Time. A Study of the Use of Fire and Incense for Time Measurement in Oriental Countries." *Transactions of the American Philosophical Society*. New Series. Vol. 53, no. 5 (1963): 1–5.

———. *The Trail of Time*. Cambridge: Cambridge University Press, 1990.

Hearn, Lafcadio. *In Ghostly Japan*. Boston: Little, Brown, 1899.

Morita, Kiyoko. *The Book of Incense*. New York: Kodansha International, 1992.

OPERA FANS MAKE AN ENTRANCE

Barbier, Patrick. *Opera in Paris, 1800–1850: A Lively History*. Translated by Robert Luoma. Portland, Ore.: Amadeus Press, 1995.

Feldman, Martha. *Opera and Sovereignty: Transforming Myths in Eighteenth-Century Italy*. Chicago: University of Chicago Press, 2007.

Fenner, Theodore. *Opera in London: Views of the Press, 1785–1830*. Carbondale: Southern Illinois University Press, 1994.

Illustrated American. "The Close of the Opera." Vol. 6. March 28, 1891.

Johnson, James H. *Listening in Paris: A Cultural History*. Berkeley: University of California Press, 1996.

Kimbell, David R. B. *Italian Opera*. Cambridge: Cambridge University Press, 1991.

———. *Verdi in the Age of Italian Romanticism*. Cambridge: Cambridge University Press, 1981.

Lindenberger, Herbert. *Opera, the Extravagant Art*. Ithaca, N.Y.: Cornell University Press, 1984.

Sennett, Richard. *The Fall of Public Man*. New York: Alfred A. Knopf, 1977.

Wagner, Richard. *Wagner on Music and Drama: A Compendium of Richard Wagner's Prose Works*. Selected and arranged by Albert Goldman and Evert Sprinchorn. Translated by H. Ashton Ellis. 1964. New York: Da Capo, 1988.

MOVING PICTURES UNFURL

Baugh, Christopher. "Philippe de Loutherbourg: Technology-Driven Entertainment and Spectacle in the Late Eighteenth Century." *Huntington Library Quarterly* 70, no. 2 (June 2007): 251–268.

Bermingham, Ann. "Introduction: Gainsborough's Show Box: Illusion and Special Effects in Eighteenth-Century Britain." *Huntington Library Quarterly* 70, no. 2 (June 2007): 203–208.

Brewer, John. "Sensibility and the Urban Panorama." *Huntington Library Quarterly* 70, no. 2 (June 2007): 229–249.

Griffiths, Alison. *Shivers Down Your Spine: Cinema, Museums, and the Immersive View*. New York: Columbia University Press, 2008.

Joppien, Rudiger. *Philippe Jacques de Loutherbourg (1740–1812)*. London: Greater London Council, 1973.

Liu, Alan. "Toward a Theory of Common Sense: Beckford's 'Vathek' and Johnson's 'Rasselas.' " *Texas Studies in Literature and Language* 26, no. 2 (Summer 1984): 183–217.

Terpak, Frances. "Free Time, Free Spirit: Popular Entertainments in Gainsborough's Era." *Huntington Library Quarterly* 70, no. 2 (2007): 209–228.

SARAH BERNHARDT PLAYS HAMLET

Anderson, Joseph L. *Enter a Samurai*. Tuscon, Ariz.: Wheatmark, 2011.

Cambridge Companion to the Actress, The. Edited by Maggie B. Gale and John Stokes. Cambridge: Cambridge University Press, 2007.

Gottlieb, Robert. *Sarah: The Life of Sarah Bernhardt*. New Haven: Yale University Press, 2010.

Howard, Tony. *Women as Hamlet: Performance and Interpretation in Theatre, Film, and Fiction*. Cambridge: Cambridge University Press, 2007.

Huret, Jules. *Sarah Bernhardt*. London: Chapman & Hall, 1899.

Kemp, Theresa D. *Women in the Age of Shakespeare*. Santa Barbara, Calif.: Greenwood Press, 2010.

Literary Digest. "Sarah Bernhardt's Hamlet." Vol. 19. July 8, 1899.

Mullenix, Elizabeth Reitz. *Wearing the Breeches: Gender on the Antebellum Stage.* New York: St. Martin's Press, 2000.

New York Times. "Bernhardt's New Hamlet." June 4, 1899.

———. "Catulle Mendes in a Duel." May 24, 1899.

Roberts, Mary Louis. *Disruptive Acts: The New Woman in Fin-de-Siècle France.* Chicago: University of Chicago Press, 2002.

Shudofsky, Maurice M. "Sarah Bernhardt on Hamlet." *College English* 3, no. 3 (December 1941): 293–295.

World Shakespeare Conference (1976: Washington, D.C.). *Shakespeare, Pattern of Excelling Nature: Shakespeare Criticism in Honor of America's Bicentenniel.* Edited by David M. Bevington and Jay L. Halio. Newark: University of Delaware Press, 1978.

LET THE HANKY-PANKY BEGIN

Butterworth, Philip. *Magic on the Early English Stage.* Cambridge: Cambridge University Press, 2005.

Chrysti, the Wordsmith. *Verbivore's Feast: A Banquet of Word & Phrase Origins.* Helena, Mo.: Farcounty Press, 2004.

During, Simon. *Modern Enchantments: The Cultural Power of Secular Magic.* Cambridge, Mass.: Harvard University Press, 2002.

Encyclopaedia Britannica: A Dictionary of Arts, Sciences, Literature, and General Information, The. 11th ed. Edited by Hugh Chisholm. Vol. 6. New York: Encyclopaedia Britannica, 1910.

Houdini, Harry. *Games of Skill; and Conjuring.* London: Warne & Routledge, 1862.

Lane, Edward William. *An Account of the Manners and Customs of the Modern Egyptians.* London: C. Knight, 1836.

Paton-Williams, David. *Katterfelto: Prince of Puff.* Leicester, U.K.: Matador, 2008.

Robert-Houdin, Jean-Eugène, *Memoirs of Robert-Houdin: Ambassador, Author, and Conjurer.* Edited by R. Shelton Mackenzie. Philadelphia: G. G. Evan, 1859.

Stafford, Barbara Maria. *Artful Science: Enlightenment, Entertainment, and the Eclipse of Visual Education.* Cambridge, Mass.: MIT Press, 1994.

LADIES AND GENTS DRESS FOR DINNER

Durant, David N. *Where Queen Elizabeth Slept & What the Butler Saw.* 1st U.S. ed. New York: St. Martin's Press, 1997.

Freeman, Ira Henry. "The Tuxedo at 69, Gayer Than Ever." *New York Times,* October 10, 1955.

Lennox, Doug. *Now You Know Royalty.* Toronto: Dundum Press, 2009.

New York Times. "Evening Gowns and White Tie and Tails Latest War Casualties, Cleaners Say."
February 26, 1943.

———. "Value of the 'Society' Way." September 17, 1893.

Schrock, Joel. *The Gilded Age*. Westport, Conn.: Greenwood Press, 2004.

Vanity Fair. "Our London Letter on Men's Fashions." January 1923.

Womanhood. [Untitled article]. Vol. 17. December, 1906.

RUTH ST. DENIS HEADS EAST

Coorlawala, Uttara Asha. "Ruth St. Denis and India's Dance Renaissance." *Dance Chronicle* 15,
no. 2 (1992): 123–152.

Cullen, Frank, with Florence Hackman and Donald McNeily. *Vaudeville, Old & New: An Encyclopedia of Variety Performers in America*. 2 vols. New York: Routledge, 2007.

Desmond, Jane. "Dancing Out the Difference: Cultural Imperialism and Ruth St. Denis's
'Radha' of 1906. *Signs* 17, no. 1 (Autumn 1991): 28–49.

New York Times. "Bringing Temple Dances from the Orient to Broadway." March 25, 1906.

Shelton, Suzanne. *Divine Dancer: A Biography of Ruth St. Denis*. Garden City, N.Y.: Doubleday, 1981.

Sherman, Jane. *The Drama of Denishawn Dance*. Middletown, Conn.: Wesleyan University Press,
1979.

———. *Soaring: The Diary and Letters of a Denishawn Dancer in the Far East, 1925–1926*. Middletown, Conn.: Wesleyan University Press, 1976.

Sherman, Jane, and Christena L. Schlundt. "Who's St. Denis? What Is She?" *Dance Chronicle* 10,
no. 3 (1986): 305–329.

Wentink, Andrew Mark. "'From the Orient . . . Oceans of Love, Doris': The Denishawn Tour of
the Orient as Seen through the Letters of Doris Humphrey." *Dance Chronicle* 1, no. 1 (1977):
22–45.

DINNER À L'AVANT-GARDE

Dickie, John. *Delizia!: The Epic History of the Italians and Their Food*. New York: Free Press, 2008.

Marinetti, Filippo Tommaso. *The Futurist Cookbook*. Translated by Susan Brill. San Francisco:
Bedford Arts, 1989.

Novero, Cecilia. *Antidiets of the Avant-Garde: From Futurist Cooking to Eat Art*. Minneapolis: University of Minnesota Press, 2010.

Rosen, Michael J. "Aeropictorial Lunch." *New York Times,* January 21, 1990.

Vasari, Giorgio. *Stories of the Italian Artists from Vasari*. Arranged and translated by E. L. Seeley.
New York: Dutton, 1908.

———. *Vasari on Theatre*. Selected and translated by Thomas A. Pallen. Carbondale: Southern
Illinois University Press, 1999.

DINNER À L'ANCIENNE

Edwards, Catharine. *Death in Ancient Rome*. New Haven: Yale University Press, 2007.
Fletcher, Nichola. *Charlemagne's Tablecloth: A Piquant History of Feasting*. London: Weidenfeld & Nicolson; New York: St. Martin's Press, 2005.
Jones, Brian W. *The Emperor Domitian*. London: Routledge, 1993.
May, Gita. *Elisabeth Vigée Le Brun: The Odyssey of an Artist in an Age of Revolution*. New Haven: Yale University Press, 2005.
Vigée-Lebrun, Louise-Elisabeth. *Madame Vigée Le Brun*. Masters in Art, vol. 6, pt. 6. Boston: Bates & Guild, 1905.
———. *Memoirs of Madame Vigée Lebrun*. Translated by Lionel Strachey. New York: Braziller, 1989.
Visser, Margaret. *The Rituals of Dinner: The Origins, Evolution, Eccentricities, and Meaning of Table Manners*. New York: Grove Weidenfeld, 1991.

DESSERTS AFLAME

Charpentier, Henri, and Boyden Sparkes. *Life à la Henri: Being the Memories of Henri Charpentier*. New York: Modern Library, 2001.
Davidson, Alan. *The Oxford Companion to Food*. Oxford: Oxford University Press, 1999.
Funderburg, Anne Cooper. *Chocolate, Strawberry, and Vanilla: A History of American Ice Cream*. Bowling Green, Ohio: Bowling Green State University Popular Press, 1995.
Grigson, Jane. *Jane Grigson's Fruit Book*. New York: Atheneum, 1982.
Lovegren, Sylvia. *Fashionable Food*. New York: Macmillan, 1995.
Marling, Karal Ann. *Ice: Great Moments in the History of Hard, Cold Water*. St. Paul, Minn.: Borealis Books, 2008.
Newnham-Davis, Nathaniel. *The Gourmet's Guide to London*. New York: Brentano's, 1914.

LIGHT BECOMES ART

Adcock, Craig E., and James Turrell. *James Turrell*. Tallahassee: Florida State University Gallery & Museum, 1989.
Betancourt, Michael. *Thomas Wilfred's Clavilux*. Maryland: Wildside Press, 2006.
Beveridge, Patrick. "Color Perception and the Art of James Turrell." *Leonardo* 33, no. 4 (2000): 305–313.
Konody, P. G. "The Clavilux and Its Future." *The Sackbut* 5 (July 1925): 355–356.
Lester, Elenore. "Intermedia: Tune in, Turn On—And Walk Out?" *New York Times*, May 12, 1968.
New York Times. "New Kind of Painting Uses Light as Medium." December 8, 1931.
———. "Thomas Wilfred, Artist and Inventor, Dead at 79." August 16, 1968.

Chard, Chloe. *Pleasure and Guilt on the Grand Tour: Travel Writing and Imaginative Geography, 1600–1830*. Manchester, U.K.: Manchester University Press; New York: dist. by St. Martin's Press, 1999.

Cheeke, Stephen. *Byron and Place: History, Translation, Nostalgia*. Houndsmills, U.K., and New York: Palgrave Macmillan, 2003.

Davy, John. *Memoirs of the Life of Sir Humphry Davy*. London: Longman, Rees, Orme, Brown, Green & Longman, 1836.

Emerson, Ralph Waldo. *The Journals of Ralph Waldo Emerson*. Edited by Edward Waldo Emerson and Waldo Emerson Forbes. 10 vols. Boston: Houghton Mifflin, 1909–1914.

Goethe, Johann Wolfgang von. *The Autobiography of Goethe: Truth and Poetry from My Own Life*. Translated by John Oxenford. 2 vols. London: George Bell & Sons, 1874.

Hopkins, Keith, and Mary Beard. *The Colosseum*. Cambridge, Mass.: Harvard University Press, 2005.

James, Henry. *Letters*. Edited by Leon Edel. 4 vols. Cambridge, Mass.: Belknap Press of Harvard University Press, 1974–1984.

———. *The Portable Henry James*. Edited by Morton Dauwen Zabel. New York: Viking Press, 1951.

Knickerbocker. "Literary Notices." Vol. 7. June 1836.

Pfister, Manfred, ed. *The Fatal Gift of Beauty: The Italies of British Travellers; An Annotated Anthology*. Amsterdam: Rodopi, 1996.

SHANGHAI DANCES THE FOXTROT

Field, Andrew. *Shanghai's Dancing World: Cabaret Culture and Urban Politics, 1919–1954*. Hong Kong: Chinese University Press, 2010.

Gandelsonas, Mario, Akbar Abbas, and M. Christine Boyer. *Shanghai Reflections: Architecture, Urbanism, and the Search for an Alternative Modernity; Essays*. New York: Princeton Architectural Press, 2002.

Lee, Leo Ou-fan. *Shanghai Modern: The Flowering of a New Urban Culture in China, 1930–1945*. Cambridge, Mass.: Harvard University Press, 1999.

Macdonald, Sean. "The Shanghai Foxtrot (a Fragment) by Mu Shiying." *Modernism/Modernity* 11, no. 4 (November 2004): 797–807.

Shi, Shumei. *The Lure of the Modern: Writing Modernism in Semicolonial China, 1917–1937*. Berkeley: University of California Press, 2001.

THE ROLLER COASTER PLUMMETS

Cartmell, Robert. *The Incredible Scream Machine: A History of the Roller Coaster*. Bowling Green, Ohio: Bowling Green State University Popular Press, 1987.

Dumbarton Oakes Colloquium on the History of Landscape Architecture (20th). *Theme Park Landscapes: Antecedents and Variations*. Edited by Terence Young and Robert Riley. Washington, D.C.: Dumbarton Oakes Research Library and Collection, 2002.

Immerso, Michael. *Coney Island: The People's Playground*. Piscataway, N.J.: Rutgers University Press, 2002.

Jones, Karen R. *The Invention of the Park: Recreational Landscapes from the Garden of Eden to Disney's Magic Kingdom*. Cambridge, U.K., and Malden, Mass.: Polity, 2005.

Marsh, Carole. *Ohio Roller Coasters!* Decatur, Ga.: Gallopade Publishing Group, 1992.

Mitrašinović, Miodrag. *Total Landscape, Theme Parks, Public Space*. Aldershot, U.K.: Ashgate, 2006.

Schivelbusch, Wolfgang. *Disenchanted Night: The Industrialization of Light in the Nineteenth Century*. Berkeley: University of California Press, 1988.

MOON GAZERS CONVENE

Classical Chinese Poetry: An Anthology. Translated and edited by David Hinton. New York: Farrar, Straus & Giroux, 2008.

Cooper, Arthur R. V. *Li Po and Tu Fu: Poems Selected and Translated, with an Introduction and Notes*. Harmondsworth, U.K.: Penguin Books, 1973.

Li, Bai. *The Selected Poems of Li Po*. Translated by David Hinton. New York: New Directions, 1996.

Sasaki, Sanmi. *Chado: The Way of Tea*. Translated by Shaun McCabe and Iwasaki Satoko. Boston: Tuttle, 2002.

HAYDN PLAYS A SERENADE

Beghin, Tom, and Sander M. Goldberg, eds. *Haydn and the Performance of Rhetoric*. Chicago: University of Chicago Press, 2007.

Geiringer, Karl. *Haydn: A Creative Life in Music*. Berkeley: University of California Press, 1982.

Heartz, Daniel. *Haydn, Mozart, and the Viennese School, 1740–1780*. New York: W. W. Norton, 1995.

Larsen, Jens Peter, with Georg Feder. *The New Grove Hadyn*. New York: W. W. Norton, 1983.

Steen, Michael. *The Lives and Times of the Great Composers*. Oxford: Oxford University Press, 2004.

Webster, James, and Georg Feder, eds. *The New Grove Haydn*. New York: St. Martin's Press, 2001.

Zaslaw, Neal, and William Cowdery, eds. *The Compleat Mozart: A Guide to the Musical Works of Wolfgang Amadeus Mozart*. New York: W. W. Norton, 1990.

SKY WATCHERS NAME THE STARS

Allen, Richard Hinckley. *Star Names: Their Lore and Meaning*. New York: Dover, 1963.

Kanas, Nick. *Star Maps: History, Artistry, and Cartography*. New York: Praxis Publishing, 2007.

Lachièze-Rey, Marc, and Jean-Pierre Luminet. *Celestial Treasury: From the Music of the Spheres to the Conquest of Space.* Cambridge: Cambridge University Press, 2001.

Ridpath, Ian. *Star Tales.* New York: Universe Books, 1988.

ALLEN GINSBERG LETS LOOSE WITH *HOWL*

Campbell, James. *This Is the Beat Generation: New York, San Francisco, Paris.* Berkeley: University of California Press, 2001.

Eberhart, Richard. "West Coast Rhythms." *New York Times,* September 2, 1956.

Ginsberg, Allen. *Howl and Other Poems.* Pocket Poets, no. 4. San Francisco: City Lights Books, 1959.

———. *Howl: Original Draft Facsimile, Transcript & Variant Versions.* Edited by Barry Miles. New York: Harper & Row, 1986.

Hyde, Lewis, ed. *On the Poetry of Allen Ginsberg.* Ann Arbor: University of Michigan Press, 1984.

Kirsch, Adam. "Starving Hysterical Naked," review of *The Poem That Changed America: "Howl" Fifty Years Later,* ed. by Jason Shinder. *Poetry* 188, no. 5 (September 2006): 442–448.

Morgan, Bill, and Nancy Joyce Peters, eds. *"Howl" on Trial: The Battle for Free Expression.* San Francisco: City Lights Books, 2006.

O'Neil, Paul. "The Only Rebellion Around." *Life.* November 30, 1959.

Raskin, Jonah. *American Scream: Allen Ginsberg's "Howl" and the Making of the Beat Generation.* Berkeley: University of California Press, 2004.

WALTZERS TURN IN ECSTASY

Aldrich, Elizabeth. *From the Ballroom to Hell: Grace and Folly in Nineteenth-Century Dance.* Evanston, Ill.: Northwestern University Press, 1991.

Aloff, Mindy. *Dance Anecdotes: Stories from the Worlds of Ballet, Broadway, the Ballroom, and Modern Dance.* Oxford: Oxford University Press, 2006.

Giordano, Ralph G. *Social Dancing in America: A History and Reference.* Westport, Conn.: Greenwood Press, 2006.

Knowles, Mark. *The Wicked Waltz and Other Scandalous Dances.* Jefferson, N.C.: McFarland, 2009.

SUFI MYSTICS TASTE THE DIVINE

Morgan, Diane. *Essential Islam: A Comprehensive Guide to Belief and Practice.* Santa Barbara, Calif.: Praeger/ABC-CLIO, 2010.

Pendergrast, Mark. *Uncommon Grounds: The History of Coffee and How It Transformed Our World.* New York: Basic Books, 1999.

Toussaint-Samat, Maguelonne. *A History of Food*. Translated by Anthea Bell. New ed. Chichester, U.K., and Malden, Mass.: Wiley-Blackwell, 2009.

Weinberg, Bennett Alan. *The World of Caffeine*. London: Routledge, 2001.

Wild, Antony. *Coffee, a Dark History*. New York: W. W. Norton, 2005.

GOTHIC GLOOM IN THE GRAVEYARD

Barbauld, Anna Laetitia. *Poems*. London: Joseph Johnson, 1792.

Cavallaro, Dani. *The Gothic Vision: Three Centuries of Horror, Terror, and Fear*. London: Continuum, 2002.

Chalcraft, Anna, and Judith Viscardi. *Strawberry Hill: Horace Walpole's Gothic Castle*. London: Frances Lincoln, 2007.

Clark, Harry H. "A Study of Melancholy in Edward Young, Part 1." *Modern Language Notes* 39, no. 3 (March 1924): 129–136.

Lewis, W. S. *Horace Walpole*. New York: Pantheon Books, 1961.

Punter, David, and Glennis Byron. *The Gothic*. Oxford, U.K., and Malden, Mass.: Blackwell Publishing, 2004.

Rinaker, Clarissa. *Thomas Warton: A Biographical and Critical Study*. Urbana: University of Illinois, 1916.

Snodgrass, Mary Ellen. *Encyclopedia of Gothic Literature*. New York: Facts on File, 2004.

Walpole, Horace. *The Castle of Otranto: A Gothic Story; and, The Mysterious Mother: A Tragedy*. Edited by Frederick S. Frank. Orchard Park, N.Y.: Broadview Press, 2003.

———. *The Letters of Horace Walpole, Earl of Oxford*. 6 vols. New ed. London: R. Bentley, 1846.

INSTANTANÉISME IS BORN

Baston, Charles R. *Dance, Desire, and Anxiety in Early Twentieth-Century French Theater*. Aldershot, U.K., and Burlington, Vt.: Ashgate Publishing, 2005.

De Groote, Pascale. *Ballets Suédois*. Ghent: Academia Press, 2002.

Garafola, Lynn. *Legacies of Twentieth-Century Dance*. Middletown, Conn.: Wesleyan University Press, 2005.

Judovitz, Dalia. *Drawing on Art: Duchamp and Company*. Minneapolis: University of Minnesota Press, 2010.

Lansdale, Janet, and June Layson, eds. *Dance History: An Introduction*. London: Routledge, 1994.

Orledge, Robert, comp. and ed. *Satie Remembered*. Portland, Ore.: Amadeus Press, 1995.

———. *Satie the Composer*. Cambridge: Cambridge University Press, 1990.

———. "Satie's Approach to Composition in His Later Years (1913–24)." *Proceedings of the Royal Musical Association* 111, no. 1 (1984–1985): 155–179.

Trippett, David. "Composing Time: Zeno's Arrow, Hindemith's Erinnerung, and Satie's Instantanéisme." *Journal of Musicology* 24, no. 4 (Fall 2007): 522–580.

Tymieniecka, Anna Teresa. *Enjoyment: From Laughter to Delight in Philosophy, Literature, the Fine Arts, and Aesthetics.* Dordrecht, Netherlands, and Boston, Mass.: Kluwer Academic, 1998.

Whiting, Steven Moore. *Satie the Bohemian: From Cabaret to Concert Hall.* Oxford: Oxford University Press, 1999.

LOVE UNDER THE ANDALUSIAN STARS

Gerli, E. Michael, et al., eds. *Medieval Iberia: An Encyclopedia.* New York: Routledge, 2003.

Irwin, Robert. *Night and Horses and the Desert: An Anthology of Classical Arabic Literature.* Woodstock, N.Y.: Overlook Press, 2000.

Klinck, Anne Lingard. *An Anthology of Ancient and Medieval Woman's Song.* New York: Palgrave Macmillan, 2004.

Menocal, Maria Rosa, Raymond P. Scheindlin, and Michael Anthony Sells. *The Literature of Al-Andalus.* Cambridge: Cambridge University Press, 2000.

Robinson, Cynthia. "Seeing Paradise: Metaphor and Vision in Taifa Palace Architecture." *Gesta* 36, no. 2, Visual Culture of Medieval Iberia (1997): 145–155.

Shoshan, Boaz. "High Culture and Popular Culture in Medieval Islam." *Studia Islamica,* no. 73 (1991): 67–107.

———. "Ubi Sunt: Memory and Nostalgia in Taifa Court Culture." *Muqarnas* 15 (1998): 20–31.

Watt, W. Montgomery. *A History of Islamic Spain.* New York: Anchor Books, 1967.

BROADWAY GOES DARK

Allen, Irving Lewis. *The City in Slang: New York Life and Popular Speech.* New York: Oxford University Press, 1993.

Berger, Meyer. "All Midtown Blacked Out; Throngs Watch in Times Sq." *New York Times,* May 1 1942.

———. "Lights Bring Out Victory Throngs." *New York Times,* May 9, 1945.

———. "New Constellations on the Old White Way," *New York Times,* March 29, 1936.

———. "The Not-So-Gay White Way." *New York Times,* May 24, 1942.

Bloom, Ken. *Broadway: Its History, People and Places.* New York: Routledge, 2004.

New York Times. "City Still Too Bright for the Army; Police Make It Darker by the Hour." May 20, 1942.

———. "Drastic Cut Due in Street Lighting." May 21, 1942.

———. "Electric Sign Flies Over City at Night." September 14, 1928.

Nichols, Lewis. "Jumpin' Town—or The Great Dim Way." *New York Times,* December 27, 1942.

Rice, Diana. "Stage Managing the Great White Way." *New York Times,* October 9, 1927.

Ariès, Philippe, and Georges Duby, gen. eds. *A History of Private Life*. Vol. 3, *Passions of the Re-naissance*, edited by Roger Chartier. Cambridge, Mass.: Harvard University Press / Belknap Press, 1989.

Balcom, David. *The Greatest Escape: Adventures in the History of Solitude*. New York: iUniverse, 2004.

Du Prey, Pierre de la Ruffinière. *The Villas of Pliny from Antiquity to Posterity*. Chicago: University of Chicago Press, 1994.

Sessa, Kristina. *The Formation of Papal Authority in Late Antique Italy*. Cambridge: Cambridge University Press.

Witte, Arnold Alexander. *The Artful Hermitage: The Palazzo Farnese as a Counter-Reformation Dieta*. Rome: L'Erma di Bretschneider, 2008.

Brassaï, George. *Brassaï: Letters to My Parents*. Translated by Peter Laki and Barna Kantor. Chicago: University of Chicago Press, 1997.

——. *Brassaï: The Monograph*. Edited by Alain Sayag and Annick Lionel-Marie. Boston: Bulfinch, 2000.

Walker, Ian. *City Gorged with Dreams: Surrealism and Documentary Photography in Interwar Paris*. Manchester, U.K.: Manchester University Press, 2002.

Ekirch, A. Roger. *At Day's Close: Night in Times Past*. New York: W. W. Norton, 2005.

Hawthorne, Nathaniel. *The Complete Writings of Nathaniel Hawthorne*. Boston: Houghton Mifflin; Cambridge, Mass.: Riverside Press, 1900.

Moss, Robert. *The Secret History of Dreaming*. Novato, Calif.: New World Library, 2009.

Angeville, Henriette de'. *Mon Excursion au Mont-Blanc*. Paris: Arthaud, 1987.

——. *My Ascent of Mont Blanc*. Translated by Jennifer Barnes. London: HarperCollins, 1992.

Brown, Rebecca A. *Women on High: Pioneers of Mountaineering*. Boston: Appalachian Mountain Club Books, 2002.

Belozerskaya, Marina. *The Medici Giraffe: And Other Tales of Exotic Animals and Power*. New York: Little, Brown, 2006.

Campbell, Susan. *A History of Kitchen Gardening*. 1st Frances Lincoln ed. London: Frances Lincoln, 2005.

Coe, Sophie Dobzhansky. *America's First Cuisines*. Austin: University of Texas Press, 1994.

Kohlmaier, Georg, and Barna von Sartory. *Houses of Glass: A Nineteenth-Century Building Type*. Translated by John C. Harvey. Cambridge, Mass.: MIT Press, 1986.

Kurlansky, Mark, ed. and illus. *Choice Cuts: A Savory Selection of Food Writing from Around the World and Throughout History*. New York: Ballantine Books, 2002.

Okihiro, Gary Y. *Pineapple Culture: A History of the Tropical and Temperate Zones*. Berkeley: University of California Press, 2009.

Quest-Ritson, Charles. *The English Garden: A Social History*. London: Viking, 2001.

Taylor, Patrick, ed. *Oxford Companion to the Garden*. Oxford: Oxford University Press, 2006.

Bourbon, Diana. "Treasure Hunt in Modern London." *New York Times,* August 10, 1924.

Lindsay, Loelia. *Cocktails & Laughter: The Albums of Loelia Lindsay*. London: H. Hamilton, 1983.

Maxwell, Elsa. *How to Do It: Or, the Lively Art of Entertaining*. Boston: Little, Brown, 1957.

Montola, Markus, Jaako Stenros, and Annika Waern. *Pervasive Games: Theory and Design*. Burlington, Mass.: Morgan Kaufmann Publishers, 2009.

National Portrait Gallery (Great Britain). *The Sitwells and the Arts of the 1920s and 1930s*. 1st University of Austin Press ed. Austin: University of Texas Press, 1996.

New York Times. "Hallowe'en Hunt to Help Welfare." October 8, 1933.

——. "Scavenger Hunt Ends in Court." September 8, 1935.

——. "Scavenger Hunt Provides Thrills." November 2, 1933.

——. "Scavenger Hunt Set for Tonight." November 1, 1933.

——. "A Treasure Hunt Stirs Fifth Avenue." April 26, 1925.

Taylor, David John. *Bright Young People: The Lost Generation of London's Jazz Age*. 1st U.S. ed. New York: Farrar, Straus & Giroux, 2009.

All the Year Round. "London Guardians of the Night." Vol. 12. September 12, 1874.

Bridge, Joseph C. "Town Waits and Their Tunes." *Proceedings of the Musical Association* (54th Sess.: 1927–1928): 63–92.

Dyer, T. F. Thiselton. *British Popular Customs, Present and Past*. London: G. Bell, 1876.

Frank Leslie's Sunday Magazine. "Christmas Street Music." Vol. 25. 1899.

Monthly Musical Record. "Christmas Waits." December 1, 1885.

Musical World. "Christmas Waits." December 31, 1864.

Schivelbusch, Wolfgang. *Disenchanted Night: The Industrialization of Light in the Nineteenth Century*. Translated by Angela Davies. Berkeley: University of California Press, 1988.

Schlör, Joachim. *Night in the Big City: Paris, Berlin, London 1840–1930*. London: Reaktion Books, 1998.

Stow, John. *A Survey of London; Reprinted from the Text of 1603, with Introduction and Notes by Charles Lethbridge Kingsford*. 2 vols. Oxford: Clarendon Press, 1908.

Strand Musical Magazine. "The Waits." Vol. 6. 1897.

Woodfill, Walter L. *Musicians in English Society, from Elizabeth to Charles I*. 1953. New York: Da Capo Press, 1969.

DREAMERS TAKE FLIGHT

Arnold-Forster, Mary. *Studies in Dreams*. New York: Macmillan, 1921.

Bailey, Thomas P. Review of *La mémoir des rêves et la mémoire dans les rêves*, by R. Meunier. *Journal of Philosophy, Psychology and Scientific Methods* 4, no. 10 (May 9, 1907): 271–276.

Gollnick, James. *The Religious Dreamworld of Apuleius' Metamorphoses: Recovering a Forgotten Hermeneutic*. Waterloo, Ontario: Canadian Corporation for Studies in Religion, 1999.

Hobson, J. Allan. *The Dreaming Brain*. New York: Basic Books, 1988.

Wilson, Nigel Guy, ed. *Encyclopedia of Ancient Greece*. New York: Routledge, 2006.

DUCHAMP CUTS LOOSE

Barnet, Andrea. *All-Night Party: The Women of Bohemian Greenwich Village and Harlem, 1913–1930*. Chapel Hill, N.C.: Algonquin Books of Chapel Hill, 2004.

Cabanne, Pierre, and Marcel Duchamp. *Dialogues with Marcel Duchamp*. Translated by Ron Padgett. New York: Viking Press, 1971.

Fahlman, Betsy. *Chimneys and Towers: Charles Demuth's Late Paintings of Lancaster*. Fort Worth: Amon Carter Museum; Philadelphia: dist. by University of Pennsylvania Press, 2007.

Harnoncourt, Anne d', and Kynaston McShine. *Marcel Duchamp*. Munich: Prestel; New York: dist. by Neues, 1989.

Kuenzli, Rudolf, and Francis M. Naumann, eds. *Marcel Duchamp: Artist of the Century*. Cambridge, Mass.: MIT Press, 1989.

Lebel, Robert. *Marcel Duchamp*. Paris: Belfond, 1985.

Wood, Beatrice. *I Shock Myself: The Autobiography of Beatrice Wood*. Edited by Lindsay Smith. San Francisco: Chronicle Books, 1988.

Billington, Sandra. *Mock Kings in Medieval Society and Renaissance Drama*. Oxford: Clarendon Press, 1991.

Brand, John, and Henry Ellis. *Observations on the Popular Antiquities of Great Britain*. 2 vols. London: G. Bell & Sons, 1888–1890.

Chambers, E. K. *The Mediaeval Stage*. Oxford: Clarendon Press, 1903.

Chambers, Robert. *The Book of Days*. Edinburgh: W. & R. Chambers, 1864.

Davidson, Clifford. *Festivals and Plays in Late Medieval Britain*. Aldershot, U.K., and Burlington, Vt.: Ashgate, 2007.

Grafton, Anthony, Glenn W. Most, and Salvatore Settis, eds. *The Classical Tradition*. Cambridge, Mass.: Harvard University Press / Belknap Press, 2010.

Kinney, Arthur F. *A Companion to Renaissance Drama*. Oxford, U.K., and Malden, Mass.: Blackwell Publishing, 2002.

Knight, Charles. *The Popular History of England*. New York: J. W. Lovell, 1880.

Chevigny, Paul. *Gigs: Jazz and the Cabaret Laws in New York City*. 2nd ed. New York: Routledge, 2005.

DeVeaux, Scott. "Bebop and the Recording Industry: The 1942 AFM Recording Ban Reconsidered." *Journal of the American Musicological Society* 41, no. 1 (Spring 1988): 126–165.

——. *The Birth of Bebop: A Social and Musical History*. Berkeley: University of California Press, 1997.

Gillespie, Dizzy, with Al Fraser. *To Be, or Not—to Bop: Memoirs*. Garden City, N.Y.: Doubleday, 1979.

Martin, Henry. *Essential Jazz: The First 100 Years*. Australia: Thomson/Schirmer, 2005.

McCurdy, Ronald. *Meet the Great Jazz Legends: Short Sessions on the Lives, Times, and Music of the Great Jazz Legends*. Van Nuys, Calif.: Alfred, 2004.

Rutkoff, Peter, and William Scott. "Bebop: Modern New York Jazz." *Kenyon Review*. New Series. Vol. 18, no. 2 (Spring 1996): 91–121.

Bernard, Theos. *Heaven Lies Within Us*. New York: C. Scribner's Sons, 1939.

Veenhof, Douglas. *White Lama: In Search of Theos Bernard*. London: Rider, 2008.

Fallows, Alice Katharine. "A City's Campaign for Pure Milk." *The Century*. Vol. 66. 1903.

New York Times. "Are We All Going Crazy Because of the City's Noises?" August 20, 1911.

———. "The Milkman on His Rounds." January 14, 1940.

———. "More Annoying Noises." February 9, 1932.

———. "Other Offenders Than Milk Cans." December 20, 1906.

———. "Records Prove Din Made by Milkmen." August 30, 1952.

———. "Reform for Milkmen." December 19, 1906.

———. "Riding with the Milkman." October 21, 1888.

———. "Street Noises in London." January 23, 1880.

———. "The War Against New York Noises." September 26, 1920.

Perrottet, Tony. *Pagan Holiday: On the Trail of Ancient Roman Tourists*. New York: Random House Trade Paperbacks, 2002.

Popular Science. "Rubber Reduces Noise of Early Milkman." April 1932.

Price, Clair. "London Gives Us Anti-Noise Lessons." *New York Times,* December 22, 1935.

THE DAWN CHORUS

Clare, John. *Poems by John Clare*. Edited with an introduction by Arthur Symons. London: Henry Frowde, 1908.

Elliott, Lang. *Music of the Birds: A Celebration of Bird Song*. Boston: Houghton Mifflin, 1999.

Haughton, Hugh, Adam Phillips, and Geoffrey Summerfield, eds. *John Clare in Context*. Cambridge: Cambridge University Press, 1994.

London, April. Review of *The Natural History Prose Writings of John Clare,* by Margaret Grainger. *Review of English Studies*. New Series. Vol. 37, no. 145 (February 1986): 108–109.

Rothenberg, David. *Why Birds Sing: A Journey Through the Mystery of Bird Song*. New York: Basic Books, 2005.

Stap, Don. *Birdsong*. New York: Scribner, 2005.

Jessica Kerwin Jenkins began her career in New York, writing for *Women's Wear Daily* and for *W* magazine, later becoming *W*'s European editor in Paris. Her first book, *Encyclopedia of the Exquisite,* was one of amazon.com's top one hundred picks in 2010, and was featured in *The New York Times Book Review, The Wall Street Journal,* and *Vanity Fair,* among other publications. She writes for *Vogue* and lives on the coast of Maine.

A NOTE ON THE TYPE

The text of this book was set in Filosofia, a typeface designed by Zuzana Licko in 1996 as a revival of the typefaces of Giambattista Bodoni (1740–1813). Basing her design on the letterpress practice of altering the cut of the letters to match the size for which they were to be used, Licko designed Filosofia Regular as a rugged face with reduced contrast to withstand the reduction to text sizes, and Filosofia Grand as a more delicate and refined version for use in larger display sizes.

Licko, born in Bratislava, Czechoslovakia, in 1961, is the co-founder of Emigre, a digital type foundry and publisher of *Emigre* magazine, based in Northern California. Founded in 1984, coinciding with the birth of the Macintosh, Emigre was one of the first independent type foundries to establish itself centered around personal computer technology.